100 Works of Art celebrating

A BALANCE HOUSE BOOK

PRODUCED AND DIRECTED BY Marshall Lee

LOVERS

❦ COMPILED BY *Mary Lawrence*

romantic love, with commentaries by
the distinguished and the great

❦ FOREWORD BY SOPHIA LOREN

❦ A & W Publishers, Inc. NEW YORK

Printed in Italy by Amilcare Pizzi, S.p.A.

ISBN 0-89479-116-8

Grateful acknowledgement is given to the copyright owners for
permission to quote lines of poetry as follows:
Page 55: Copyright Edna St. Vincent Millay. Reprinted from
Collected Poems by Edna St. Vincent Millay by permission of Mrs.
Norma Millay Ellis. Page 141: Copyright 1940, renewed 1968, by
W.H. Auden. Reprinted from *W.H. Auden Collected Poems* by
W.H. Auden, edited by Edward Mendelson. Reprinted by
permission of Random House, Inc. Page 173: *The Mermaid* is
reprinted with permission of Macmillan Publishing Co., Inc. from
Collected Poems of William Butler Yeats, copyright 1928 by
Macmillan Publishing Co., Inc., renewed 1956 by Georgie Yeats.
Page 211: From *Collected Poems* by Conrad Aiken. Reprinted by
permission of Oxford University Press.

Library of Congress Cataloging in Publication Data
Main entry under title:

Lovers, 100 pictures and text by the distinguished and
 the great.

 "A Balance House book."
 1. Love in art. 2. Art. I. Lawrence, Mary, 1918-
II. Title: Lovers, one hundred pictures and text by the
distinguished and the great.
N8220.L63 1982 704.9'423 82-11372
ISBN 0-89479-116-8

IT IS SAID that all the world loves a lover. Certainly, works of art which deal with lovers attract the world widely; the actress who portrays romantic roles commands an audience; the writer who describes love sensitively is almost sure to be read; the artist who captures lovers intimately on canvas or in stone is likely to have his work viewed with intense interest. Why are we so drawn to images and tales of love? Perhaps because when we love, we forget our painful sense of being alone. For a brief space we lose ourselves and are absorbed with "the other"; we forget isolation in the sweet mystery of unity. So when we go to the theater, or the library, or the gallery, we look for other lovers in memory or in hope.

The pictures collected here show love in many forms and at many moments of life, but they are all moments that transcend loneliness. All the world loves a lover? All the world yearns to be a lover.

SOPHIA LOREN

CONTENTS

5 *Preface* SOPHIA LOREN

11 *Foreword* MARY LAWRENCE

14 John Brown / *The music lesson* ❦ MARY PICKFORD/BUDDY ROGERS

16 Oskar Kokoschka / *The tempest* ❦ JOSHUA LOGAN

18 Henri Rousseau / *Rendezvous in the forest* ❦ DR. FOREST MELICK HINKHOUSE

20 Suzuki Harunobu / *Two lovers parting at dawn* ❦ BARBARA HUTTON

22 Pablo Picasso / *The lovers* ❦ J. CARTER BROWN

24 Anon. [African] / *Luba couple* ❦ KATHERINE C. WHITE

26 Anon. [Sch. of Fontainebleau] / *Venus and Mars* ❦ GEORGE AXELROD

28 The Sosios Painter / *Achilles tending the wounded Patroklos* ❦ MARY RENAULT

30 Gustave Courbet / *The happy lovers* ❦ DR. PHILIP SANDBLOM

32 Cecil Beaton / *The Duke and Duchess of Windsor* ❦ HRH THE DUCHESS OF WINDSOR

34 Gustav Klimt / *The kiss* ❦ BROOKE HAYWARD

36 Henry Moore / *Interlocking* ❦ ARTHUR KNIGHT

38 Reza-ye Abbasi / *Two lovers* ❦ SOROYA ESFANDIARY

40 John Singer Sargent / *Paul Helleu and his wife* ❦ GENE TIERNEY

42 Anon. [German] / *A bridal couple* ❦ ANNA BING ARNOLD

44 Giorgio di Chirico / *Hector and Andromache* ❦ DR. SEUSS

46 Auguste Renoir / *The ball at Bougival* ❦ ARMAND DE LA ROCHEFOUCAULD

48 Anon. [Chinese] / *Romance of the western chamber* ❦ MARCH FONG EU

50 Jack Culiner / *Love cycle* ❦ JACK CULINER

52 Francesco Hayez / *The kiss* ❦ DEBORAH KERR

54 John Everett Millais / *The woodsman's daughter* ❦ BARBARA INGRAM

56 Robert Fagan / *The artist and his wife* ❦ DESMOND GUINNESS

58 George Bellows / *Summer night, Riverside Drive* ❦ BUDD HARRIS BISHOP

60 Henri de Toulouse-Lautrec / *The bed* ❦ COUNT DE TOULOUSE-LAUTREC/
 ALEJO VIDAL-QUADRAS

62 Anon. [Egyptian] / *King Mycerinus and his wife* ❦ OMAR SHARIF

64 Andy Warhol / *Liz Taylor diptych* ❧ CAROLYN FARRIS

66 William Page / *Cupid and Psyche* ❧ NANCY HOLMES

68 Thomas Gainsborough / *The morning walk* ❧ MARGARET, DUCHESS OF ARGYLL

70 Fletcher Martin / *Airport* ❧ FLETCHER MARTIN

72 Vivi Aluluk Kunnuk / *Couple* ❧ JANE DART

74 Jan Van Eyck / *Jan Arnolfini and his wife* ❧ ANNE BAXTER

76 Gian Lorenzo Bernini / *Daphne and Apollo* ❧ PRINCESS MARCELLA BORGHESE

78 Anon. [Indian] / *Krishna and Radha* ❧ MARY LOOS

80 Giandomenico Tiepolo / *The declaration of love* ❧ HELEN HAYES

82 Pol de Limbourg / *August* ❧ BARONESS FRANCES PELLENC

84 Elizabeth Duquette / *Pelléas and Mélisande* ❧ TONY DUQUETTE

86 Anon. [Etruscan] / *Lovers* ❧ LAURA HUXLEY

88 Giovanni Tiepolo / *Anthony meeting Cleopatra* ❧ LADY MELCHETT

90 René Prinet / *The Kreutzer Sonata* ❧ S. J. PERELMAN

92 Max Ernst / *The kiss* ❧ ARTHUR SPITZER

94 Benjamin West / *Romeo and Juliet* ❧ KENT SMITH

96 Henry Holiday / *Meeting of Dante and Beatrice* ❧ GIUSEPPE BELLINI

98 Gustav Vigeland / *Man embracing woman* ❧ TONE WIKBORG

100 John Singleton Copley / *The artist/Susanna Copley* ❧ HELEN COPLEY

102 Arthur Hughes / *The long engagement* ❧ COLLEEN MOORE

104 Giovanni Tiepolo / *Angelica and Medoro* ❧ COUNTESS MARIA TERESA CESCHI

106 Anon. [Etruscan] / *Couple* ❧ VINCENT PRICE

108 Frans Hals / *Yonker Ramp and his sweetheart* ❧ JESSAMYN WEST

110 Tamara Lempicka / *Adam and Eve* ❧ TAMARA LEMPICKA

112 Anon. [Indian] / *A Mughal prince and his mistress* ❧ DR. EDWIN BINNEY, 3rd

114 Jan Vermeer / *Young woman reading a letter* ❧ IRWIN SHAW

116 Auguste Rodin / *Eternal spring* ❧ HSH PRINCESS GRACE OF MONACO

118 Francisco Goya / *The parasol* ❧ FLEUR COWLES

120 Paul Clemens / *Robert and Francine Clark* ❧ PAUL CLEMENS/WILL DURANT

122 Alfred Jacob Miller / *Indian elopement* ❧ OLEG CASSINI

124 Gustav Klimt / *Love* ❧ GEORGE CUKOR

126 Riccio / *Satyr and satyress* ❧ SIR JOHN POPE-HENNESSY

128 Norman Rockwell / *Gaiety dance team* ❧ NORMAN KRASNA

130 Marc Chagall / *Lovers and flowers* 🌹 DR. REGINA K. FADIMAN

132 Lorenzo Lotto / *Micer Marsilio and his wife* 🌹 ALFONSO E. PEREZ-SANCHEZ

134 S. A. Aitbaev / *Happiness* 🌹 PRINCE YOUKA TROUBETZKOY

136 François Boucher / *Winter* 🌹 MERLE OBERON

138 Constantin Brancusi / *The kiss* 🌹 JEAN NEGULESCO

140 George Tooker / *Lovers* 🌹 GEORGE TOOKER

142 John Swope / *Olivier and Leigh in* Romeo and Juliet 🌹 JOHN SWOPE

144 Jacques-Louis David / *Cupid and Psyche* 🌹 HENRY FONDA

146 Francisco Goya / *The Duchess of Alba* 🌹 CAYETANA, DUCHESS OF ALBA

148 Anon. [Nepalese] / *Embracing Tantric deities* 🌹 RUMER GODDEN

150 Claude Emil Schuffenecker / *The rendezvous* 🌹 MARY MARTIN

152 François Gérard / *Napoleon I/Empress Josephine* 🌹 LOUIS JOURDAN

154 Jean-Honoré Fragonard / *The lock* 🌹 COUNTESS DE VOGÜÉ

156 Auguste Renoir / *The lovers* 🌹 ROBERT NATHAN

158 Anon. [German] / *Meeting of Joachim and Anne* 🌹 DANIEL O'KEEFE BROWNING

160 Marie Laurencin / *The kiss* 🌹 SIR HAROLD ACTON

162 L. F. Abbott / *Horatio Nelson* 🌹 FREYA STARK
George Romney / *Lady Hamilton*

164 Sandro Botticelli / *The birth of Venus* 🌹 DOROTHY McGUIRE

166 Vicente Palmaroli / *Confessions* 🌹 FRANCESCA BRAGGIOTTI LODGE

168 Emil Nolde / *Lovers* 🌹 MARGARET MALLORY

170 Anon. [Olmec] / *Loving couple* 🌹 BRADLEY SMITH

172 Edward Burne-Jones / *Depths of the sea* 🌹 JANE WYATT

174 Peter Paul Rubens / *Rubens and Isabella Brant* 🌹 ROBIN CHANDLER DUKE

176 Edvard Munch / *Man and woman in the forest* 🌹 ELIN VANDERLIP

178 Rembrandt / *The Jewish bride* 🌹 LORD CLARK

180 Gaston Lachaise / *Passion* 🌹 ELEANOR HARRIS HOWARD

182 Michele Gordigiani / *Robert Browning/Elizabeth Barrett Browning* 🌹 BRIAN AHERNE

184 Antonio Correggio / *The school of love* 🌹 CECIL GOULD

186 Jean-Honoré Fragonard / *The stolen kiss* 🌹 JANET GAYNOR

188 (Currier & Ives) / *Courtship: The happy hour* 🌹 BROOKE ASTOR

190 Albert Grafle / *Emperor Maximillian/Empress Carlotta* 🌹 JOHN GAVIN

192 Anon. [Pompeian] / *Satyr and maenad* 🌹 NEIL SIMON

194 Giovanni Boldini / *The walk in the woods* ❦ EMILIA BOLDINI

196 Ivan Mestrovic / *Well of life* ❦ MARIA MESTROVIC

198 Giovanni Segantini / *Love, fountain of life* ❦ ROSSANO BRAZZI

200 François Boucher / *Lovers in a park* ❦ HENRY G. GARDINER

202 Pablo Picasso / *Lovers on a street* ❦ DIANA VREELAND

204 Eugène Delacroix / *George Sand/Chopin* ❦ BYRON JANIS

206 Anon. [Indian] / *Lovers* ❦ DONNA REED

208 Titian / *The three ages of man* ❦ COUNTESS ELSIE GOZZI

210 Jean-Antoine Watteau / *Melody of love* ❦ ELINOR REMICK WARREN

212 Michelangelo / *Adam and Eve* ❦ KING VIDOR

215 *Index of artists*

216 *Index of commentators*

220 *Biographical note*

IN *LOVERS* I have followed the format of *Mother and Child,* my first book. To my knowledge, no one has ever compiled volumes of this kind. These books are a record of the way that a variety of distinguished people of our era respond to the art of a single theme. In a museum or gallery one sees people of various backgrounds, not just art experts, enjoying what they view. Take six people from different walks of life viewing a particular painting and you will undoubtedly have six totally different reactions. Certainly each person brings to the situation his or her own background; educational, family, emotional—all channeled through their individual personality. It has seemed to me (and the thousands of readers of *Mother and Child* apparently agree) that the personal responses to art of exceptional people who are not professional art historians have significant interest. While I am not proposing that art is democratic, nor that the educated opinion has no more value than another, I do say that art is usually created for a wider audience than the professionals alone. In these books a good number of art historians, museum directors, and curators are included—but so are a lot of highly creative others.

The one hundred works of art in this book range from 5000 B.C. to the present day and embrace many of the world's cultures. A number of the lovers portrayed here are famous lovers from mythology or history; but most are created in the artist's imagination. The varieties of love are as endless as the range of the imagination. Yet even these are exceeded by the depth and power of love. The Chinese express this transcendence in the yin-yang principle—the male and female elements in every aspect of life, locking together the two forces that make life. Active and passive, creative and receptive, light and darkness, man and woman, yin and yang, forever opposed, forever united, struggling for harmony, striving for love.

The moments when passion visits human existence are like a breath of eternity. They are moments of revelation. But love is the great de-ceiver, always eluding definition, constantly evanescent. Perhaps the answer was found by Goethe when he said: "This is the true measure of love, when we believe that we alone can love, that no one could ever have loved so before us, and that no one will ever love in the same way after us."

Like love, art touches every part of our lives. The all-pervading quality

of art was cogently expressed by Boris Pasternak: "Art serves beauty and beauty is delight in form, and form is the key to organic life, since no living thing can exist without it, so that every work of art, including tragedy, expresses the joy of existence."

Each work in this book is a world of love unto itself—no one logical order or chronological arrangement makes more sense than another. So the arrangement has been made for purely visual reasons. Turning the pages becomes an adventure in which one slips from one civilization to another; from one century to another. Unity of theme makes the thread that weaves the pages together.

I am grateful to all those who helped and to those who could not but sincerely wanted to contribute to this volume. I am ·indebted for the cooperation of the photographers, the owners of works of art who gave their permission, and all those in the many galleries, museums, and universities whose facilities were used. My heartfelt thanks particularly to all of these dear people who gave so graciously and generously of their time in writing essays, whose expressions of friendship have made this book possible. For the help of Mary Chambers and Melinda Wortz, I will always be appreciative, as also to Marshall Lee, who once again gave me his guidance and indispensable support in producing this book.

Hecaton of Rhodes is credited with this bit of advice, in which I concur with all my heart:

> I will reveal to you a love potion,
> Without medicine, without herbs,
> Without any witch's magic;
> If you want to be loved, then love.

MARY LAWRENCE

John Brown (1831–1913)

THE MUSIC LESSON

1870, oil on canvas, 24×20"

Metropolitan Museum of Art, New York, gift of Colonel Charles A. Fowler, 1921

WHEN we met almost fifty years ago, it was quite a different world. There were still many courtships that went on in the family parlor, with Mama or Papa looking in the doorway. We ourselves fell in love in Hollywood, when actresses and actors had suddenly become celebrities, the personification of romance for all Americans.

The dizzying excitement of that time made falling in love a fantastic storybook experience. Luckily for us, in our marriage we finally found the kind of sweetness we portrayed on the screen. Looking at this picture by John Brown, we feel that the music his happy couple is playing will go on and on, and that lovers throughout the ages will continue to make beautiful music together. The kind of romance we portrayed on the screen is just as much a part of our heritage as the endearing phrase "and they lived happily ever after".

MARY PICKFORD

BUDDY ROGERS

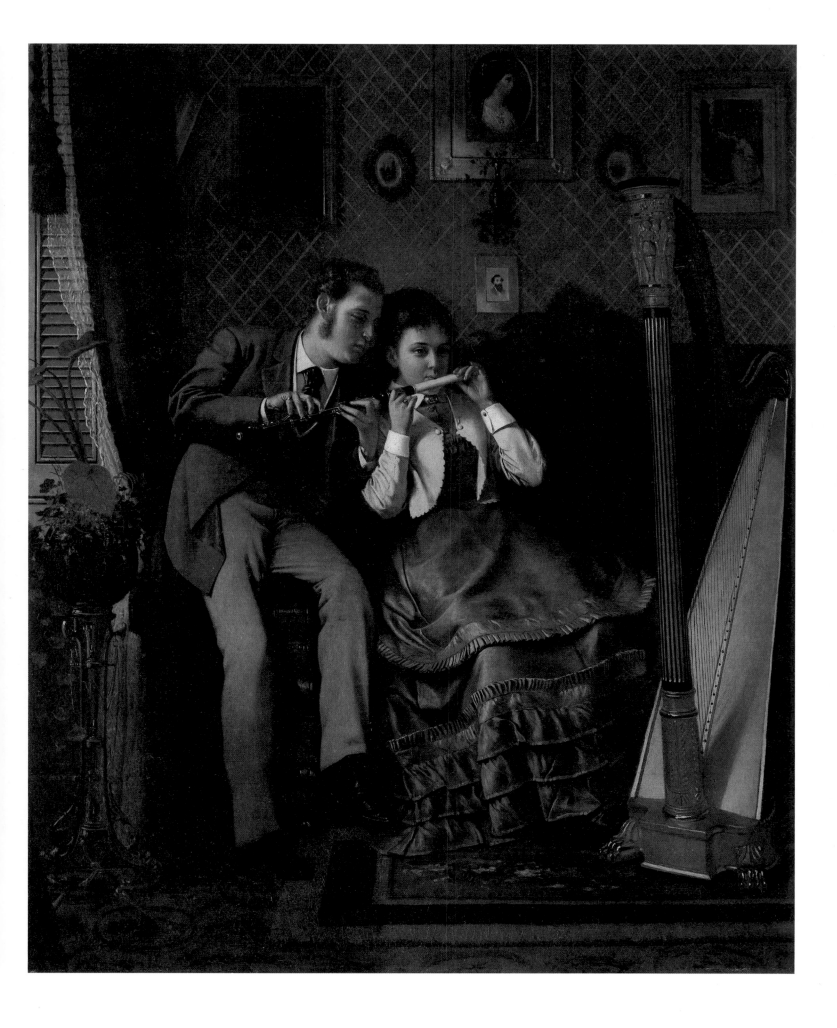

Oskar Kokoschka <small>(1886–1980)</small>

THE TEMPEST

1914, oil on canvas, 71¼ × 86⅝"

Kunstmuseum, Basle

OSKAR KOKOSCHKA was a tempest within a man. In this great painting you can see the tempestuous fury (for this is a self-portrait) as he defies the raging sea storm from his small boat. He seems to command the world about him to be calm, while nestled beside him in the boat, all femininity and trusting her lover, is Alma Mahler (for it is her portrait).

The whole composition is called *The tempest,* but which tempest? Is it the one engulfing the small boat, the seemingly more violent one in Oskar's face, or the hidden one in Alma's breasts (for she was a tempest within a woman)?

Kokoschka painted the lovers in *The tempest* in 1914. Years and years later, in 1949, he wrote to Alma of their seemingly indestructible grand amour: "There has been nothing like it since the Middle Ages, for no couple has ever breathed into each other so passionately . . . not one has known the thrill of playing with life. . . . Not one—except your lover whom you once initiated into your mysteries . . . this love play is the only child we have. . . . Your Oskar."

In 1960, Kokoschka painted my portrait. I was never allowed to pose. He made me keep talking, even gesturing animatedly to him. The resulting portrait is most of all me with my hands in movement, but it is more. It is the me I wish I were, or, rather, hope to be. It is filled with swirling color, spirit, and turbulent feeling.

He was still able, at seventy-five, to show glimpses through the blue, blue windows of his eyes of the tempest within him. He seemed to be wiry, agile, funny, and ageless. I understand why Alma loved him so. He was irresistible.

JOSHUA LOGAN

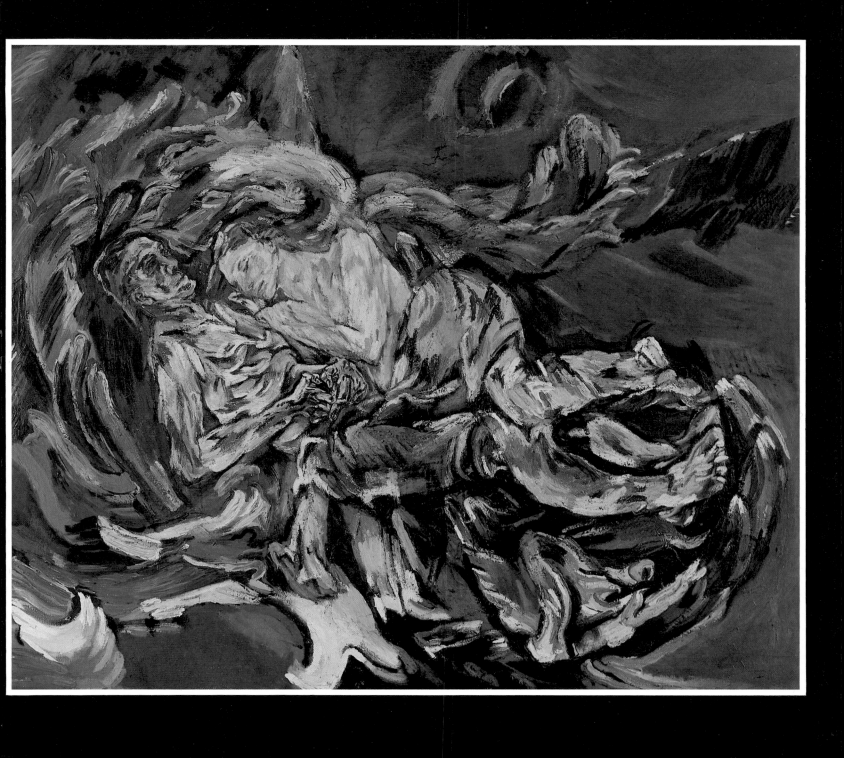

Henri Rousseau (1844–1910)

RENDEZVOUS IN THE FOREST

c. 1889–90, oil on canvas, 36¾ × 29¼"

National Gallery of Art, Washington; Gift of the W. Averell Harriman Foundation

in memory of Marie N. Harriman

THERE is a deep passion within "Douanier" Henri Rousseau's *Rendezvous in the forest,* a passion memorable, haunting, and decidedly Gallic. The lovers' trysting place is a forest—a sylvan setting more reminiscent of a dreamy tropical jungle than the oak forest of Henri Rousseau's native Laval, tucked in the bosky country of the Loire. In this forest there is the dense flora of an exotic, other-worldly Rambouillet.

During his professional life, Rousseau served as a minor customs official in the governments of Napoleon III and his successors. He was entirely self-taught as well as self-effacing; yet the brilliance of his imagination and his dash in the application of paint would seem to belie this.

Rousseau has about his painting a dreamland quality, a happy innocence that helps him to escape oversimplified classification. His immensely romantic *Sleeping gypsy,* with its bizarre subject matter, might shock fragile sensibilities of the late nineteenth-century viewers. At the same time, the painting here offers a glimpse into a world of art half a century earlier—the world of the Forest of Fontainebleau whose golden artists brought a renewed belief, a respect for, and fidelity to, the balanced, sylvan landscape, with and without figures.

The telling of the tale in this painting is achieved with great tenderness. The artist has captured a feeling of burnished euphoria. The cadence of the scene is slow, uncontrived, replete with a deeply evocative eighteenth-century lyricism. *Rendezvous in the forest* is a painting of lovers out of a classical myth, suggesting the inifinite mysteriousness of life itself.

DR. FOREST MELICK HINKHOUSE

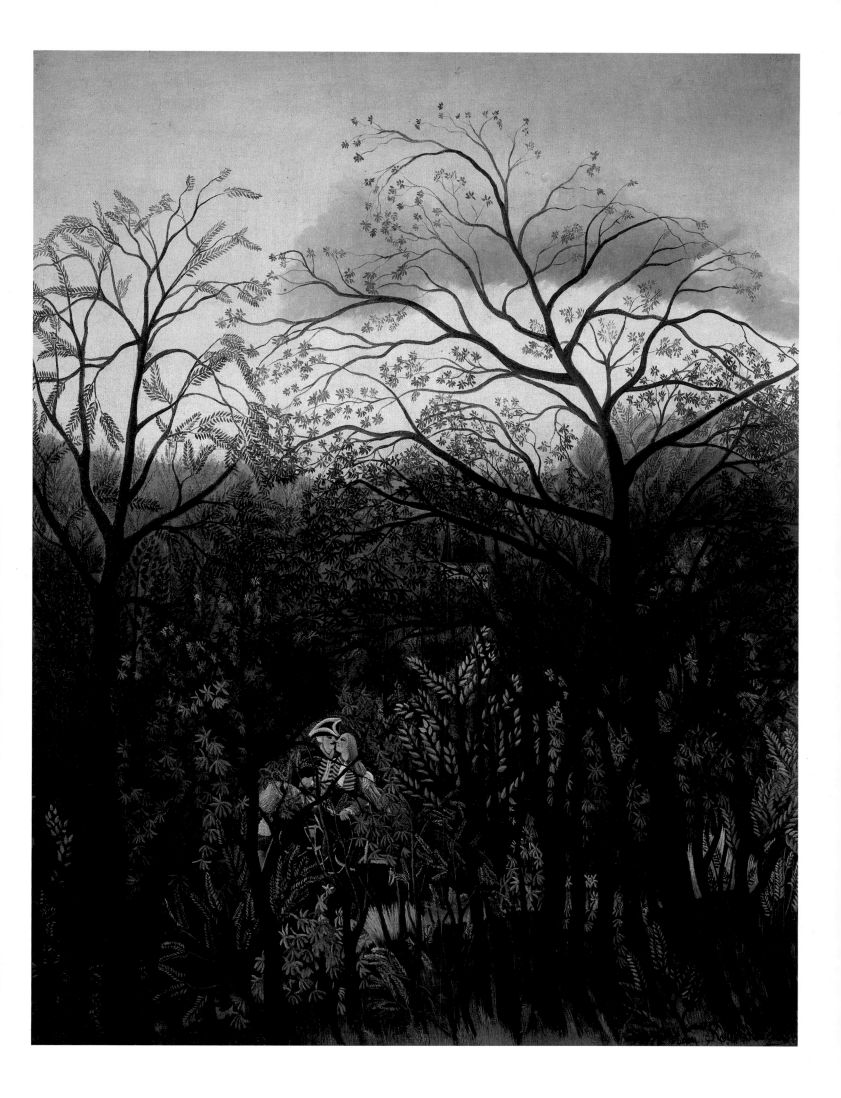

Suzuki Harunobu (c. 1718–1770)

TWO LOVERS PARTING AT DAWN

1768–70, wood block print, 27.9×21.1"

Royal Ontario Museum, Toronto, Collection Sir Edmund Walker

I HAVE always thought that Japan is the most aesthetically sensitive country in the world. You can see the incredibly refined and subtle sensibility of the Japanese not only in their art but in all aspects of their daily lives—the simplest wooden utensils, the printed fabrics of everyday clothes, the arrangement of food on a plate. And an appreciation for the beauty of each moment, in the lives of lower-class people, not just aristocrats, is the very heart of the Ukiyo-e style seen in Harunobu's woodblock print, *Two lovers parting at dawn*. The Ukiyo-e artists represented the "Floating World", floating in the sense of transient, particularly the transient world of pleasure, whether in erotic love, music, games, dancing, or the theater. The same sense of the fleeting nature of pleasure appears in Japanese poetry. One of my favorites is the short poem by Taku-an, a Zen master.

> *This day will not come again.*
> *Each minute is worth a priceless gem.*

Harunobu captures this mood perfectly in the moment of parting. Each movement is refined, considered, elegant. Look how gracefully the man inclines his long neck toward his beloved, how wistfully she touches his robe, how incredibly small and delicate both their hands are. The loveliness of their emotion is echoed in the languorous, continuing curves of their robes, which tie them visually to each other. In the painted screen behind the lovers these flowing lines continue to the foot of Mount Fuji, linking the beauty of their feelings with the harmony of nature itself, even in the interior of their bedroom. Thus we see in Harunobu's print the Japanese feeling for the underlying, aesthetic unity of all aspects of life, from loving to leaving, birth to death.

BARBARA HUTTON

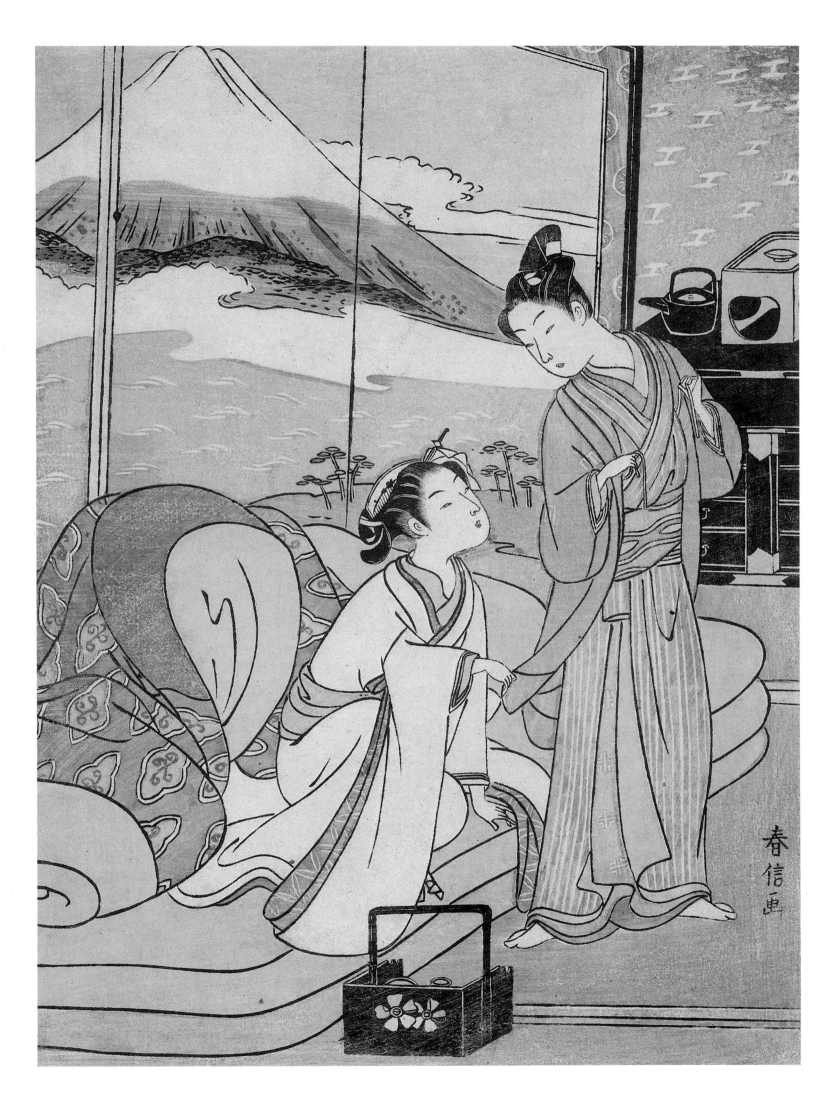

Pablo Picasso (1881–1973)

THE LOVERS

1923, oil on canvas, 51½ × 38½"

National Gallery of Art, Washington, D.C., Chester Dale Collection

PICASSO, the man who had shattered, at the beginning of this century, three thousand years of Western man's visual tradition; Picasso, the inventor of Cubism, a new pictorial language whose influence, through art and architecture, has touched us all—could this be the same Picasso, reaching back after all that in 1923, to the same great classical tradition he had just abjured?

He was forty-two. The years of poverty and obscurity were behind him. With his first marriage, to a ballerina in Diaghilev's Ballets Russes, Olga Koklova, in 1918, and with their first child, in 1921, Picasso had found a new serenity. His trip to Rome in 1917 had had much the effect of Renoir's Italian rediscovery. The weighty, sculptural forms and a mood of suspended time appear again and again in his paintings and particularly his graphic works, where, in a single outline, economy becomes eloquence.

Realistic as this great life-sized painting in our National Gallery might seem by comparison to the complex intellectuality of his earlier abstract achievements, there is artifice here, too. The colors are brushed on in flat areas as on the stage scenery with which he had become so intensely involved. And what colors they are— warm for the man, cool for the woman, each area relating harmonically as in a great chord. Yet the bodies are chalky white, as in an antique statue, or as with the greasepaint of the theater, abstracting the performer from the everyday. The man, in a leotard, holds the woman as if she had been spun into his embrace choreographically.

Yet, timelessly serene as their non-meeting glances are, one cannot help but feel the intensity of the emotions dammed up behind them. And with the incisiveness of those few sharp black brushstrokes, gathering at their eyes and in their touching hands, one senses a deeply felt, and deeply human, tenderness.

J. CARTER BROWN

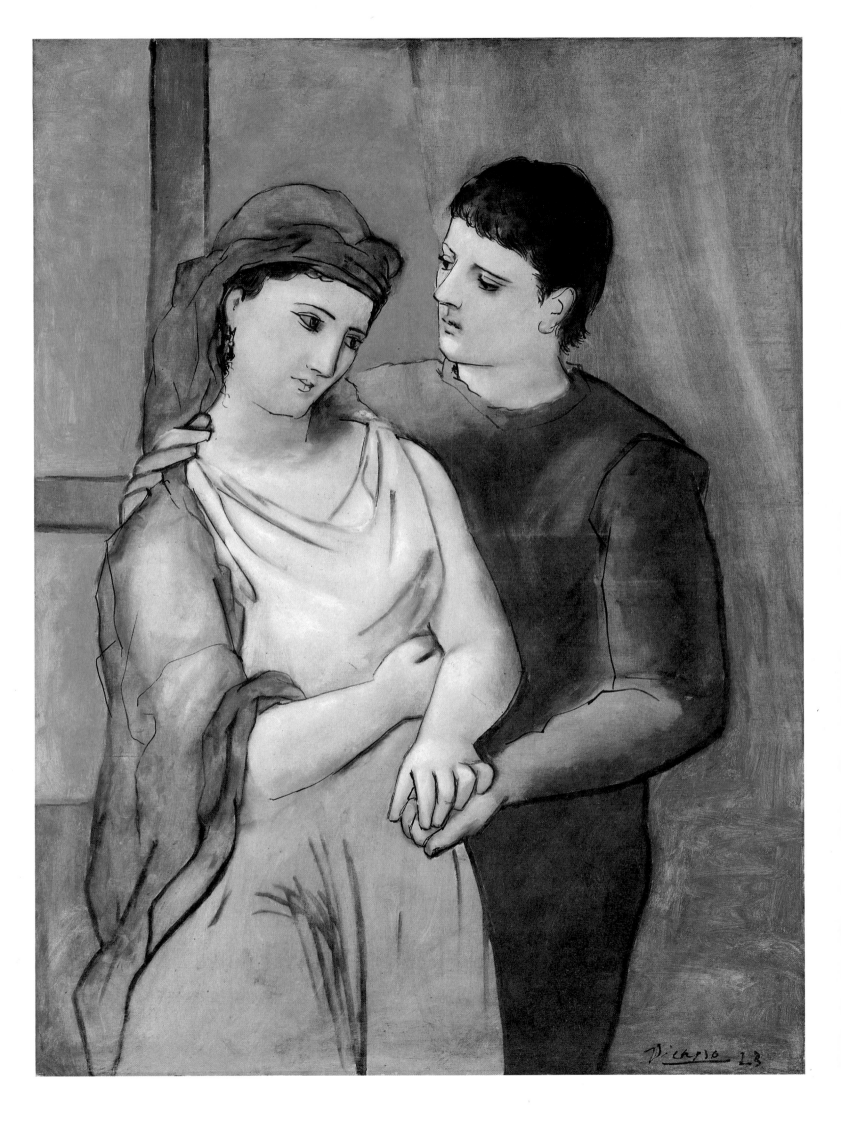

Anon.

LUBA COUPLE

19th or 20th cent. (African), carved wood, height 7½"

Collection Baron Lambert, Brussels

To SLEEP is more than to dream in Africa. It is to release spirits that may wander. It is to be vulnerable, helpless in the vast darkness of the night, filled with the wraiths of all those others, animals, humans, half-human animals, which prowl at will over vast distances with the speed of thought. Dangerous. Sleep is not safety. The head of a lineage, a clan, is also not powerful enough to guard himself or his unconscious from invasion. He would indeed go to great lengths to shield himself, and through him those he commands. He would commission the finest adept of the region to carve a pillow, a wish, an amulet almost, to aid him. The object would be most carefully done, in the highest possible style, with the greatest possible beauty, to be admired for its artistry. As the patriarch moved from one house to another in his compound, the headrest would follow, the wives hiding it in a basket from unfamiliar eyes.

In this instance, the two sweet, gentle little figures bring with their flowing gestures the reassurance of the ancestors, male and female, whose souls, being remote and in the ether, are exquisitely capable of protecting. The male has his hair in the classic Luba Hemba mode, four strands tightly braided, crossing over, away from the back of his head, in stiff geometry. The female wears the Luba Shankadi "cascade" style, shelves built from her head with mud, a permanent sculpture which she sometimes adorns with shining brass studs. Her body has the usual scarifications received at puberty, which signal not only adulthood but that she is socially acceptable, ready to be touched, stroked with delight, enjoyed and married.

Their eyes are closed; that extreme discretion, lowered lids which see all, keep all secrets, soothe, beguile, brings ineluctable peace and love.

KATHERINE C. WHITE

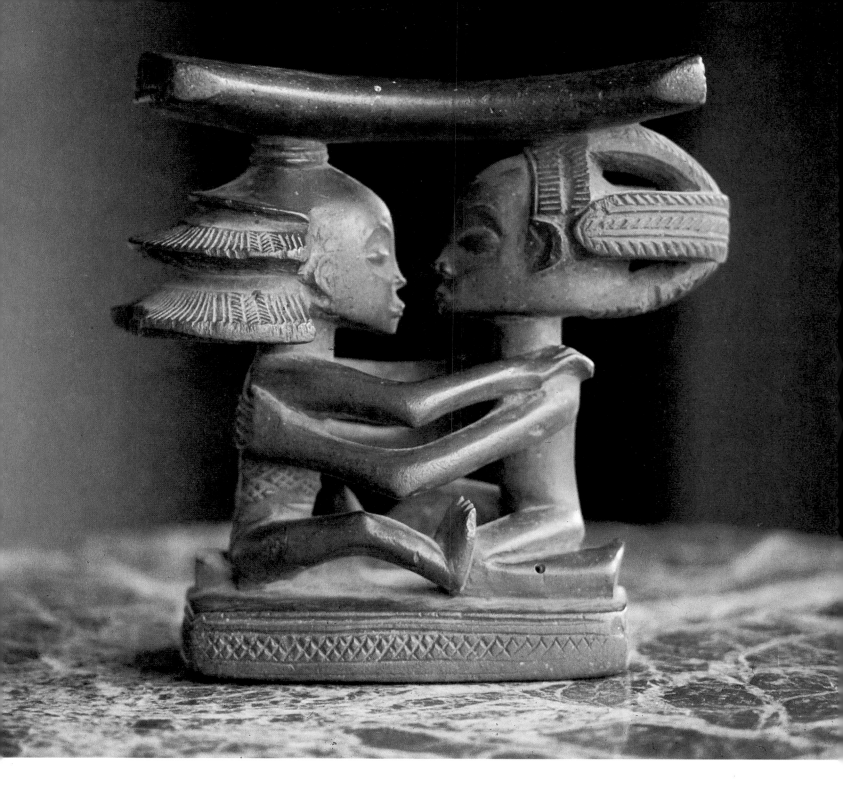

Anon.

VENUS AND MARS

16th cent. (School of Fontainebleau), oil on wood, 37⅝×28″

Palace Museum, Paris

IT WAS inevitable that Aphrodite, or Venus as she later called herself, would wind up in Fontainebleau among the rowdy, absinthe-swilling Barbizonians.

In a recent interview at the Polo Lounge—in town to plug her memoirs and just back from three weeks at La Costa ("It was absolute *Hades*, darling, but one must be skinny for the talk shows, no?")—she was reticent about her early life. "The thing with Mercury, the grotesque business with Hephaestus and Ares, the Beauty Contest, the Trojan War, all that I save for the memoirs!"

She sipped her Diet Nectar for a moment.

"No, darling," she said thoughtfully, "the Trojan War was a real bummer. That was when I decided to change my name, take off for Italy, and try to get into pictures. For a while I was the hottest thing that ever happened. The new kid in town. Titian. Veronese. I worked with all the big boys. But always in the nude. I was typed. Naked, she's a star, was the phrase they used. It was the old story. Too much success too soon. Eventually the booze and fettucini began to show and the only offers I was getting were for hard-core stuff.

"But the guys out at Fontainebleau, they liked their women built like *women*. Oh, those were the days! We were all stoned most of the time. Nobody ever knew who painted what. That's why it's all just signed 'Ecole de Fontainebleau'. Kind of like Warhol's Factory in a way.

"One funny that's not in the book. Mars dropped by for a weekend and they conned him into posing with me. It was freezing in the studio, of course, and he refused to take off his socks. It's accidents like that that start great traditions. Good old Mars—he was the first man in a French postcard to keep his black socks on!

"By the way," she added in closing, "you might mention the Diet Nectar. I'm franchising it under my own label in the fall."

GEORGE AXELROD

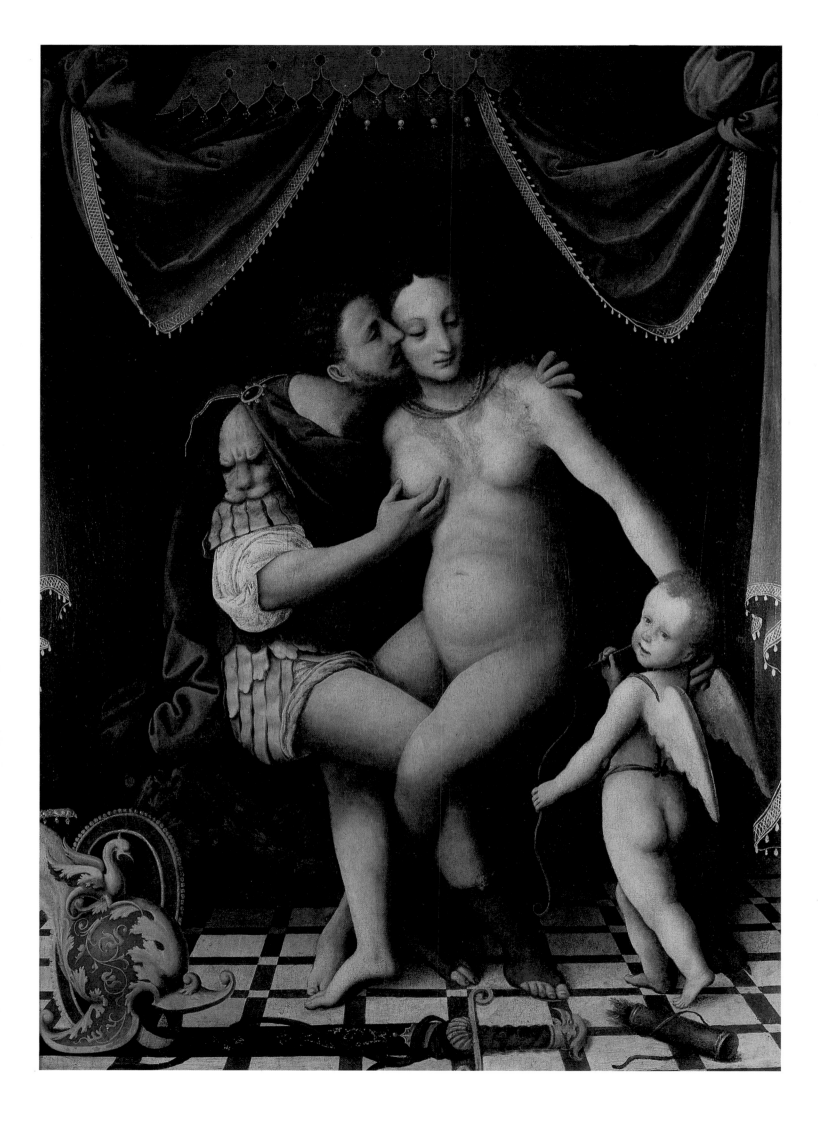

The Sosias Painter

ACHILLES TENDING THE WOUNDED PATROKLOS

500 B.C. Antiken Museen, Berlin, 7″ diam.

WHAT Romeo and Juliet are to heterosexual romance, Achilles and Patroklos were to the aristocratic homosexual cult of classical Greece. They typified the heroic bond of warrior lovers, inseparably loyal, guardians of each other's honor, faithful to the death.

The incident depicted by this master vase-painter is not in Homer. It may come from the lost *Epic Cycle*, where perhaps the pair were explicitly lovers. Homer does not say so, indeed gives them both mistresses. Yet their deep devotion—"You may delight my heart"— the agonized grief of Achilles for Patroklos' death in battle, his implacable vengeance for it despite a prophecy that his own death would follow; all these seemed, three centuries later, perfectly to express the ideal union of which Plato's *Symposium* says: "If a state or an army could be formed only of lovers and their beloved, how could any company hope for greater things than these, despising infamy and rivaling each other in honor? Even a few of them, fighting side by side, might well conquer the world."

This was more than a poet's dream. Such a corps was actually formed: the Sacred Band of Thebes, where the cult reached its apogee. Never defeated in any battle till their last, never retreating, the lovers of the Band met their end in one of history's sad ironies. They fell to a man at the Battle of Chaironeia, their victorious enemy the eighteen-year-old Alexander, already companioned by his beloved Hephaistion; a pair who, openly identifying with Achilles and Patroklos, were to carry their legend across two continents in a long meteoric blaze, with much the same tragic climax. Fighting side by side, they did conquer the world; but they also changed it, and the Homeric vision died with them.

MARY RENAULT

Mary Renault

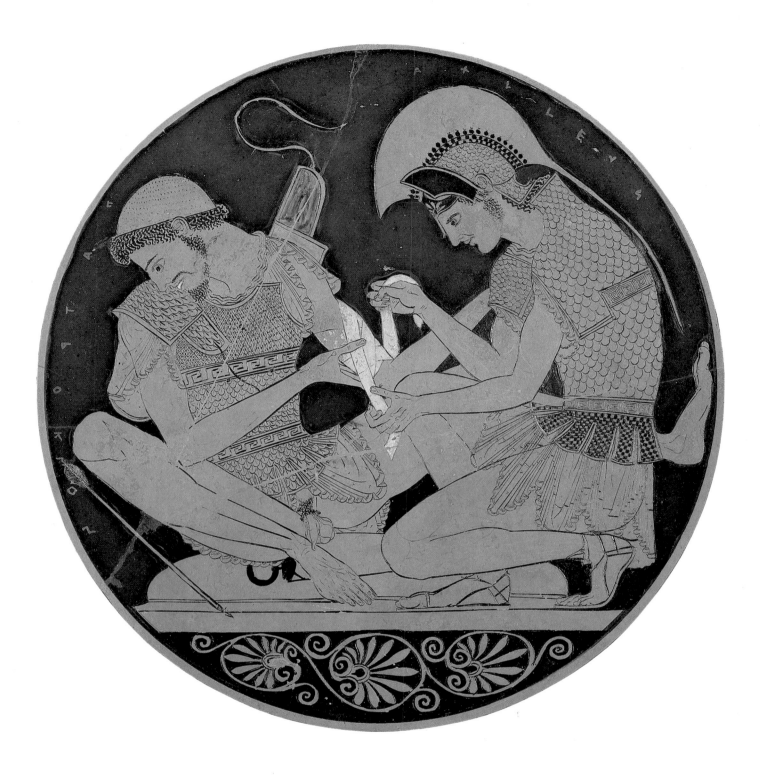

Gustave Courbet (1819–1877)

THE HAPPY LOVERS

1844, oil on canvas, 30½×23⅝"

Musée des Beaux-Arts, Lyon

30

THE high aim of Gustave Courbet was to create living art. To accomplish this, he abandoned the mythological and literary themes that had been favored by his predecessors and would paint only what he saw with his own eyes.

This by no means excluded romantic scenes, provided that he had experienced them in person. The lovers in the country are not Romeo and Juliet, but a couple Courbet knew intimately from many points of view: it is the artist himself, dancing with a beautiful girl who was his model as well as his mistress. (Courbet's original title for this painting was *Valse*).

Courbet loved to paint portraits of himself. He was utterly self-centered. He admitted proudly to being "the most conceited man in France", but he really was very handsome. His friends describe him as looking like an Assyrian king, and he trimmed his beard to conform to this flattering comparison. Through the years we meet the haughty glance from his beautiful, velvety eyes in many self-portraits. It is only in his youth that he deigns to share the stage with female company, at least in a painting.

This one was painted when Courbet was twenty-five years of age, before he developed the plastic force and genuine realism that made him a giant in the history of art. Instead, he had already mastered the sensuous glow, inherited from the great Venetians. Is there then anything in this rather conventional painting that forecasts the new ideas? The lovers are absorbed in an intense languishing feeling as they dance together into the approaching night. In the height of their emotion they join hands to express not only a romantic spiritual harmony but also a real and obvious desire for physical closeness. With this charming gesture, the happy lovers form a link between romanticism and realism.

DR. PHILIP SANDBLOM

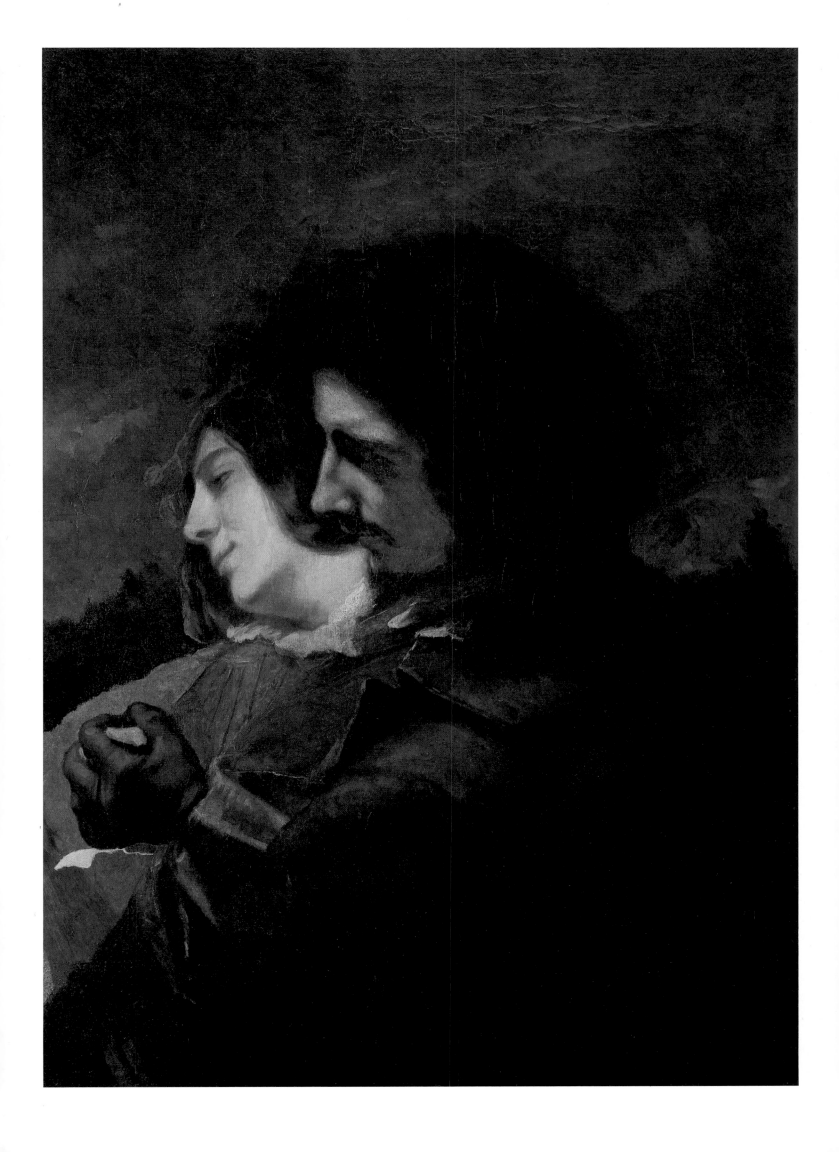

Cecil Beaton (1904–1980)

THE DUKE AND DUCHESS OF WINDSOR ON THEIR WEDDING DAY

Photograph, June 3, 1937, at the Château de Cande (negative 35mm)

Collection, the Duchess of Windsor

IS OUR fate in our stars or does it lie within ourselves? A woman's life is composed of the record of her hopes, thoughts, dreams, sorrows, and joys. "To everything there is a season and a time to every purpose under heaven—a time to weep and a time to laugh, a time to rend and a time to sew—a time to love and a time to hate."

The Duke said, "I cannot go on without the woman I love by my side". Later he said, "Whatever I am to be I must be with you; any position I am called upon to fill I can only fill with you".

No one can dictate the heart's direction. When you fall in love and the object of your affections returns your love, you are indeed blessed. My love for the Duke and his for me changed the course of history. We could hardly guess when we met what the future held for us. Our path was not smooth but we treasured the years we shared.

Any woman who has been loved as I have been loved, and who, too, has loved, has experienced life in its fullness. I have found a great measure of contentment and happiness. As Byron wrote:

> *Man's love is of man's life a thing apart*
> *'Tis woman's whole existence.*

THE DUCHESS OF WINDSOR

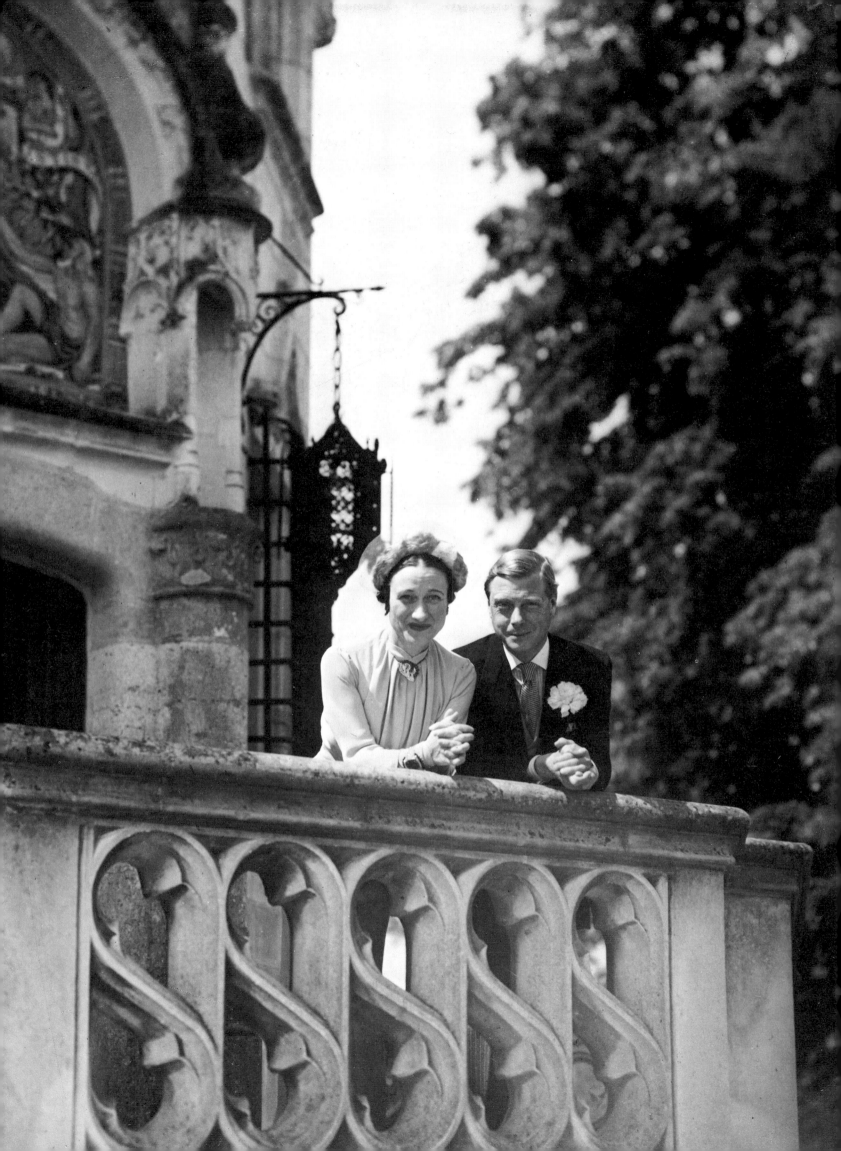

Gustav Klimt (1862–1918)

THE KISS

1907–8, oil on canvas, 70⅞ × 70⅞"

Osterreichische Gallery, Vienna

I WENT to Vienna just to see this painting. Extravagant, romantic, perhaps; but an essential visit to a very old friend.

Many years ago, the Guggenheim Museum mounted a retrospective of the works of Gustav Klimt and his contemporary, Egon Schiele, a show that presaged the subsequent popularity of those two artists in this country. I well remember my delight when I accidentally wandered into that exhibit; for sheer magic I had never seen anything like it before. With time, however, I've often questioned my memory and wondered if what I had once seen first hand could possibly be as wonderful as it had seemed.

It was; it is. And *The kiss* is one of Klimt's most beautiful and erotic paintings. It is important to know that for all his masterful use of decorative overlays, for all his sensuous façades, Klimt—like his fellow Viennese, Sigmund Freud—was focused on sexuality as the primary spectacle and motivation of life. By the time he painted *The kiss* he had come to believe that the dynamics of the entire cosmos were predicated on one principle: fertility and regeneration.

The kiss completely dominates the upstairs room of the gallery in which it hangs. The lifesize figures kneel on a bed of flowers suspended in golden air; so much gold the eye is dazzled. Molten gold on gold, golden cloth floating in golden space (it is interesting to know that Klimt's father was a goldsmith). The isolation of the lovers is total—no horizon lines to distract from their rapture. In fact, one is reminded of an icon, an icon to ecstasy. Amidst all this ornament and in spite of the artist's delicacy, his subject matter—an embrace—crackles with sexual tension, as the lovers press against each other upright until only their heads surrender, bending and swooning to the side.

I shall have to return to Vienna. No reproduction can do the painting justice, and I continue to be haunted by it.

BROOKE HAYWARD

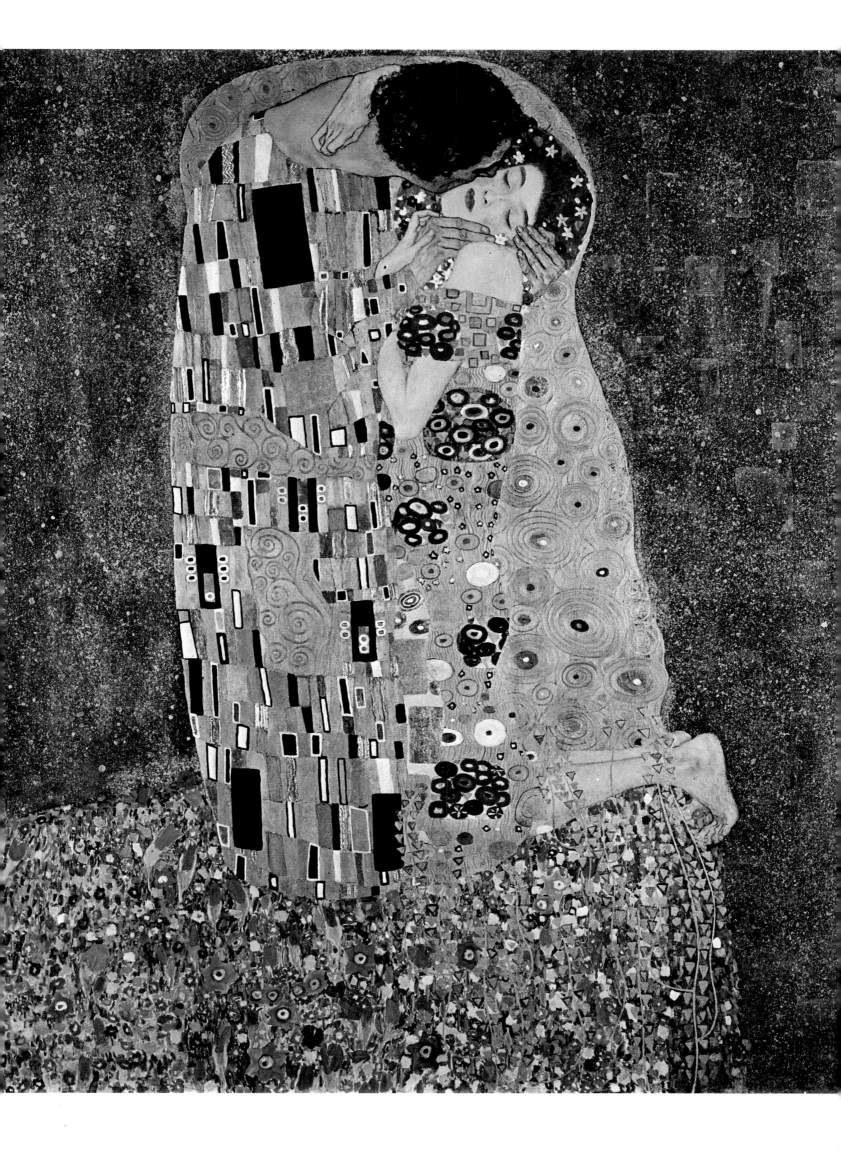

Henry Moore (b. 1898)

INTERLOCKING

1968, white marble, 4½ × 5"

Collection Mary Moore

ERNEST HEMINGWAY once wrote of "the ultimate loneliness of contact"—a phrase recalled by this sculpture of Henry Moore. What attracts me to it is less its subtle interlocking of forms than the utter isolation, the self-containment of those forms. And I find something sad about that. To be sure, lovers love to be alone. They want the privacy to explore each other's souls and bodies, solitude to achieve the one-ness that Moore's sculpture projects so well. But what if the isolation is too complete? What if the lovers remain forever locked together away from the world—and other lovers? Moore has eternalized a tender moment of total togetherness; but soon the world will rush in and draw the two apart. Or worse, the world might leave them in their isolation, and in their "ultimate loneliness", their spirits could shrivel and die.

Loneliness is something we all need, long for . . . and fear. Moore has given us loneliness at its best, the alone-ness of two people alone in their interlocked togetherness. It may last only for a moment, but that moment is sublime.

ARTHUR KNIGHT

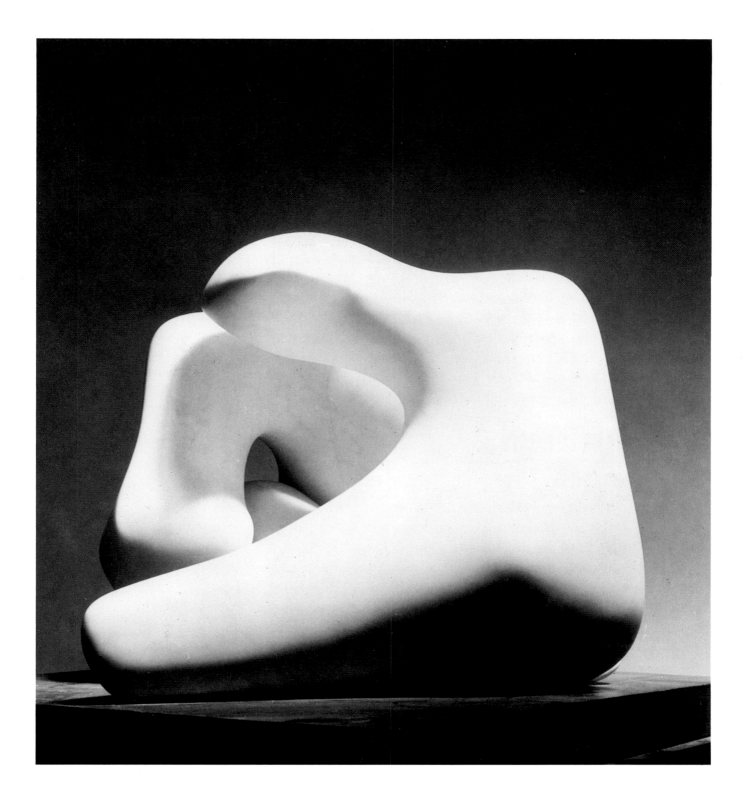

Reza-ye Abbasi

TWO LOVERS

1630 A.D. (Iranian), tempera and gilt on paper, 7⅛ × 4¹¹/₁₆"

The Metropolitan Museum of Art, New York, Francis M. Weld Fund, 1950

THIS lovely Persian miniature is by a seventeenth-century master of the Safavid Period, Reza-ye Abbasi, who comes from one of my favorite cities, Isfahan. His painting of lovers subtly evokes both the essential, rhythmic harmony between mankind and nature, and the ephemerality of life, love, and concord in the universe as a whole; characteristics which underly the Middle Eastern attitudes toward love. Erotic and aesthetic consonance are inherent in Abbasi's depiction of the two lovers. They form an uninterrupted visual unit, inscribed by a continuously flowing, sensuous line, with no space between any parts of their bodies. The white flesh of their faces, hands, and torsos form a visual unit, as do the repeated folds at the sleeves and hems of their garments. Both hold their hands in the same position and focus their gazes of entrancement in a single direction, on an object outside the range of the painting. The partially consumed plate of fruit, the decanter, and the dish of sweet-smelling oil indicate the range of their sensual delights.

Abbasi not only unites the lovers in a continuous, linear embrace but also integrates every detail of nature with their erotic union. Notice how the grasses and clouds above them and the leaves below them echo and reinterpret the movements of the lovers' bodies themselves.

Both the lovers and the fragments of nature—grasses, leaves—are seen in movement, a single moment of action which is but an ephemeral microcosm in the continual unfolding of the universe. Within this moment the human lovers, nature, and ultimately the cosmos are in utter harmony, as they are at any moment. The nature of their harmony, however, as all of us who have been lovers and loved know, is in a continual state of change.

SOROYA ESFANDIARY

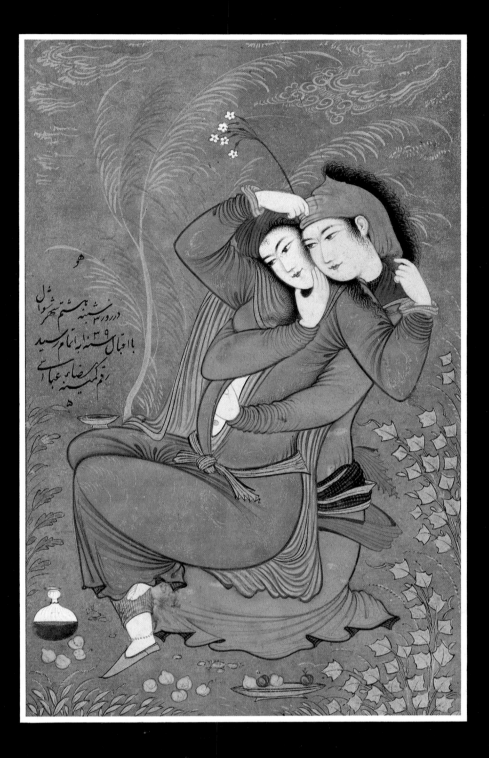

John Singer Sargent (1856–1925)

PAUL HELLEU SKETCHING, AND HIS WIFE

1889, oil on canvas, 25⅝×31¾"

Brooklyn Museum, New York

COMPANIONSHIP and shared interests between lovers probably contribute as much to a strong relationship as anything does. It is evident in this painting of *Paul Helleu sketching, and his wife* that the eighteen-year-old Alice Guerin, Paul's bride, will always be by his side, supportive and close, encouraging him by her proximity. Although she admires Helleu's talent and he has already obtained a respected reputation during his brief career, her loyalty and love will be felt as they are in this canvas.

Most French impressionists were concerned with light, color, and atmosphere. However, the American impressionists stressed one more ingredient, subject matter. John Singer Sargent is classed in this group, and he is best known for his many portraits executed both in America and in England.

This scene was painted at Fladbury Rectory, near Broadway and the Avon River. What an inspiration to place a red canoe across a canvas and play with the subtle combinations of color and indirect light! Paul Helleu brought his bride to visit Sargent and this painting resulted. The reflected illumination confirms the triumph of Sargent's exhibition in Boston the previous year. "Nothing is commonplace or conventional", said one commentator about his paintings. That is also true of all people in love—surely lovers live in a world of their own, and Sargent has caught that atmosphere in this painting.

GENE TIERNEY

Gene Tierney

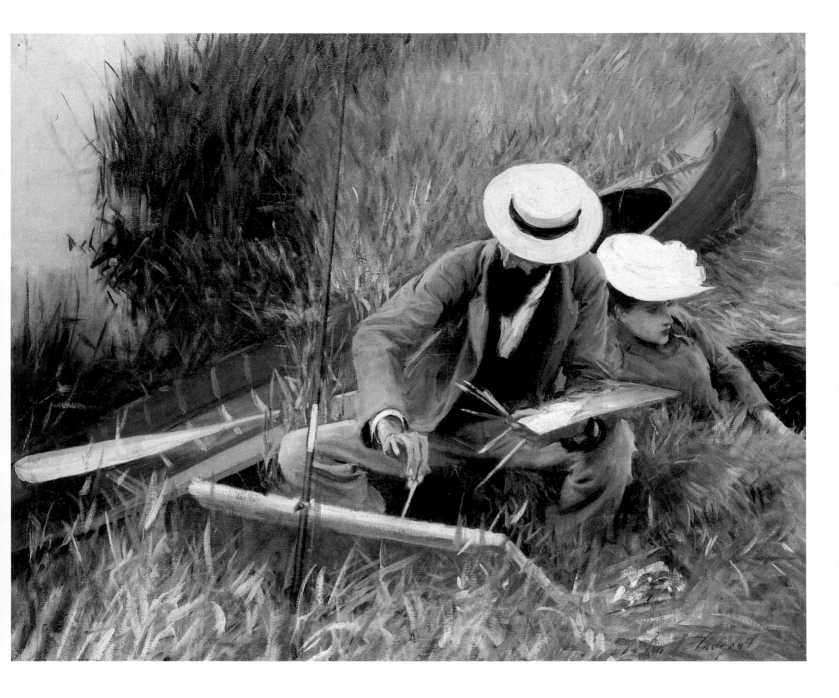

Anon.

A BRIDAL COUPLE

c. 1470 (South German master), oil on fir panel, 25½×15½"

Cleveland Museum of Art, purchased 1923, Delia E. Holden Fund and L. E. Holden Fund

YOUNG Swabian lovers, centuries old, but alive in the skill and dream of a great painter. He has endowed them with all the blessings of wealth and beauty, yet they are held as flowers are in nature's plan. Hope asks that all young lovers may be fulfilled in the physical consummation of their bodies' joy, but also in an enduring devotion between them, growing into a love of life and of their fellow beings.

The Bible instructs us to "Love thy neighbor as thyself". It tells us that our first love is self-love, taught us by our helpless needs and by the tender attention we receive during the years when we must be given more than we can give and absorb more than we can express. Hope prays that young lovers have learned to love themselves openly, not defensively; thoughtfully, not compulsively. For it is only when we feel whole and in harmony with our own being that we are free to offer our love to another. And only when we value our own worth can we honor and treasure the love the other offers us.

So love of self and love of others are joined to create a vitality and a resonance between them, bringing serenity and strength, which are life-giving to each lover and spread beneficence on all within their radiance.

ANNA BING ARNOLD

Anna Bing Arnold

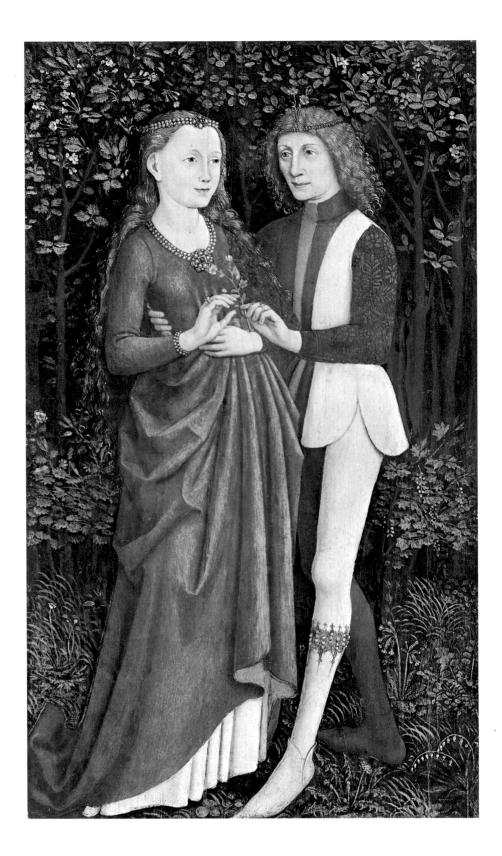

Giorgio de Chirico (1888–1978)

HECTOR AND ANDROMACHE

1917, oil on canvas, 35½ × 23⅝"

Private Collection, Milan

DR. SEUSS has long since publicly admitted that, as a fledgling art student in Paris in the early 1920's, he did indeed have an "association" with the enchanting Ms. Andro, the model for this painting.

The following six lines, however, are all that he is willing to disclose concerning his memories of this lady:

She drank a lot.
But I didn't much mind.
That merely made her eyes blank.
What I did mind
was the sloppy rivet job
that made her lovely thighs klank.

DR. SEUSS

Dr. Seuss

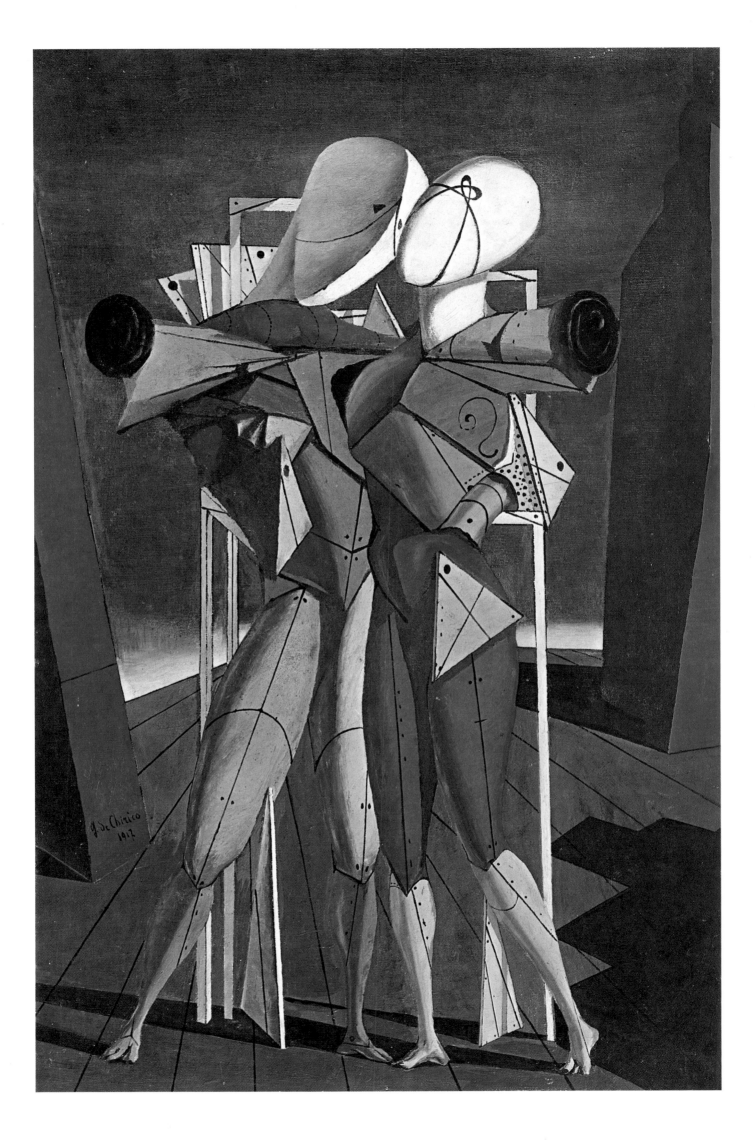

Auguste Renoir (1841–1919)

THE BALL AT BOUGIVAL

1883, oil on canvas, 70½ × 37¾"

Museum of Fine Arts, Boston Picture Fund, 1937

BEFORE Renoir painted *Le Bal à Bougival*, he made a lovely pen drawing of the dancing couple that is now in the collection of Henry P. McIlhenney in Philadelphia. It bears a particular significance because of the inscription that Renoir wrote on the bottom of the drawing: "Elle valsait délicieusement abandonnée entre les bras d'un blond aux allures de canotier" (She was waltzing in delicious abandon in the arms of a blond man with the manners of a boatman). Perhaps this was the moment of falling in love.

Who knows what comes over us when we do fall completely in love? The atmosphere Renoir has recorded with such sensitivity certainly paves the way. My father lived at the time when Renoir painted, and the romantic period the Master immortalized relates to family memories of a world long past.

Flirtation as an attribute of French women can be a happy prelude to love. The lady in Renoir's painting has obviously mastered this art. Proust says: "The sacred moments in our lives lift us above the profane world. The Act of Love." I like to believe that art, too, contributes to this feeling, and Renoir contributes more than most artists.

ARMAND DE LA ROCHEFOUCAULD,
DUC DE DOUDEAUVILLE

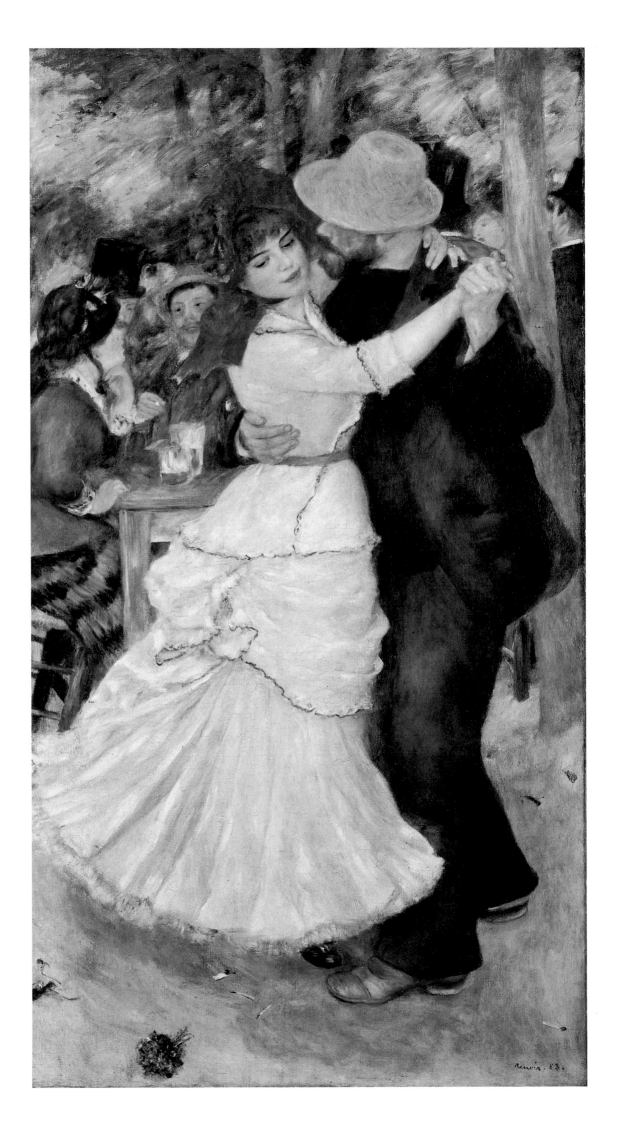

Anon.

SCENE FROM THE ROMANCE OF THE WESTERN CHAMBER

18th cent. (Chinese), ink and color on silk, 78⅛ × 51½"

Freer Gallery of Art, Smithsonian Institution, Washington, D.C.

THE painting depicts the main characters from the Yuan Dynasty drama *Hsi-hsiang chi* (*The Romance of the Western Chamber*). Around the turn of the ninth century, the poet Yüan Chên wrote what has become one of China's most famous love stories. Believed to be based on Chên's own life, the story was later reworked for the stage and is still performed in various adaptations throughout China. Reminiscent of *Romeo and Juliet,* it tells of an amour between a young student, Chang Jun-jui, and his cousin, Ts'ui Ying-ying.

Ying-ying is the only daughter of a distinguished minister, and her mother has advised Chang Jun-jui that her daughter will be permitted to marry only a man with prospects of equal distinction. The two young lovers must convey their desires to one another by a faithful maid and matchmaker, who brings the famous and oft-quoted message from Ying-ying: "To wait for the moon—I am sitting in the Western Parlor; To greet the wind, I have left the door ajar. . . ."

Unhappy with this need for clandestine meetings, Chang Jun-jui sets off for the capital city to sit for the Imperial examinations. He is awarded the title of First Scholar, is appointed a magistrate, and returns to marry Ying-ying. Unlike *Romeo and Juliet,* this famous Chinese love story ends "happily ever after".

MARCH FONG EU

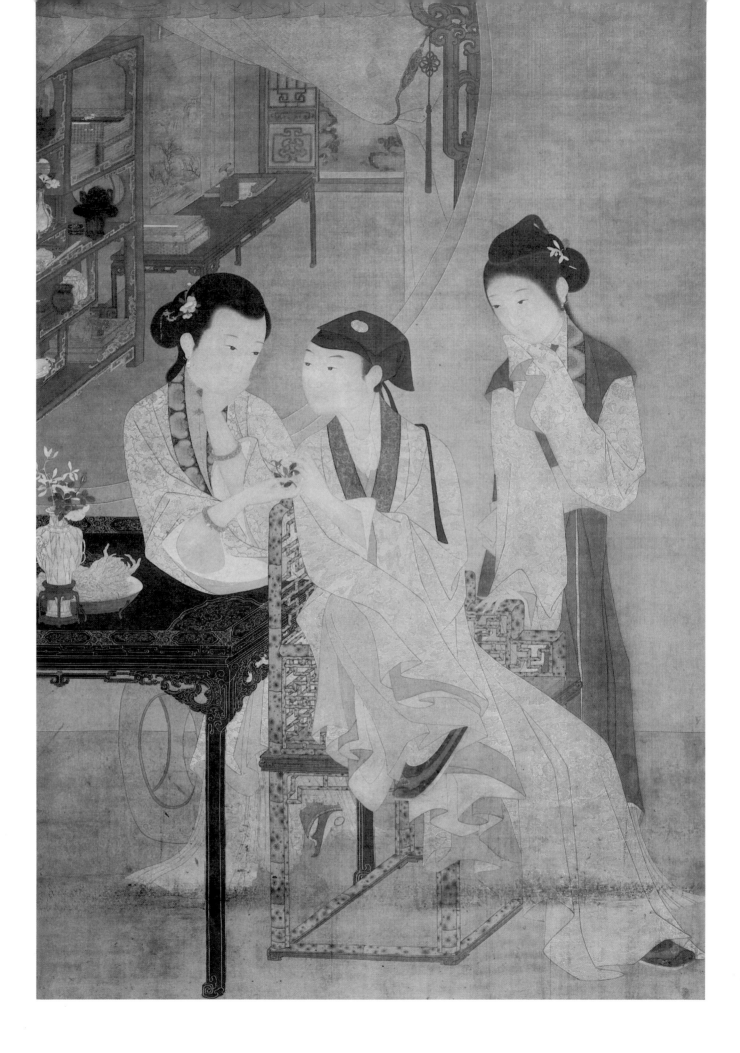

Jack Culiner (b. 1913)

LOVE CYCLE

1975, polished bronze, 11×9½×2¼"

Private collection, Toronto

50

LOVE CYCLE is the culmination of a developing relationship between a man and a woman. They think and feel as one, as expressed by the united heads.

Their lives are in the process of going full cycle—from separate beings to a single unit, having grown together through a developing and maturing love. Thus they become one form, a perfect oval form. This final form represents an assimilation of mind and body.

JACK CULINER

Jack Culiner

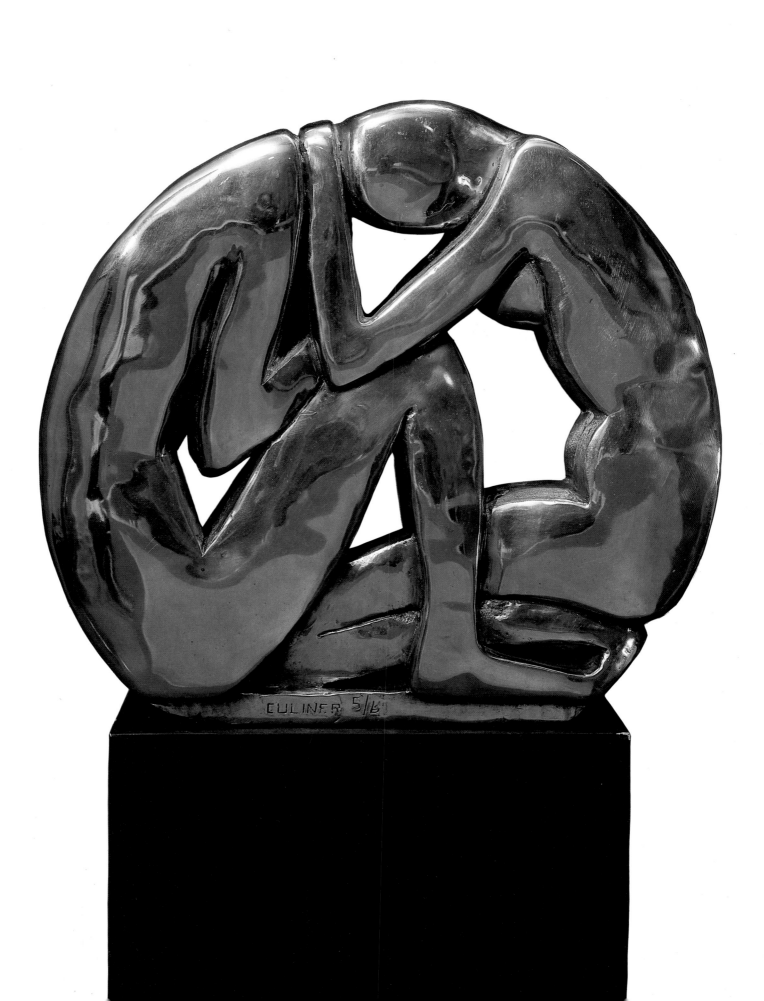

Francesco Hayez (1791–1881)

THE KISS

1859, oil on canvas, 43¼×34⅝"

Pinacoteca di Brera, Milan

IHAVE often looked at this passionate and charming painting and, though knowing nothing of its history, have always been moved by it. The tenderness of the man's hand upon the woman's face, his other hand so possessively holding her head. . . the suppliance of her lovely body in its exquisite satin dress, leaning so yearningly against his . . . in my imagination I have conjured up little stories about these two figures. Were they meeting again after an unbearable separation? Were they clandestinely indulging in a passionate embrace, and would she perhaps return to a room full of people, including a husband? Or were they parting, painfully, as his cloak and feathered hat suggests? A poem of Robert Bridges that I loved in my romantic teens comes to mind; it expresses better than I can, my interpretation of the painting:

I will not let thee go.
Ends all our month-long love in this?
Can it be summed up so,
Quit in a single kiss?
I will not let thee go.

I will not let thee go.
If thy words' breath could scare thy deeds,
As the soft south can blow
And toss the feathered seeds,
Then might I let thee go.

I will not let thee go.
Had not the great sun seen, I might;
Or were he reckoned slow
To bring the false to light,
Then might I let thee go.

I will not let thee go.
The stars that crowd the summer skies
Have watched us so below
With all their million eyes,
I dare not let thee go.

I will not let thee go.
Have we not chid the changeful moon,
Now rising late, and now
Because she set too soon,
And shall I let thee go?

I will not let thee go.
Have not the young flowers been content,
Plucked ere their buds could blow,
To seal our sacrament?
I cannot let thee go.

I will not let thee go.
I hold thee by too many bands:
Thou sayest farewell, and lo!
I have thee by the hands,
And will not let thee go.

DEBORAH KERR

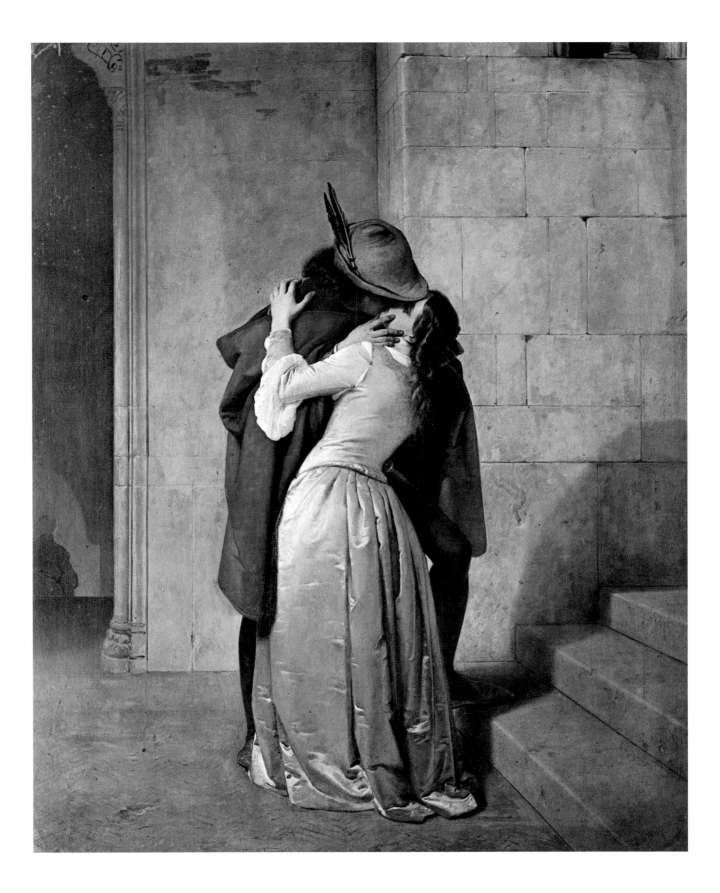

John Everett Millais (1829–1896)

THE WOODSMAN'S DAUGHTER

1851, oil on canvas, 35 × 25½"

Guild Hall Art Gallery, London

THE first stirrings of love bring a rush of confusing inclinations: protectiveness and tenderness toward one who was formerly an alien creature, generosity with property once fiercely hoarded. The young boy in this picture is pale and sobered by the unfamiliar aching beneath the breastbone. The girl, surprised and delighted, extends receptive and guileless hands for the strawberries.

John Everett Millais painted in England with a group termed Pre-Raphaelite because, in part, they sought to restore to art the spiritual content that had existed in the Middle Ages. He has painted the youngsters in medieval garb, but the moment is universal. When we look at the young nobleman and the woodsman's daughter, we remember the boy in sixth grade who, wonderfully and inexplicably, offered cookies from his lunch pail to the girl across the aisle.

> *Love in the open hand, nothing but that,*
> *Ungemmed, unhidden, wishing not to hurt,*
> *As one should bring you cowslips in a hat*
> *Swung from the hand, or apples in her skirt,*
> *I bring you, calling out as children do:*
> *"Look what I have!—And these are all for you."*
>
> Edna St. Vincent Millay

BARBARA INGRAM

Barbara Ingram

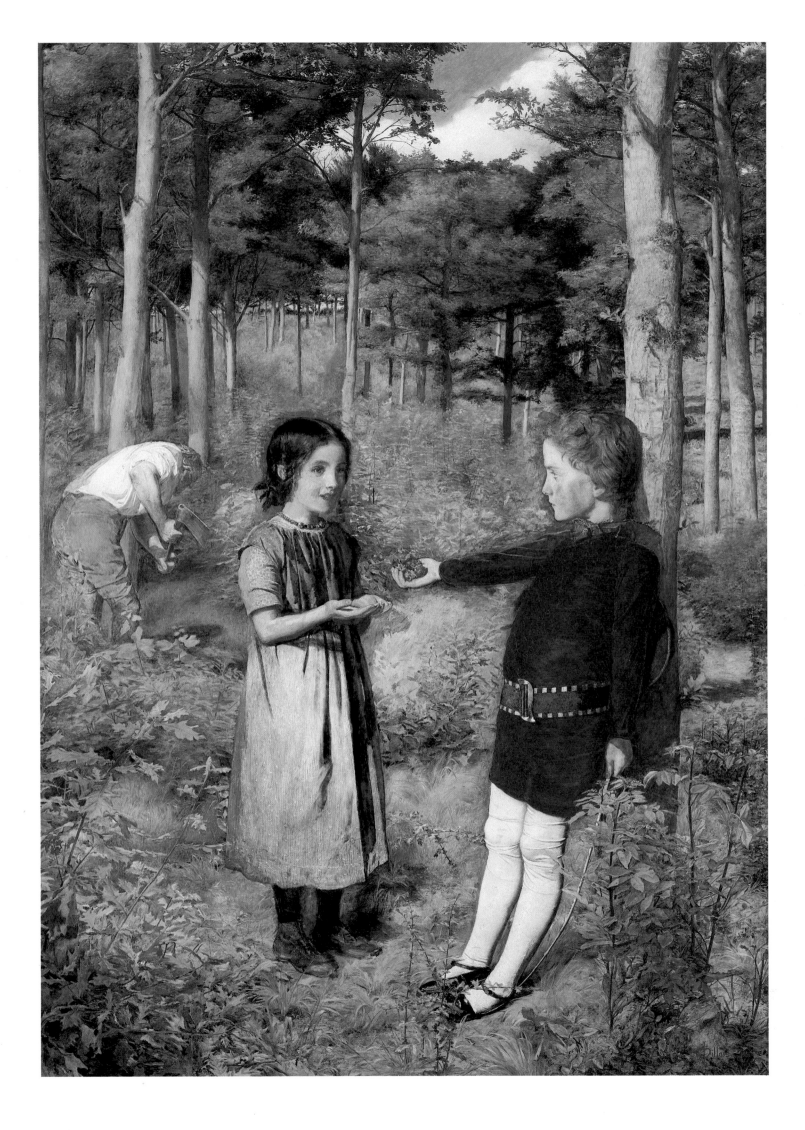

Robert Fagan (1761–1816)

SELF-PORTRAIT OF THE ARTIST AND HIS WIFE

1803, oil on canvas, 27×36″

Private collection, Dublin

ROBERT FAGAN'S self-portrait, with his adoring wife Maria, was the sensation of the exhibition of Irish portraits that was held in the 1970's in Dublin and London. The artist's family came from County Cork in Ireland, and although his youth was spent in London, where his father owned a prosperous bakery, Fagan remained an "Irish Catholic rebel" all his life. He felt at home in Italy, where he earned his living by archaeology, and was one of the host of unscrupulous picture dealers who systematically milked the great Italian collections for the benefit of their English and Irish clients. Only six weeks after the death of his first wife, Fagan took as his second wife Maria Flajani, a girl half his age; at the time of the painting she was not yet twenty. She was the daughter of the Pope's physician.

The picture remained in the possession of the artist's descendants through the daughter of his first marriage, Astine. In the Victorian era, Maria's breasts were given a dressing of paint for the sake of modesty. The picture was bought in 1947 by the late Mr. John Hunt, the antiquarian and scholar, and has been in Ireland ever since.

Maria is shown gazing lovingly at her husband. His quizzical expression and sensitive looks have a haunting and romantic quality. However, there is a touch of tragedy in his eyes, foreshadowing the difficult times ahead, which were eventually to lead to his suicide.

DESMOND GUINNESS

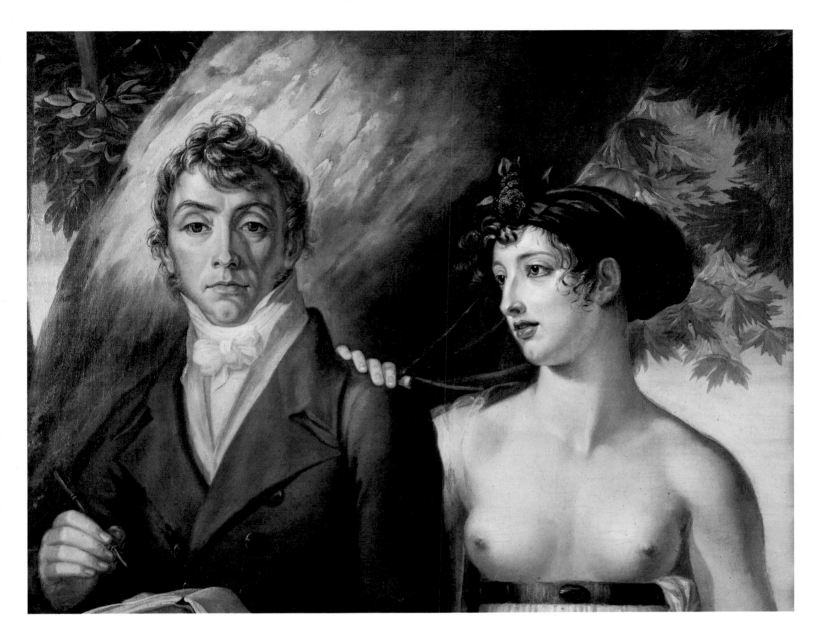

George Bellows (1882–1925)

SUMMER NIGHT, RIVERSIDE DRIVE

1909, oil on canvas, 35½×47½"

Columbus Museum of Art, Ohio, Bequest of Frederick W. Schumacher

EVENTS surrounding the creation of this night scene by George Bellows—a work of rare romantic mood—are clues to its inspiration.

In late summer, 1909, the year of *Summer night, Riverside Drive,* Bellows' life and career were ascendant. His three-year courtship of a lovely fellow student, Emma Story, was soon to be consummated in marriage. Of all the artists gathered under Robert Henri's leadership, Bellows was being singled out for praise by the ordinarily conservative members of the National Academy of Design. Along with increasingly favorable reviews and notices, he was beginning to get good prices for his paintings. The young artist had reason to feel expansive, joyous, and affirmative.

He came originally from Columbus, Ohio, but he thrived on the complex visual environment of New York City, both personally and in his painting, and his early New York works reflect a fascination with the urban scene. He developed a brand of lyrical realism that he exploited equally effectively in roughhouse subjects such as prizefighting and in quieter, gentler observations of life and human relationships.

Employing the strong contrasts of light and dark that he loved, *Summer night* captures the warm, lingering quality of early twilight in a New York park. Riverside Drive in 1909 was fashionable and serene, probably a familiar route for the young artist and his lady on their frequent evening strolls as well as for other young lovers. Bellows' emotional state surely heightened his response to this atmosphere.

The deep, saturated colors, the richly modulated tonal passages, and the brilliantly executed highlights and details combine in this remarkable work to invoke the distilled essence of a moment and of a place—at once intimate and universal.

BUDD HARRIS BISHOP

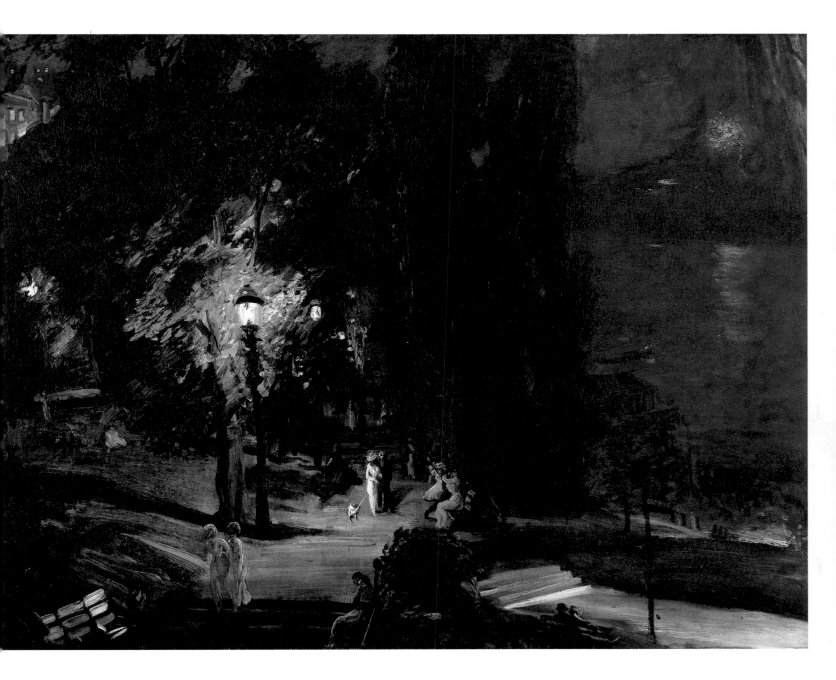

Henri de Toulouse-Lautrec (1864–1901)

THE BED

1892–95, oil on canvas, 21¼ × 27¾"

Louvre, Impressionist Museum, Paris

60

As "Head of the House of Toulouse-Lautrec in Name and in Arms" (as we say in France) I feel responsible for the reputation and defense of those who have preceded me and all those who have borne our family name with honor. None have inspired as much fervor, admiration—and disparagement—as my distant uncle, the painter Henri de Toulouse-Lautrec. Of this illustrious ancestor I shall praise his qualities of humanity and kindness, his intelligence and the dedication to his work which transformed his natural gifts into a brilliant explosion of genius.

COUNT DE TOULOUSE-LAUTREC

Two heads emerging from an ocean of sheets and pillows. Lovers painted after love-making? So it seems, but no one is certain—even the gender of the bed-tousled pair is unclear. There is no doubt, however, about the sensual pleasure of the artist painting these blues, yellows, and greens reflected in the white sheets and pillows, as well as the reds of the embroidered cover, with no consideration at all for the contemporary esthetic rules. Here Henri de Toulouse-Lautrec is revealed as one of the greatest innovators in the profession of painters.

ALEJO VIDAL-QUADRAS

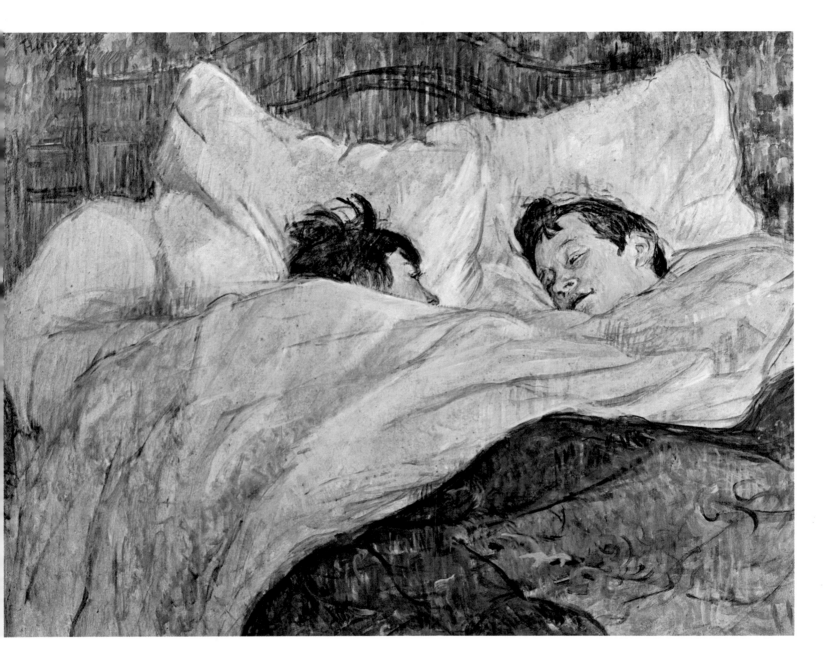

Anon.

KING MYCERINUS AND HIS WIFE

c. 2500 B.C. (Egyptian), stone, height 55″

Museum of Fine Arts, Boston

THIS impressive Egyptian sculpture of King Mycerinus and his wife is an ancient reminder of the potent force of love through the centuries. Though their poses and faces are very formal, as is fitting for royalty, their half-nude bodies are young and strong, and the wife's grasp of her husband speaks louder than words of love. How nobly this regal pair expresses the emotion. How richly the aesthetic heritage of Egypt (my heritage) communicates this feeling even thousands of years later. The language of love is truly universal and timeless.

OMAR SHARIF

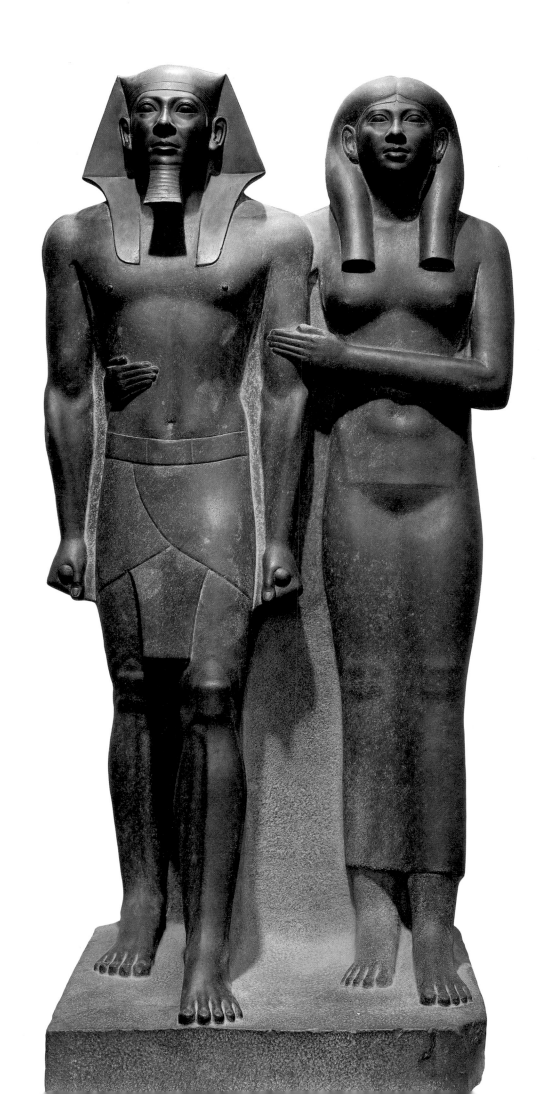

Andy Warhol (b. 1931)

LIZ TAYLOR DIPTYCH

1963, silkscreen on canvas, 48×48"

Collection Dr. and Mrs. Jack Farris

ELIZABETH TAYLOR is a love symbol. The world has followed her many marriages and romances since her teens, not always approvingly, but always with great interest. Her portrait pinpoints the fascination with glamorous movie stars and their romantic involvements that is so much a part of our culture.

The canvas is painted silver, suggesting the silver screen, and upon it a photo image of the actress has been silkscreened. Over this the artist has added color by hand. This particular method of creating a painting is significant in itself. Silkscreening is an industrial process, used in manufacturing wallpapers and fabrics, but here it is applied to art.

Creating art by means of a mechanical process is not a new idea. It is simply an extension of fixed art ideas owing much to Marcel Duchamp. The fact that a work of art can be produced in this manner attests to the validity of the theory that the hand of the artist is not as important as the concept.

The painting is a diptych, suggesting a double portrait, but one canvas is blank except for the silver-painted background. Usually the empty canvas heightens the impact of the image hanging next to it. However, as one looks at the blank space, one cannot help but speculate that perhaps this canvas represents her husband. Or is it a past or future husband? Maybe all of them. The choice is ours.

CAROLYN FARRIS

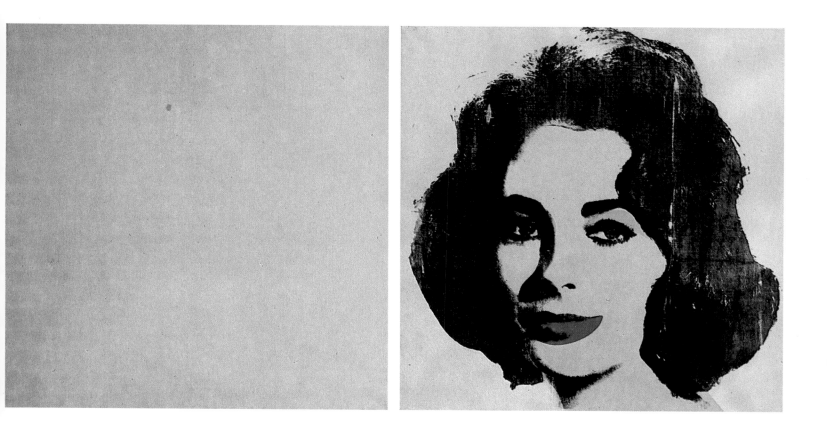

William Page (1811–1885)

CUPID AND PSYCHE

1843, oil on canvas, 10⅞ × 14¾"

M. H. de Young Memorial Museum, San Francisco

How often do we see love?

The tenderness and understanding between lovers is a private domain reserved for them alone, never meant to be shown off or even seen by those outside. The boastful lover is a braggart, loving only himself.

True lovers live, for seconds or centuries, for each other. Surely Cupid, holding Psyche as he does here, gives us a rare and unforgettable glimpse of the strength and immortality of love.

NANCY HOLMES

Nancy Holmes

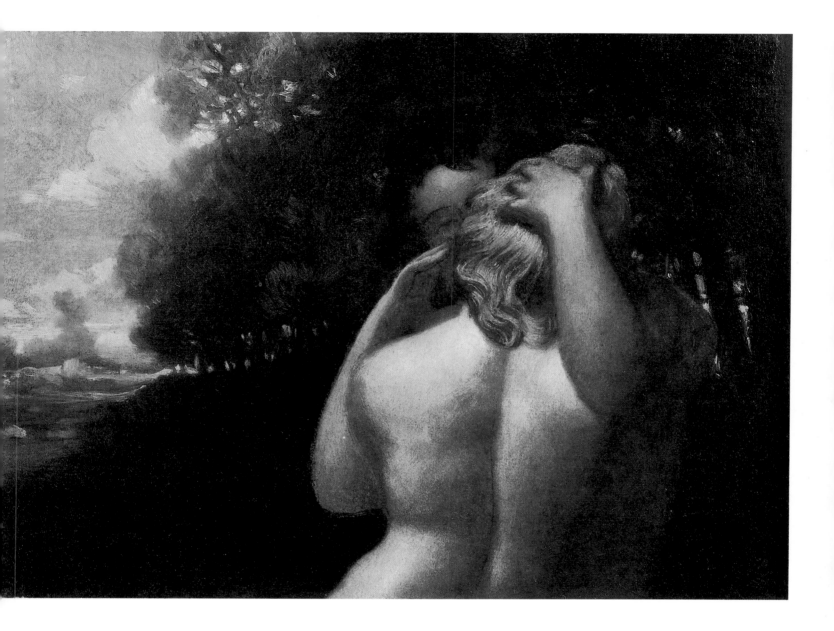

Thomas Gainsborough (1727–1788)

THE MORNING WALK

1785–86, oil on canvas, 93 × 70"

The National Gallery, London

THOMAS GAINSBOROUGH was born in Sudbury, Suffolk, in 1727, the son of a clothier. His mother was an amateur painter, who persuaded his father to send young Thomas to London at the age of fourteen to study painting. Her help and guidance contributed much to Thomas Gainsborough's success as one of England's greatest painters.

His first love was landscapes—*Great Cornard Wood* and *The market cart* are the most famous. However, an artist could not live by painting landscapes, and Gainsborough turned to portraying the "beautiful people" of his period in the works for which we know him best.

The morning walk has a mysteriously romantic quality that engenders curiosity: Who was this young couple? Could anyone doubt that they were lovers? Whether their decorous air is due to Gainsborough's style or whether their lavish dress inhibited the young lovers' passions, only their attentive dog could know.

In fact, all that is known is that the gentleman was William Hallett, and the lady, Elizabeth Stephen. They were married on July 30, 1785, and this portrait probably commemorated their marriage. The contemporary records tell us that the picture left Gainsborough's studio by the spring of 1786, perhaps to accompany them through the trials of married life.

Thus we are left with one of the most beautiful of all English paintings—and the enigma of two young lovers on a morning walk.

MARGARET, DUCHESS OF ARGYLL

Margaret Argyll

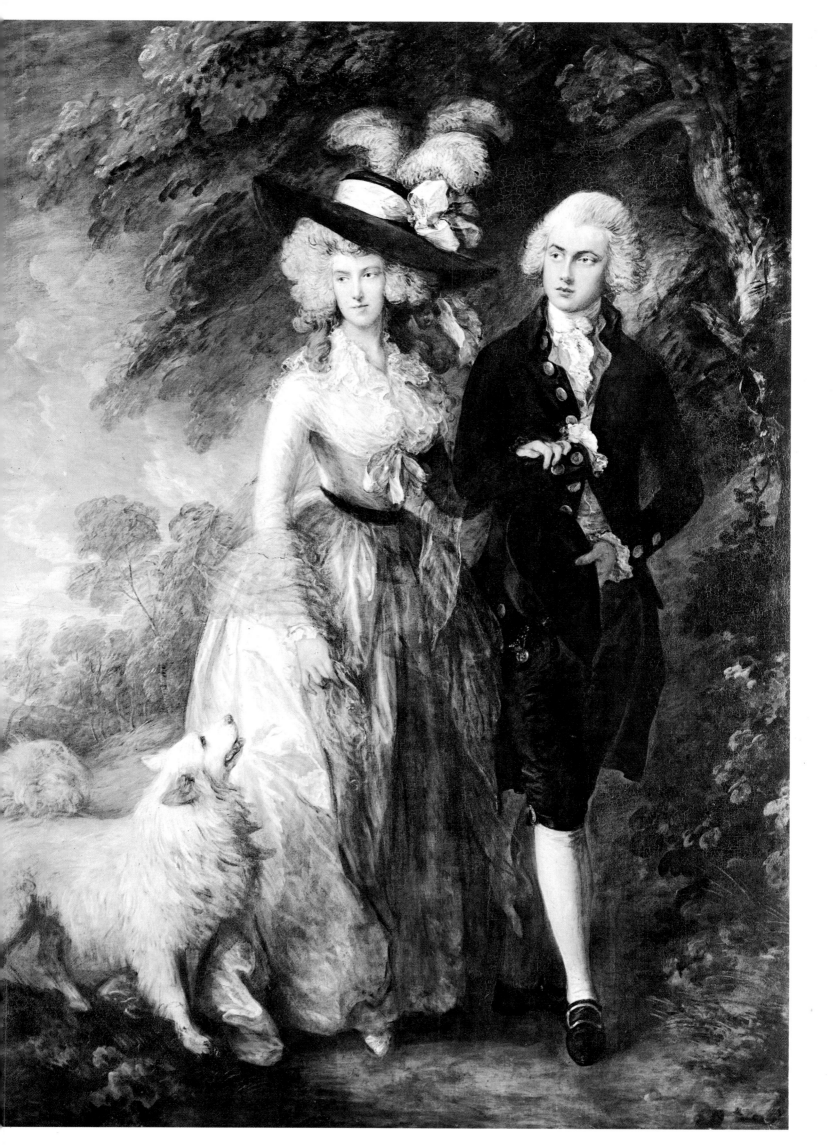

Fletcher Martin (b. 1904)

AIRPORT

1972, oil on masonite panel, 26×20"

Collection Harold M. Weiner

70

THE airport is the point of separation of loved ones as the depot and the dockside used to be.

The man in this painting is the traveler. The lady is his wife, fiancée, or lover. Their closeness is made apparent by design devices. Their love is evident.

The jet will carry him across the world by tomorrow and could bring him back as soon. But the moment is sad because they will be so far apart. However, their hearts *will* grow fonder.

FLETCHER MARTIN

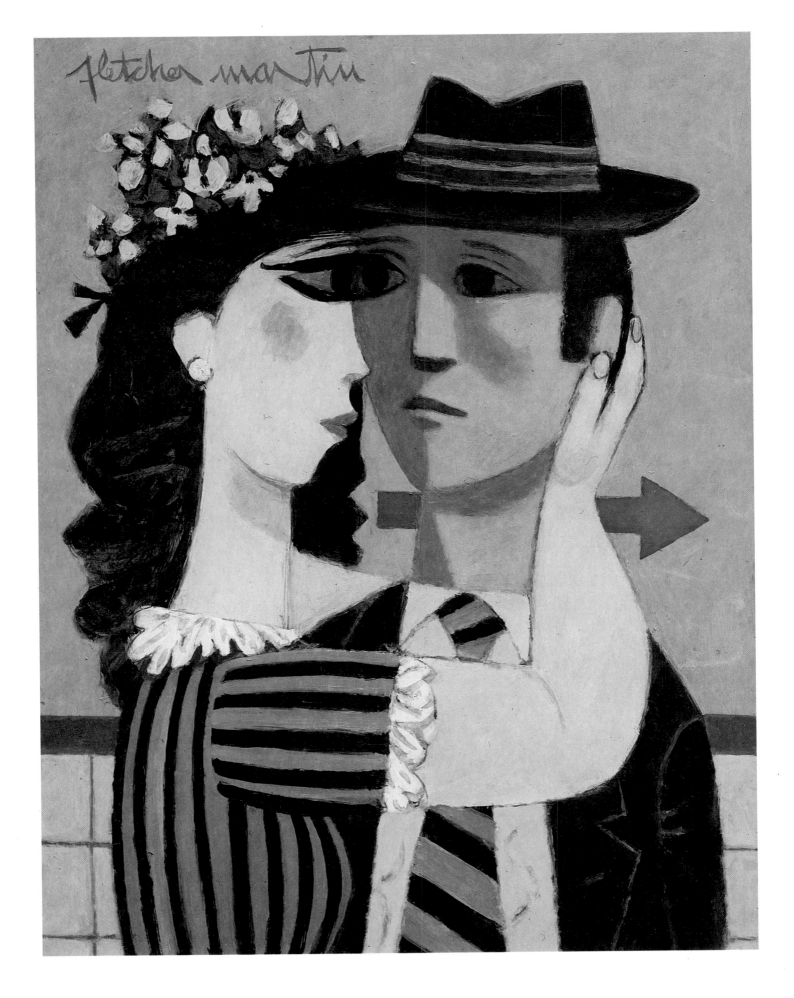

Vivi Aluluk Kunnuk, (b. 1932)

COUPLE

1972, soapstone carving, 7×12×2"

Private collection, Los Angeles

THE moment has come. The exhilaration . . . quivering weakness. Pounding hearts. Swallowed whispers share the moment of love discovered.

The wonder is that the artist could sustain the eloquent passion throughout the carving.

Nothing has been added. The emotion is pure, without laminates of sophistication. It is basic, primitive, inspired. It is love.

JANE DART

Jane Dart

Jan Van Eyck (1380/90–1441)

JAN ARNOLFINI AND HIS WIFE

1434, oil tempera on wood, 33×22½"

The National Gallery, London

A ROOM chilly with perfection, but fired by the star-grazing genius of Jan Van Eyck. Truth seeps in like his icy daylight; his suns were dipped in quicksilver. Van Eyck was a magician with light and revolutionary oil paint. What prescient taste this high-born Italian couple had; to marry alone and then to engage Van Eyck to freeze their moment supreme in time.

To please them, he crowded the room with symbols; an obedient small dog for faithfulness, the glacial convex mirror for purity, a single lighted candle for God's all-seeing eye, ripe fruit for Eden. They are shoeless in honor of the holy marrying place—but the shoes seem tossed in corners. They appear the epitome of non-sex—but the bed glows rose. How could the most trenchant of birds and bees have stormed so stern a bastion? Those Victorian birds and bees entered my seven-year-old ken via a nice clear book and a firm-voiced mother. Hypnotized by this alluring aloof portrait of a couple swaddled in tradition and elegance, I am reminded that my child's eye refused to leap the gulf between adult decorum and abandon. Now it tickles me to imagine what may have followed Van Eyck's meticulously cerebral prologue.

Will the pious gentleman doff that lamp shade of a hat; grin irreverently at his virginal lady; lift off her frosty lave and linen headcloth, watching her caramel hair loop into buttons he will fumble? With tender impatience, will they shuck the furred and velvet husks of musts and ought to's, and melt into the warm bending and unbending of connubial bliss in the proverbial feathers?

N.B.: Fifteenth-century ladies wore their bustles in front.

ANNE BAXTER

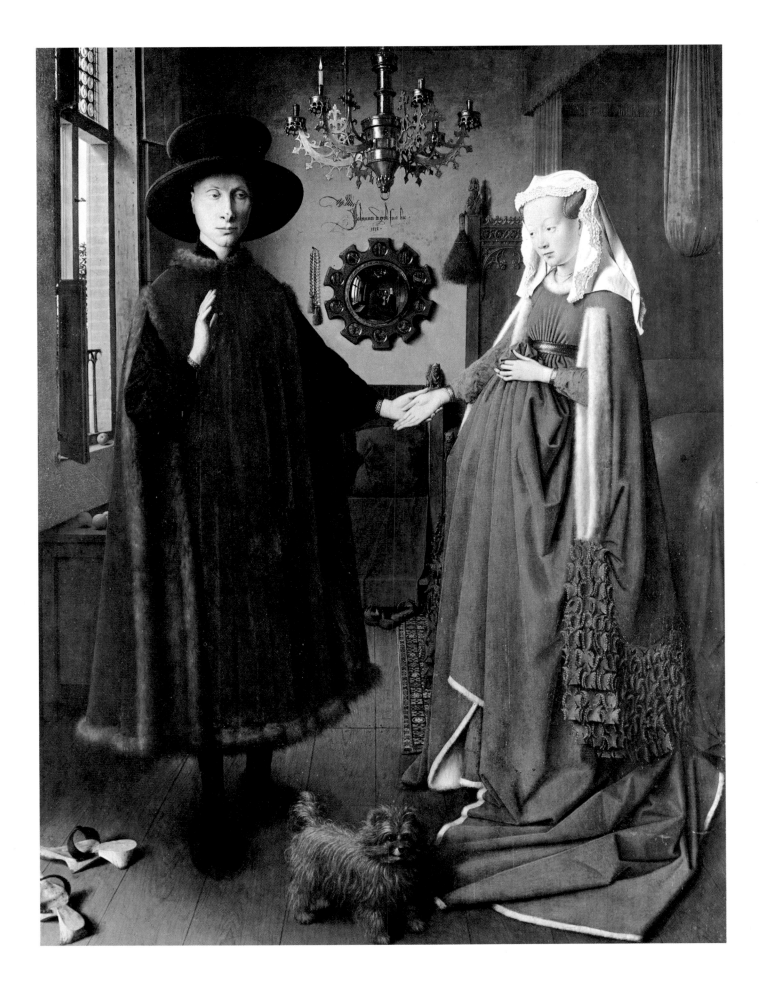

Gian Lorenzo Bernini (1598–1680)

DAPHNE AND APOLLO

c. 1622, Carrara marble, height 95⅝"

Borghese Gallery, Rome

WHEN I was a child, my mother used to take me to churches and galleries so that, starting very young, I would develop a love for everything beautiful and artistic. One day I said: "Mother, dear, if we go on looking at churches and cathedrals, you will drown me in holy water!"

But my mother was right and early on I took a real fancy for anything that had to do with art, painting, sculpture, and music. When I was about twelve years old, I told my astonished mother to go and look, once more, at Bernini's famous statue of *Daphne and Apollo* in the Borghese Gallery in Rome. I had been struck by that marvellous group.

Bernini, who was responsible for so many amazing achievements in Rome, both as a sculptor and an architect, knew how to breathe life into marble. I am told he was only fifteen when he created that other wonder. *David killing Goliath,* which is also in the Borghese Gallery in Rome.

The lightness of the two figures, the young, mysterious Apollo and the fantastically feminine Daphne, who seem not to touch the ground, have always enraptured me.

It is perhaps the most wonderful expression of love that any master has been able to achieve in marble. In this troubled world, it reconciles one with life. Look at the movement of the two bodies: could any expression of life and love be more perfect?

PRINCESS MARCELLA BORGHESE

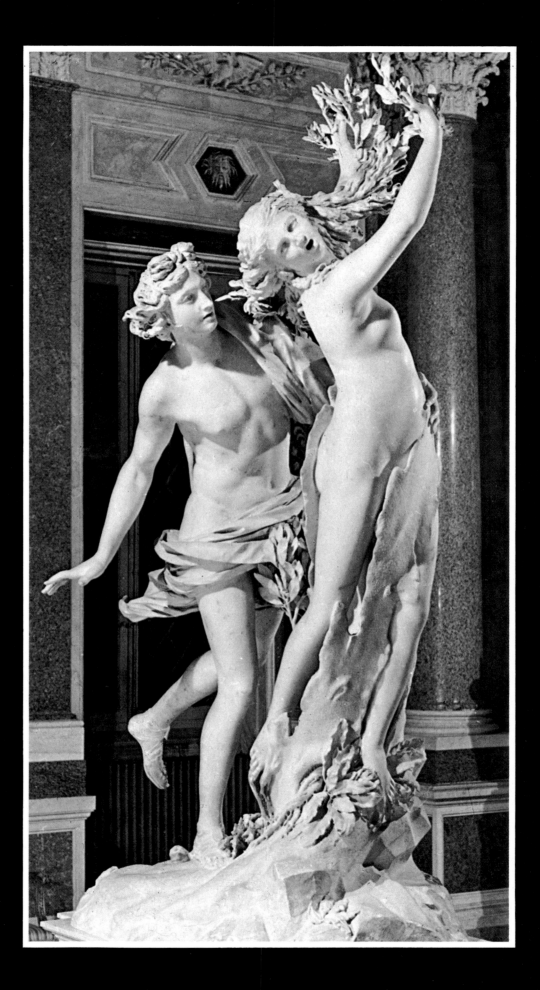

Anon.

KRISHNA AND RADHA

c. 1850 (Indian), watercolor, 8×12"

Private collection

THE supreme and sensuous god (Krishna), eighth incarnation of the Hindu god Vishnu was one of the most fortunate and mysterious divinities worshipped in the history of mankind.

Not only was he revered; he also had the charisma to be popular. He performed miracles, slew dragons, played the flute, and is depicted as the hero of many *bhakti,* devotional cults which over the centuries celebrated his talents in poetry, music, and painting.

Mysteriously, he was always described in the epic *Mahabharata* as "black" or "dark as a cloud", and portrayed as dark blue. (*Krishna* is the Hindu word for black.)

From the fifth century, this exotic hero was remembered as a lover. His dalliance was interpreted religiously as symbolic of the loving interplay between God and the human soul. Mischievous in youth, as a handsome young cowherd he used the skills of his fluteplaying to lure the *gopi,* women of the cowherders, out of their huts, to dally with him in the woods. Thus he was often depicted in paintings.

His favorite was Radha, and with her love came a feast of the senses; there was music wherever they sported, adoring handmaidens (is it possible there is jealousy, or even lust, on the face of the maiden crouching with a bowl of food?). There were spicy perfumes, lush carpets, embroidered pillows, and a bed suspended from the ceiling to give excitement to the slightest move.

Fortunate Krishna, Hindu god in a black mortal's body: his legend is one of the most intriguing mysteries. Who was this individual who reveled so in love and feasting?

MARY LOOS

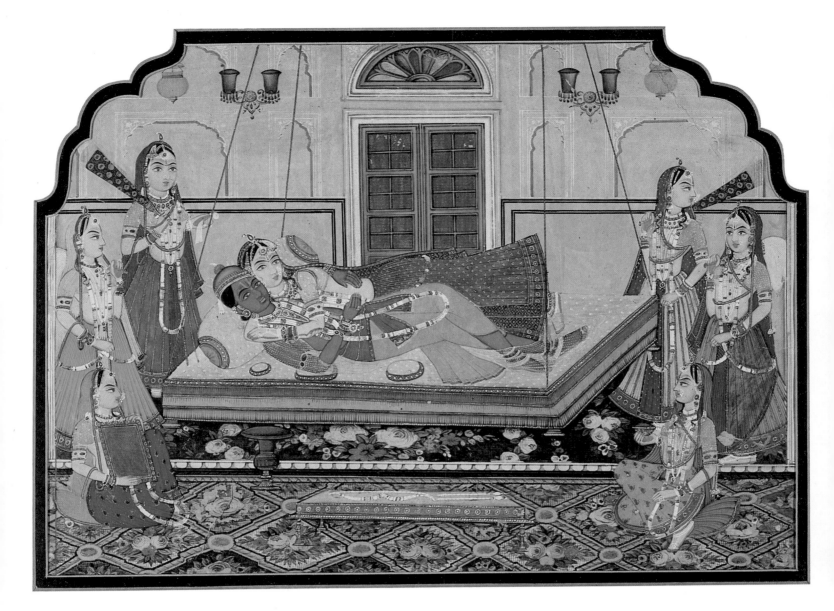

Giandomenico Tiepolo (1727–1804)

THE DECLARATION OF LOVE

1757, fresco, 86⅝×59"

Villa Valmarana, Vicenza, Italy

IN VICENZA many years ago I was enchanted by this delightful painting by Giandomenico Tiepolo, son of the renowned Venetian, Giovanni Tiepolo. The boy and girl, in their charming costumes, express perfectly those agonies and ecstasies endured by young lovers of all times and places. Her hand in his, she yearns to acquiesce. But should she? He is determined, ardent. He gestures toward the mysterious delights they could share, if only . . .

Standing before that painting, thinking of the gallant suitor who became my husband and lover, I dearly hoped she would say yes. Romantic love, with its wilderness of peaks and valleys, can tear unmercifully at the heart. Yet a woman who has been deeply loved bears the glow of it forever.

The young maid of Vicenza turns away; she's not yet ready to meet her suitor's passionate glance. But if and when she does, love's battle will be won. And, romantic that I am, I choose to believe that neither lover will have lost.

HELEN HAYES

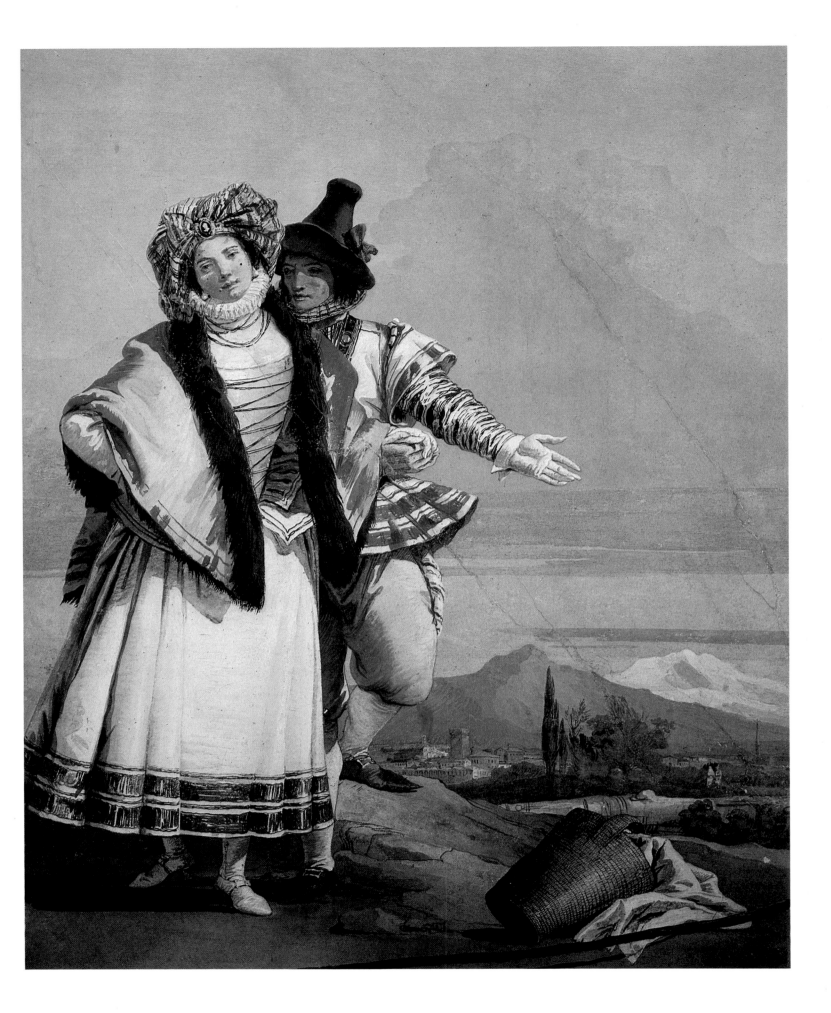

Pol de Limbourg

AUGUST

ca. 1412, tempera on vellum, 8¾ × 5½″

Condé Museum, Chantilly, France

THE *Très riches heures* is certainly the most beautifully painted medieval manuscript still in existence and the masterpiece of Pol de Limbourg, its creator. It was executed for Jean, Duc de Berry, brother of King Charles V of Orleans and uncle of Charles VI. The pleasures of Summer for the "August" page represent falconry.

In this painting the artist has noticed and depicted the peasants from Étampes Castle swimming in the Seine river. In the foreground are our lovers; the young lady is seated on her horse behind her beloved, her arms around his waist. They are riding off to a falcon hunt, but from the amorous look in the young lady's eyes, one guesses that the hunt may be only an excuse to get away alone into the cool nearby forest and make love. We do not know who they are, but as falconry was a sport reserved for the nobility, they were probably friends of the Duke or of the young King.

This picture reminds me of a scene my husband and I shared often in southern Morocco where we used to spend the winter. We would gallop out into the valley behind the native falcon hunters, picturesque and proudly mounted on their beautiful and richly decorated Arab horses, handsome in their flowing robes and turbans. In the distance lay the snow capped mountains rising above the hot desert of golden sand.

Although the *Très riches heures* is essentially a devotional text, it appears in this illustration that the earthly pleasures of the green and golden summer afternoon, for peasants and nobility alike, rival those of Heaven itself. What a glorious setting for lovers of any time!

BARONESS FRANCES PELLENC

Frances Kier Pellenc

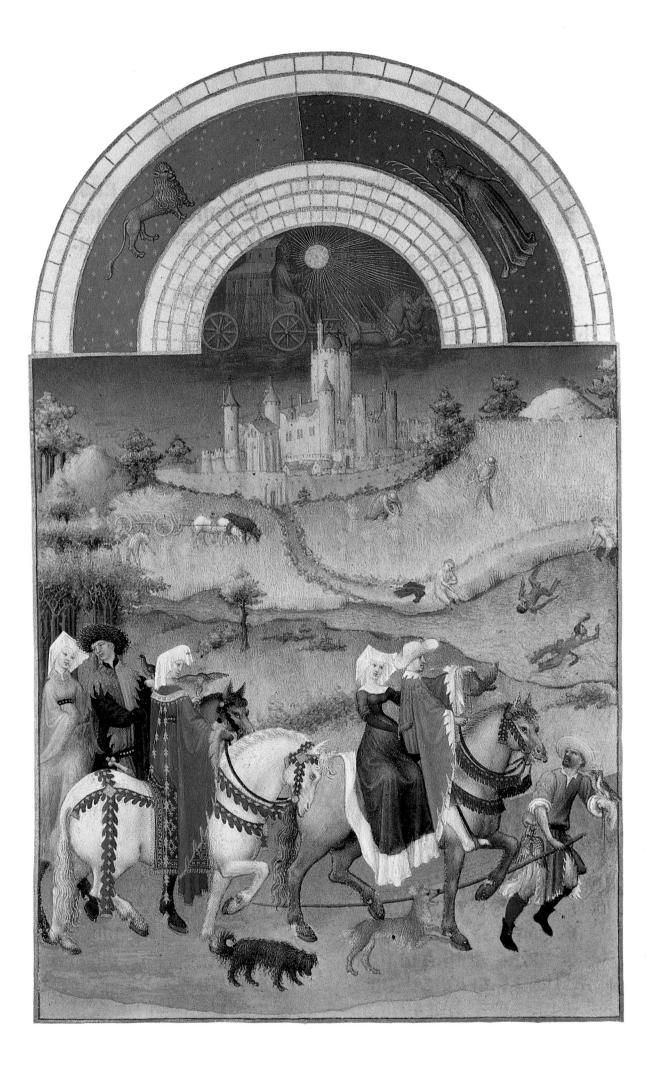

Elizabeth Duquette (b. 1922)

PELLÉAS AND MÉLISANDE

1970, acrylic on board, 40×32"

Private collection, Los Angeles

WITH a sensitive blending of tendresse and melancholia, my artist-wife, Elizabeth, captures in an amethystine haze the true love and tragic story of Pelléas and Mélisande. Only a moment before, the married but childlike Mélisande has lost her wedding ring in a spring. When we see them in this painting, the future lovers, innocently drawn together, are wandering through a forest. A dragonfly has left the water over which he always hovered, to accompany the beautiful pair. Blue, with the blue iridescence of a butterfly, this dragonfly follows them—symbolizing another life, perhaps eternal. That life which we trust they will live together after Pelléas' death at her husband's hand, and after Mélisande too has left the world, as gently as she lived—not from a sword-prick under her breast, but from the sweetness and pathos of love itself.

TONY DUQUETTE

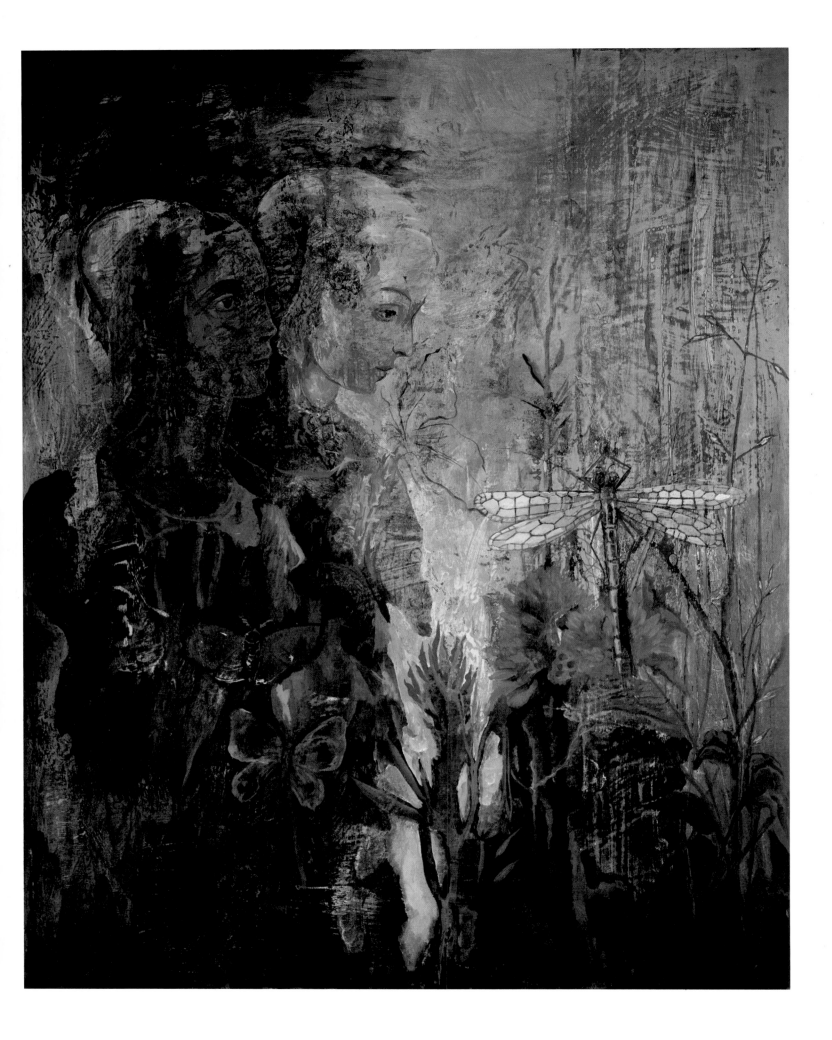

Anon.

LOVERS

5th cent. B.C., (Etruscan), height 5½"

Archaeological Museum, Arezzo, Italy

BEING born, making love, dying—these basic life themes have infinite variations, mostly due to individuality and culture. Eroticism can transform a human being into a brutish beast or a Godlike creature. In our culture the first alternative is too often stimulated by the fusing of sex, drunkenness, and violence. What a relief to see the amorous nobility of the Etruscan lovers, the depth of their unending ecstasy! How well the artist knows body and sensation of both man and woman.

Conquerors and gamblers, traders, warriors, and artists, the enigmatic Etruscan had a language—still undeciphered—different from all known languages. It is our good fortune that the record of that civilization has come to us in magnificent frescoes, potteries, carvings. From this one we can assume the Etruscan loved beautifully.

LAURA HUXLEY

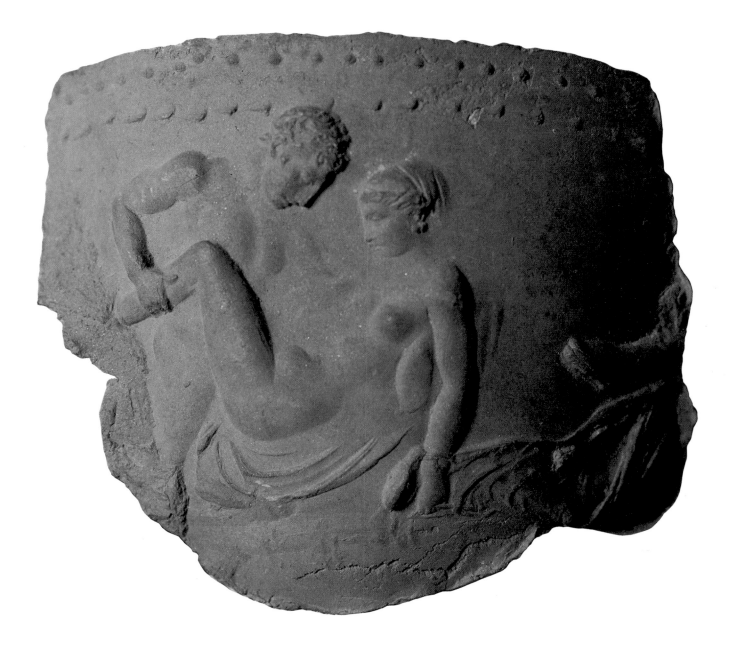

Giovanni Tiepolo (1696–1770)

ANTHONY MEETING CLEOPATRA

ca. 1743, oil on canvas, 15×26¼"

National Gallery of Scotland, Edinburgh

THE artist has recorded better than any historian the concept of romantic love. The Greeks had a word for it, "agape", meaning spiritual, abstract, and unselfish love, as opposed to "eros"—a purely physical love requited by passion.

The meeting between Anthony and Cleopatra depicted so movingly by Tiepolo took place at Tarsus in 41 B.C. and foreshadowed a love that has inspired artists and writers ever since. When Anthony, deserted by his foreign troops and seamen, fled after Cleopatra because he was so hopelessly infatuated, Plutarch said: "He thus proved the truth of the saying which was once uttered as a jest, namely, that a lover's soul dwells in the body of another, and he allowed himself to be dragged along after the woman as if he had become a part of her flesh and must go wherever she led him."

Many scholars question the Plutarchian view, accepted by Shakespeare, and argue along more prosaic lines that in fact Anthony acquired Cleopatra's ships and money, and Cleopatra got back the empire of the Ptolemies. But Virgil in his *Aeneid,* the most popular of all ancient works in the medieval world, devoted one of his most solemn passages to these lovers. Dante saw Cleopatra as a "lascivious and insatiable harlot" and compared her to Helen of Troy. (But then the Romans regarded uncontrolled sensuality as typically Greek—she in their eyes was a degenerate foreign Queen.) I would prefer to believe that this was romantic love in its true meaning: A triumph of the soul over the flesh, with the final self-sacrifice of death.

LADY SONIA MELCHETT

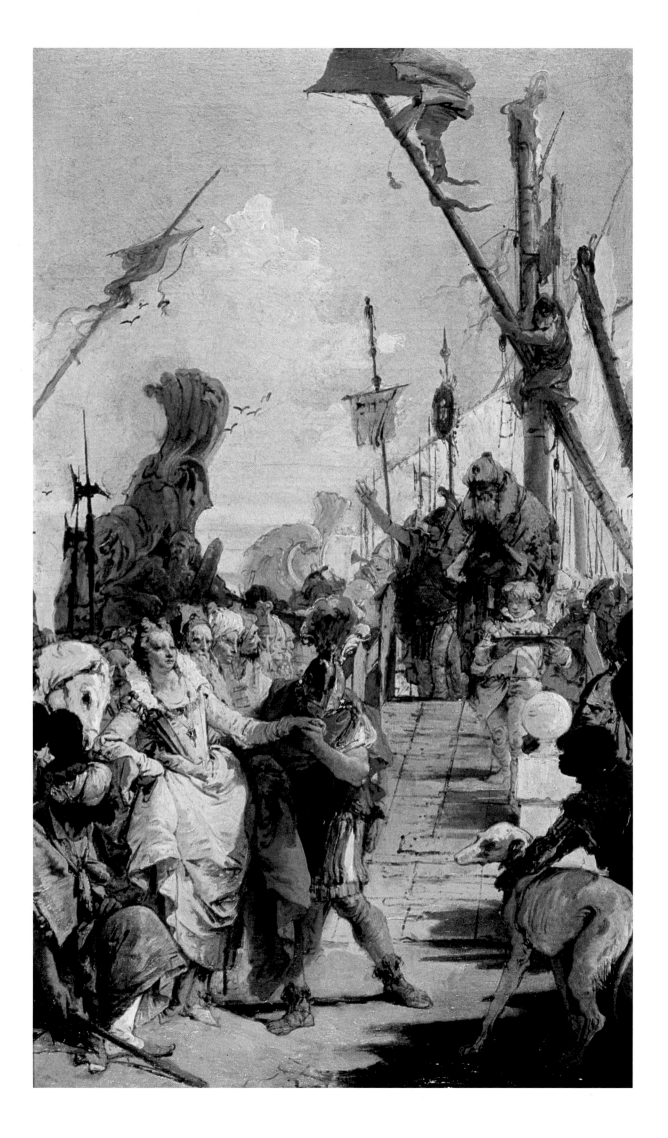

René Prinet (1851–1946)

THE KREUTZER SONATA

1898, oil on canvas, 28×36"

Dana Perfumes Corp., New York

One day, long ago, idling through the pages of a sophisticated monthly, I was suddenly oppressed by a shortness of breath, mingled with giddiness and general trepidation, that results when one gets too near an advertisement for Tabu. This exotic scent is widely publicized as "The Forbidden" perfume! The language used to describe Tabu is an essence compounded of Pierre Loti and the Symbolist poets, so fiery that it sets every nerve aquiver.

This art work, I assume, is an attempt to crystalize the elusive quality of Tabu. Two citizens in evening dress, engaged in a refined musicale, having apparently experienced a common libidinal drive are fused in a fierce embrace before a piano. The ardor of the pair is well-nigh volcanic. The gentleman's hair cascades down his forehead and he holds a violin at arm's length, as though to pulverize it in his fingers; the lady, her wrists trailing the piano keys, is bent backward in an arc recalling the Camel Walk of 1922. It seems a pity that the Tabu people, while they were busy stirring the senses, could not have provided some slight clue to a glamorous situation. What provoked it? Had a drop of the sultry, lid-lowering essense whispered its way around the young woman's corsage, ultimately driving her cavalier to distraction? Whatever incident we create, the undeniable fact is that these two are riddled with emotion.

S. J. PERELMAN

Max Ernst (1891–1976)

THE KISS

1927, oil on canvas, 50⅜×63″

Collection Peggy Guggenheim, Venice

THE KISS did not start with civilization, it started with life. No wonder Max Ernst was so much involved in his creativity with the mysteries of Energy, "Stars, Sun, Moon," etc. From a trace of the nebula he takes us to the beginning of life . . . to the lunar consciousness . . . then to his work.

No human being did, or could, escape this most natural instinct, need, and pleasure of touch and kiss—yet a pleasure, partly and justly, even narcissistic. Nothing is more natural, ageless, and important than the kiss.

Breathing, eating, we must do to stay alive . . . but the kiss is more. It gives and creates life. And no artist is better qualified to tell us about love, life, *The kiss* than Max Ernst, this great sensualist, mystic, astronaut, philosopher, playwright, humorist, and *lover*.

ARTHUR SPITZER

Benjamin West (1738–1820)

ROMEO AND JULIET

1778, oil on canvas, 59 × 44¼"

Museum of Art, New Orleans

ROMEO AND JULIET have been the archetypes of passionate, frustrated, and thus romantic lovers for centuries of youths, even before Shakespeare dubbed them "star-crossed". This painting, executed in the grand manner used for depicting classical scenes from antique literature and history, portrays the action at the beginning of Act III, Scene V, of Shakespeare's *The Tragedy of Romeo and Juliet*. It anticipates the high Romantic style of the early nineteenth century, and also suggests the manner of playing used by the actors of that period. The scene is enhanced by a dramatic use of light to heighten the excitement; the details of costume and the textural qualities of each material are exquisitely painted. Yet the lovers seem curiously unmoved by the danger implicit in their discovery. Only the Nurse shows her anxiety. One seems to hear the lines delivered in cadenced tones, faultlessly inflected, but with no sense of the anguish of lovers forced to part. Juliet's face is hidden; Romeo points off-handedly to the lark, fast disappearing into the dawn.

> *Juliet:* Believe me, love, it was the nightingale.
> *Romeo:* It was the lark, the herald of the morn,
> No nightingale. . . .
> *Nurse:* Your lady mother is coming to your chamber.
> The day is broke; be wary, look about.
> *Juliet:* Then, window, let day in, and let life out.

KENT SMITH

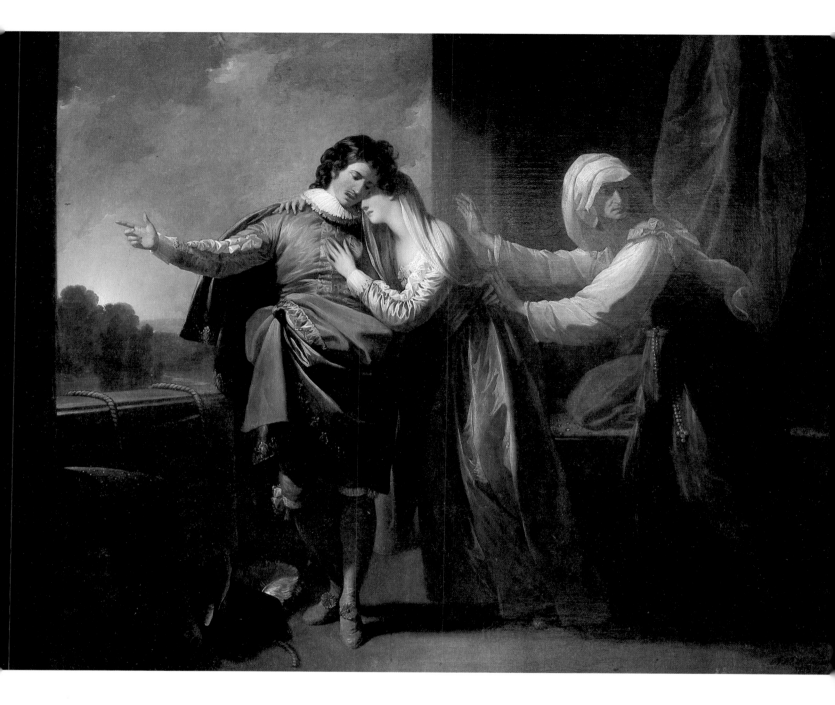

Henry Holiday (1839–1927)

MEETING OF DANTE AND BEATRICE

1883, oil on canvas, 56×80"

Walker Art Gallery, Liverpool

THOSE who talk of Dante think of Beatrice, and those who talk of Beatrice think of Love. When talking of their love, one immediately thinks of Florence. Florence, in the dramatic, insecure period we are experiencing today, still sends her message of love among peoples of all countries, in the hope and desire that Dante and Beatrice—poetry and art—will live again, as in that great immortal period.

Henry Holiday has chosen to paint the Ponte Vecchio as the background for the auspicious moment when Beatrice and Dante's eyes first meet. Dante wrote about love, and became the interpreter of a cosmic sentiment: his poetry has a choral rhythm and has penetrated art, imagination, creativity, dreams, and the hopes of successive generations. In his *Divine Comedy*, Beatrice and love reach their highest and most poetic moment. Love's influence on the field of art is explained as the logical, natural expression of a common sentiment.

Love, the propulsive power of the universe, is a part of our daily lives, though marked by good and evil, joy and sorrow, even hatred. The tests of human vicissitudes intertwine to capture the beauty of life, as Henry Holiday has captured this meeting on canvas.

GIUSEPPE BELLINI

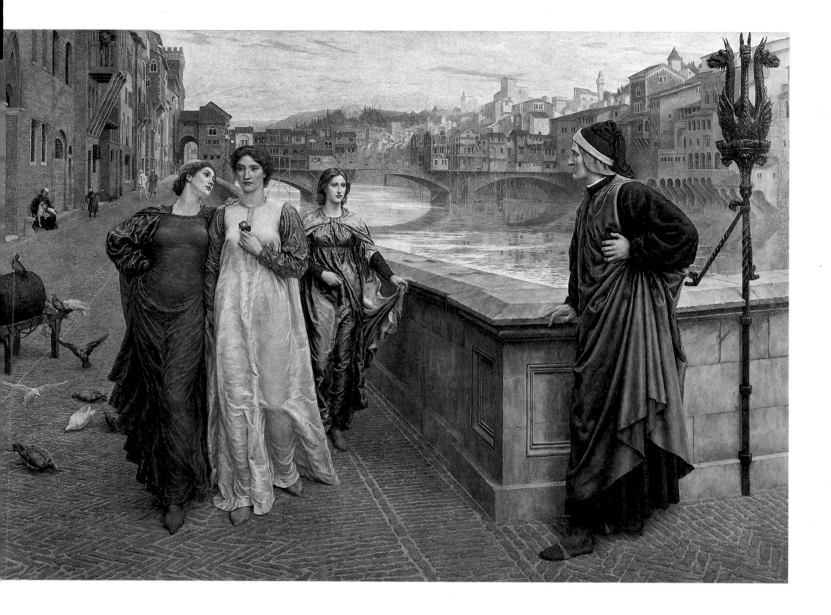

Gustav Vigeland (1869–1943)

MAN EMBRACING WOMAN

ca. 1930, bronze, height 73¼"

Vigeland Park, Oslo

A PERVASIVE theme in Gustav Vigeland's work is the relationship between man and woman. He analyzes all its emotional possibilities: the longing and the rejection, the tenderness and the bitterness, and innumerable shades between these counterpoints.

His couples do not represent literary or mythological figures. With the approach of realism in the last century, intimate love between man and woman was no longer the concern only of gods and goddesses but was brought down to earth, to be shared by everyday man and woman. The sculptor who most conspicuously made this transition was Auguste Rodin, whose influence was felt by most young sculptors around the turn of the century, and Vigeland was no exception. After a stay in Paris in 1893, where he visited Rodin's studio several times, the love theme became an important part of Vigeland's *oeuvre* also, in sculpture as well as in hundreds of drawings. More than Rodin, however, Vigeland, as time went by, monumentalized his couples with the intention of displaying them in the open air.

Man embracing woman or *Man standing behind a woman* are the noncommital, purely descriptive titles. He wanted us to use our own imaginations in order to capture the content and mood of his sculptures.

In this particular piece, the man and the woman are standing upright, in an almost static position, their feet firmly placed on the ground. Although they are young, the figures are at once heavy and broad yet simple and monumental. There is only a slight movement within the group. The woman bows her head to the side, the man stands very close behind her and inclines his head toward her neck, clasping his hands to her breasts. With the quiet gesture of her bowed head, she seems to express a mood of melancholy or sadness. The man embracing her responds to her feelings, but with the firm grasp around her he also gives her strength and solace. They are not only united by physical nearness; there is also an emotional bond between them.

TONE WIKBORG

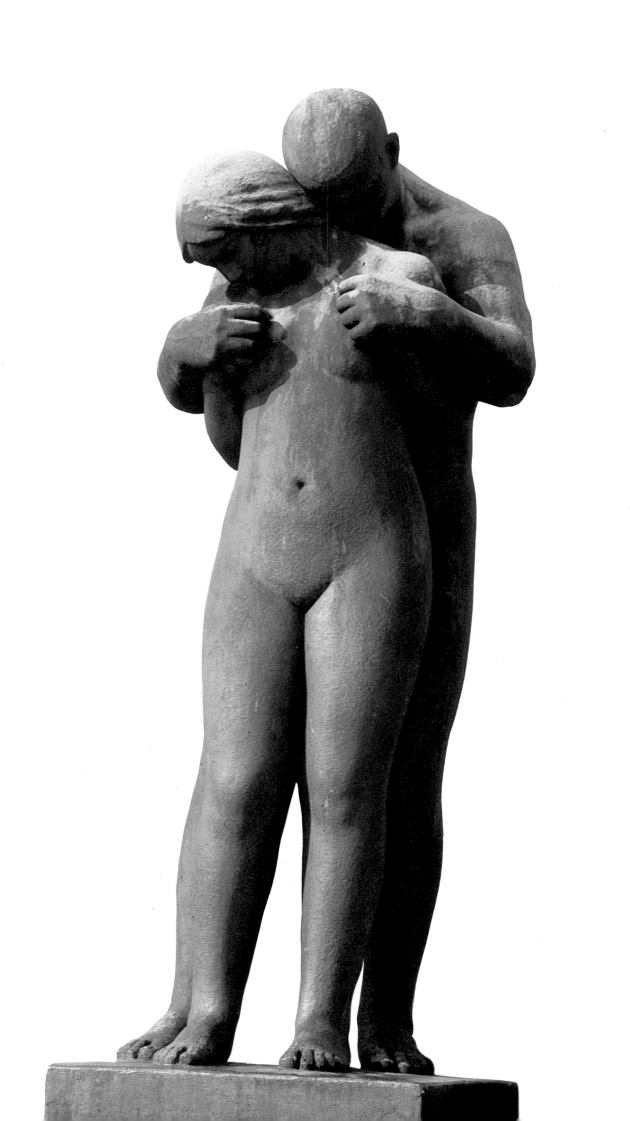

John Singleton Copley (1738–1815)

THE ARTIST

1770–1771, gesso over wood, 30½×24⅞ (frame)

SUSANNA CLARKE COPLEY

1770–1771, pastel on paper 23⅛×17¼ (frame)

Henry Francis du Pont Winterthur Museum, Delaware

I HAVE lived with two Copleys: James Strohn Copley, whom I loved and married, and a John Singleton Copley portrait of John Hancock, which Jim and I both loved. My first response on looking at these pastel portraits by John Singleton Copley of himself and his wife, Susanna (Sukey) Farnham Clarke, was that they did not look much like lovers. Both appear so staid, prim, and cool. I took a second look and felt that Copley's gaze was not so cool and distant as appraising, the look of a man who knows quality, his own worth, as well as the merits of others.

Copley, who made a superb living by painting portraits of New England's rich and successful merchants, their wives and children, had to recognize and then capture on canvas the pleasing exterior qualities as well as the hidden inner nature of his sitters. The artist appraised his lovely wife very highly. This pastel captures the warmth of her manner. Her countenance shows a quiet charm, a spiritual loveliness, and above all, a tranquility which her husband was desperately to require in his later years.

Although Copley's self-portrait is richer than that of his wife, his dress is fastidiously tasteful, informal, and in keeping with the fashion of his day. The artist obviously likened himself in pictorial terms to other successful young merchants, and his wife is an attractive counterpart to her elegant husband.

The pastels were executed shortly after their marriage in November, 1769, when Copley had only recently achieved the same social standing and financial success as many of his merchant and political patrons. Their union was to produce six children and to last forty-five years, until the artist's death in 1815. The marriage was a work of art, and these individual portraits remind me of Saint-Exupéry's comment that "Love does not consist in gazing at each other but in looking together in the same direction."

HELEN COPLEY

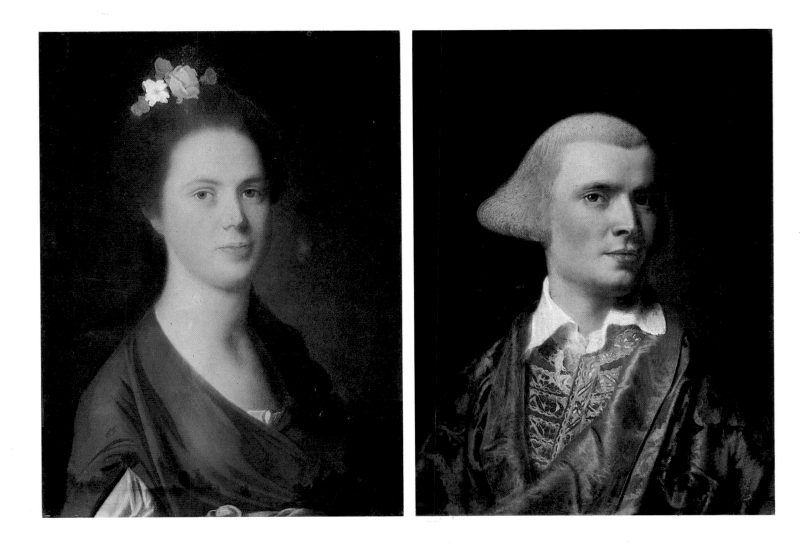

Arthur Hughes (1832–1915)

THE LONG ENGAGEMENT

1859, oil on canvas, 41½ × 20½"

City Museum and Art Gallery, Birmingham, England

THIS Arthur Hughes painting, *The long engagement,* is well titled, for the girl's pregnant condition makes the engagement seem too long for the Victorian era, even a trifle long for today. The dog, definitely her dog, appears to be pleading with the young man to marry his mistress. Can the man hiding in the bushes be the girl's father, waiting with a gun to see if the young man does right by his Nell?

Or can this be another Nathaniel Hawthorne classic and the girl another Hester Prynne, the red material on her breast a "Scarlet Letter"? The weak look on the young man's face parallels the same hiding-behind-God character of the Reverend Dimmesdale. The man in the bushes could be Hester's long-thought-dead husband. Or is this all my imagination, because in the very early thirties I made a talking version of *The Scarlet Letter?*—and perhaps I only *thought* I saw a man in the bushes . . .

The picture perhaps represents a lovers' goodbye, as the young man sets sail to seek his fortune so they can be married. The seeming pregnancy showing under the lavender fold at the front of her dress could be only the new style puffed front, matching the bustle at the back, a stomacher made of silk, and virtue triumphs again.

COLLEEN MOORE

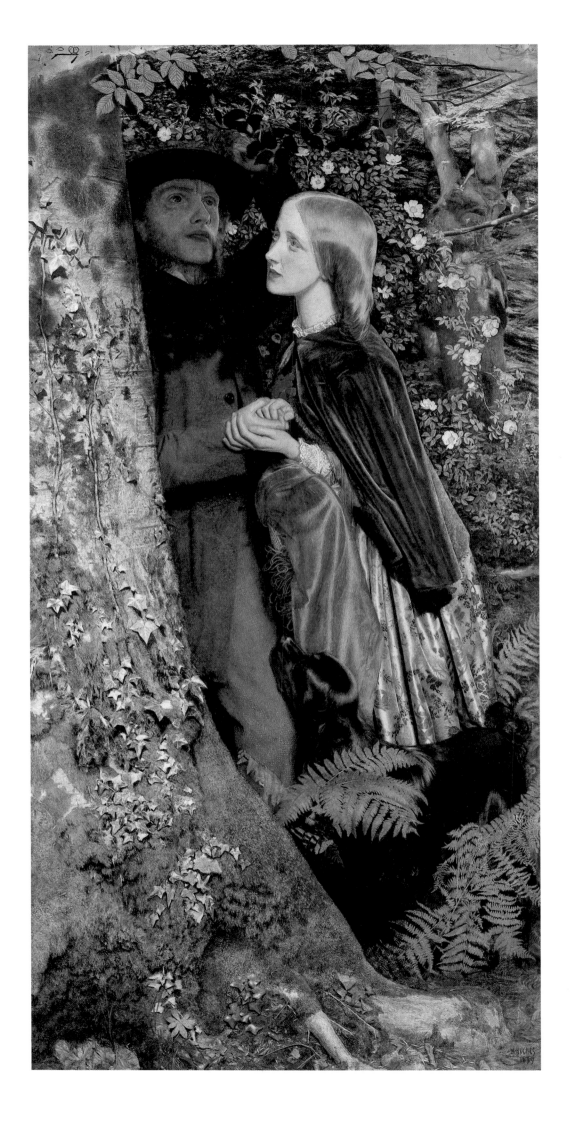

Giovanni Tiepolo (1696–1770)

ANGELICA AND MEDORO

ca. 1755, fresco, 66×76"

Villa dei Nani, Vicenza, Italy

OLD love, new love—Tiepolo has captured the magic of both. The two old peasants, lined, brown, weatherbeaten, need no endearing gesture to show to each other a passion which years of living and toiling together has mellowed and made as lasting as the trees on their fields. Lovely Angelica, the aloof, untouchable princess for whom the most brilliant knights (Christians and pagans alike) have lost their hearts in vain, has happened to find the handsome young soldier, Medoro, who has been severely wounded while trying to recover his master's dead body from the battlefield. He is the embodiment of purity, strength, and loyalty. The eloquent pleading of her budding love secures the shelter and hospitality of the old couple's barn. And, finally, the warmth of her loving pity brings back life to his limbs, sweet young life, and his eyes open into hers, the spark is lit, and love is there. That deep, feminine instinct, motherliness, the same which prompts the old peasant woman to shelter the wounded boy in the barn, the same which made Angelica, a princess, nurse the wounded young soldier back to life, now explodes in that other, primeval, uncontrollable passion; the love of a woman for her man.

The world outside with its strife is forgotten; only the still, warm countryside is important for them, with its nights and its dawns and the heady fragrance of summer grass. The two old ones, in their rough thick clothes, their heads covered against the sun, look on, and there is protectiveness in their eyes. Deep in the frescoed walls still warm with sunlight, it comes to us, this lovely story, as fresh and enchanting as when it first emerged from the master's brush.

COUNTESS MARIA TERESA CESCHI

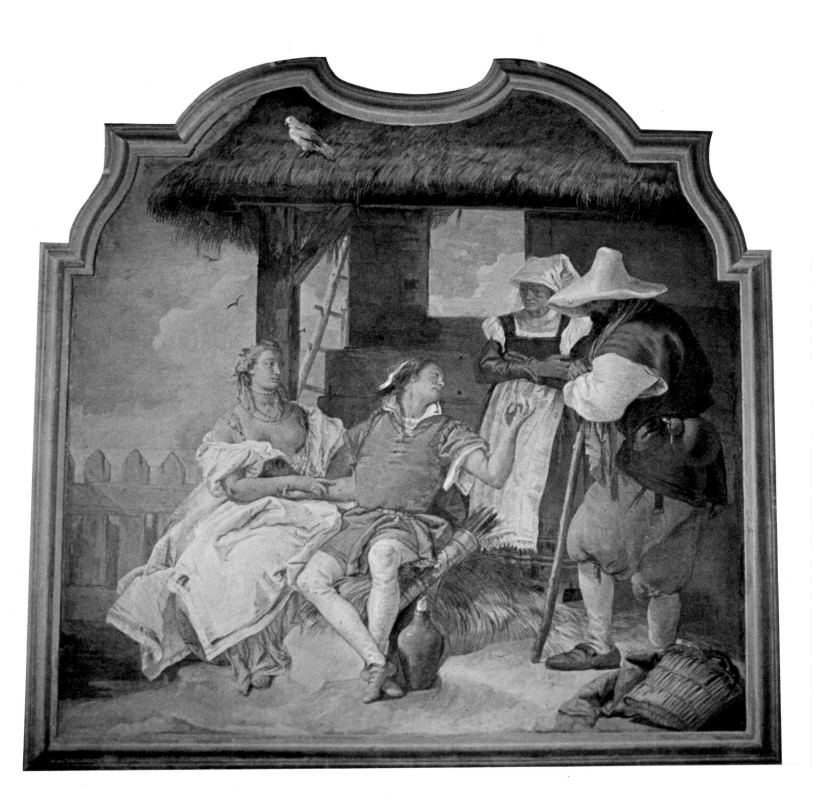

Anon.

COUPLE

6th cent. B.C. (Etruscan), alabaster, length 6'8", height 4'2"

Villa Giulia, National Museum, Rome

SEPULCHRAL art holds great fascination for the living. We are astounded by the golden beauty of the death apparel of Tutankamun, by the solemn grandeur of the memorial monuments of Greece and Rome, by the elaborate fancies of popes and princes in the Renaissance executed by the greatest masters. We are none the less enthralled by the simple headstones seen in old English cemeteries. How men remember those that they must follow into the ultimate adventure will always intrigue us. For the most part these are celebrations of death.

But the mysterious Etruscans in their frieze-painted tombs and living sculptured sarcophagii seem to celebrate life as though, loath to leave it, they would remind the living forever to enjoy it while they can. Those joyous frescoes deep in their earth-carved tombs in central Italy are memorials of the living, not the dead.

In this masterpiece of sepulchral art we see the lovers at home, as it were, on the conjugal couch, alive and anticipating the act of love itself. Call it eternal togetherness, the celebration of the physical, call it anything but death. These living lovers chose to be remembered thus alive and loving. And there is nothing sentimental, sad, or lifeless in their pose, nor in the enigmatic, beautiful smiles upon their lips, the glint of eyes that have known the lovers's closeness and content, the ultimate individual secret of a man and woman together.

This monument to art and life is one of the greatest inspirations left to us by time. It proves that time cannot conquer love nor death make us forget the joys of life.

VINCENT PRICE

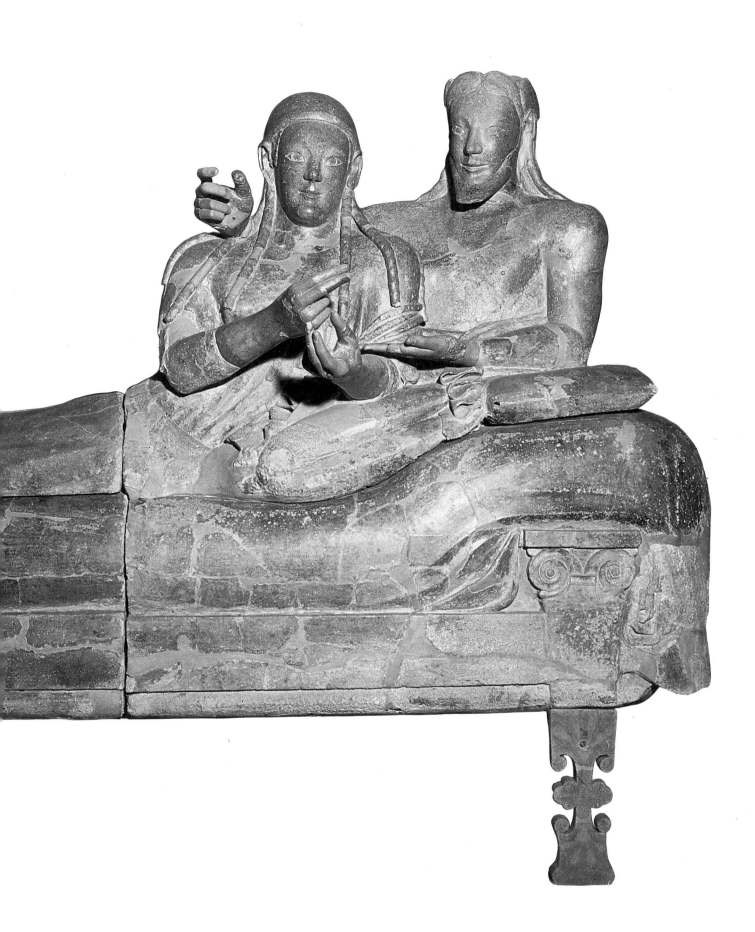

Frans Hals <small>(1580?–1666)</small>

YONKER RAMP AND HIS SWEETHEART

1623, oil on canvas, 41½×31¼″

The Metropolitan Museum of Art, New York, Bequest of Benjamin Altman, 1913

WRITERS are not good judges of paintings. If invited to do so—and *Yonker Ramp and his sweetheart* makes this invitation because of its title—they are inclined to see characters and stories instead of brushstrokes, color, or composition in the painting.

What a writer sees here, as he is instructed by Frans Hals, is one sweetheart and Yonker Ramp. This is not a painting to delight feminists. The man has a name; the woman is just a "sweetheart", as a wife is often just a wife.

It is obvious that Yonker's sweetheart loves Yonker. Her face reflects her admiration, her hands clasp him. Who does Yonker love? No telling. With one hand he hoists a glass. Toasting his sweetheart? Perhaps. But he has hoisted many a glass before. With his other hand he caresses his dog. His mouth is open as he addresses his companions, one of whom can be seen behind him.

What is Yonker celebrating? His coming marriage? The success of his dog in the dog trials? In any case, Yonker's sweetheart loves Yonker and takes pride in him. If the day comes when companions, occasion to celebrate, drink, and dogs fail him, she will still be by his side.

JESSAMYN WEST

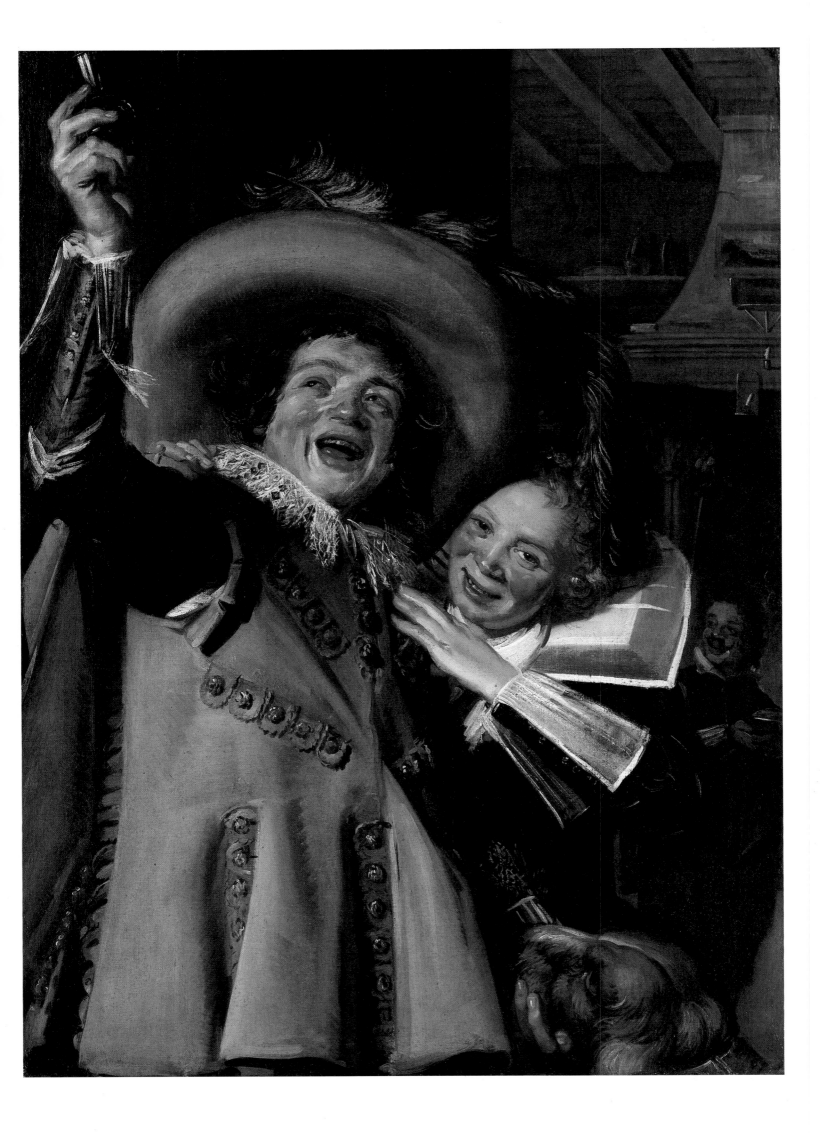

Tamara Lempicka (1905–1980)

ADAM AND EVE

1931, oil on canvas, 50×32"

Private collection

I HAVE often been asked, "Why did you represent Adam and Eve as modern lovers on a background of skyscrapers?"

The answer seems obvious: since Genesis, the destiny of those two lovers has haunted the human race; their images have inspired poets and painters down through centuries. For me, as an artist sensitive to outward forms of beauty, the revelation of this truth struck me one day in my Paris studio as I was making sketches of a nude model, a creature of divine body who suddenly stretched her hand toward a bowl of fruit and carried to her lips an apple, in the irrepressible and timeless gesture attributed to the Eve of Paradise. I was struck with the vision of a modern Eve biting into the forbidden fruit—Eve liberated, her hair cropped in the style of our own emancipated times, naked, yet chaste in her nudity, and therefore all the more desirable.

To provide her with a partner seemed to be the next natural step, and Adam was created, in reversal of the Divine order. His body is that of a modern sun-bronzed athlete, although his features already bear the traces of human frailty.

And behind their intertwined bodies loom the skyscrapers, casting their menacing shadows, threatening to engulf, but never quite destroying, this divine moment of Paradise.

TAMARA LEMPICKA

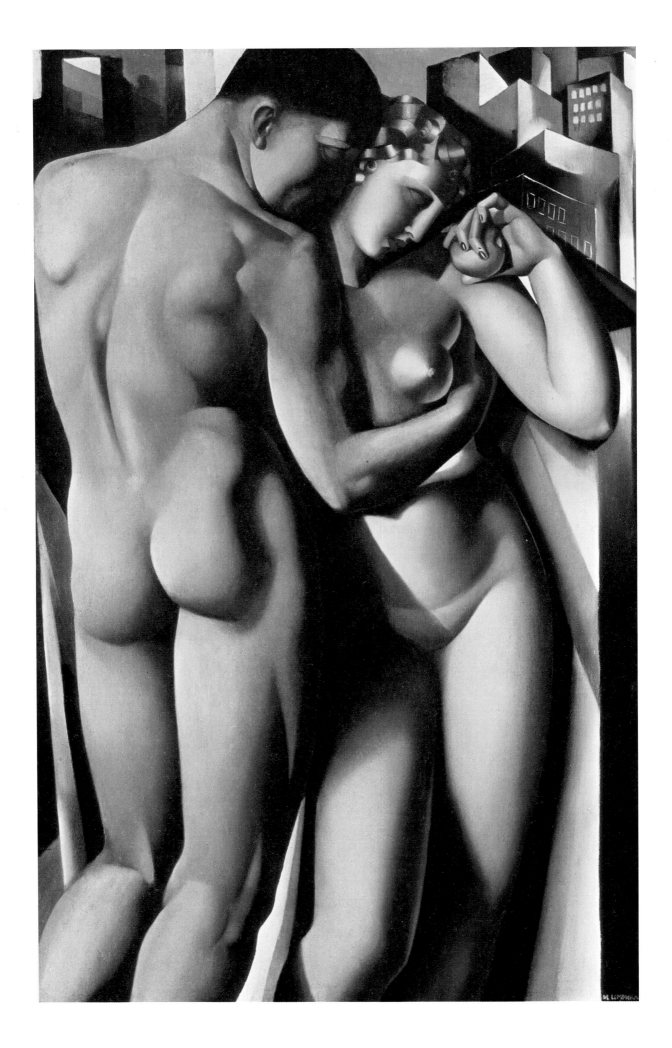

Anon.

A MUGHAL PRINCE OFFERING WINE TO HIS MISTRESS

c. 1740, (Indian), watercolor, 11½×7" (within all borders)

Collection Dr. Edwin Binney, 3rd

THIS Indian lady is the embodiment of the ideal in Muslim harem inmates; her lord a perfect "male chauvinist" treating her as she deserves and even demands—a love object. Her expression is rapt as she gazes at the object of her desire.

The Mughal artist who produced this miniature painting was a palace official as much as a creator of works of art. He knew the political stagnation of his master's realm: a sapping of vital energy, which transformed the Mughal noble from a valiant doer of great deeds to a puppet whose sole role was that of languid lover—a sex object.

This lady recognized the slowing down of vitality. She gazes directly into her master's face, yet is content with his vague regard, which seems to caress only the pearls on her forehead, while his hand fingers her necklace. The rigid trunk of the tree, with its lush flowering and gorgeous sky behind, suggests the culmination of his passion rather than its incidence.

The Mughal Empire may be shaky, its warriors dissatisfied with themselves as they are unable to cope with an enforced peace. But its artists, catering to a sybaritic coterie at its courts, can still transform the day-to-day routine into masterpieces.

DR. EDWIN BINNEY, 3RD

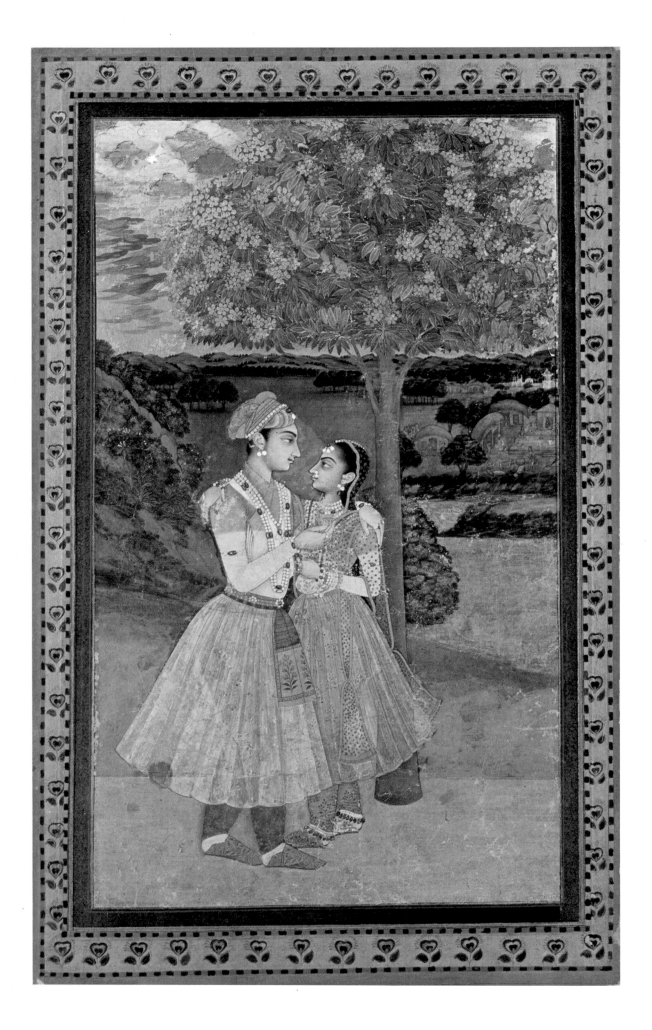

Jan Vermeer (1632–1675)

YOUNG WOMAN READING A LETTER

1660, oil on canvas, 18¼ × 15½"

Rijksmuseum, Amsterdam

THE lady is alone in a quiet room. The golden light of an afternoon of another century illuminates the single figure. The pregnant young woman in a fine sky blue silk blouse stands reading a letter, her face gentle and pensive, the color of her blouse unobtrusively repeated in the upholstery of the solid, wood-framed chairs of the sturdy, scrubbed Dutch house in which she lives.

She is in a zone of silence, removed for a moment from the cheerful bustle of kitchen and nursery, but there is a triple presence in the tranquil scene. There is the woman herself, neat, serene, secure in her time, place, and condition; there is the child in her womb, with all its infinite promise; and there is the writer of the letter, the husband who, one can imagine, is a young merchant briefly absent on a voyage of affairs, penning an undramatic short account of his travels, his transactions, his estimate of the date of his return, all this homely trivia an enduring witness to his undemonstrative devotion to his wife, who will soon be the mother of his child. Over the young woman's shoulder we can almost read the contents of the note, every stilted, formal line replete with love, passion decorously hidden in the bourgeois marital propriety of the written word, the true message on the flimsy sheet of paper unmistakably clear to sender and receiver alike.

In our romantic age we are inclined to believe that passion is expressed only in emotional excesses, in tears and blood, in wild depths and dizzying heights. Vermeer, with his extraordinary gift, teaches us, across the years, how deep passion can be in the sacred ordinary passage of our days.

IRWIN SHAW

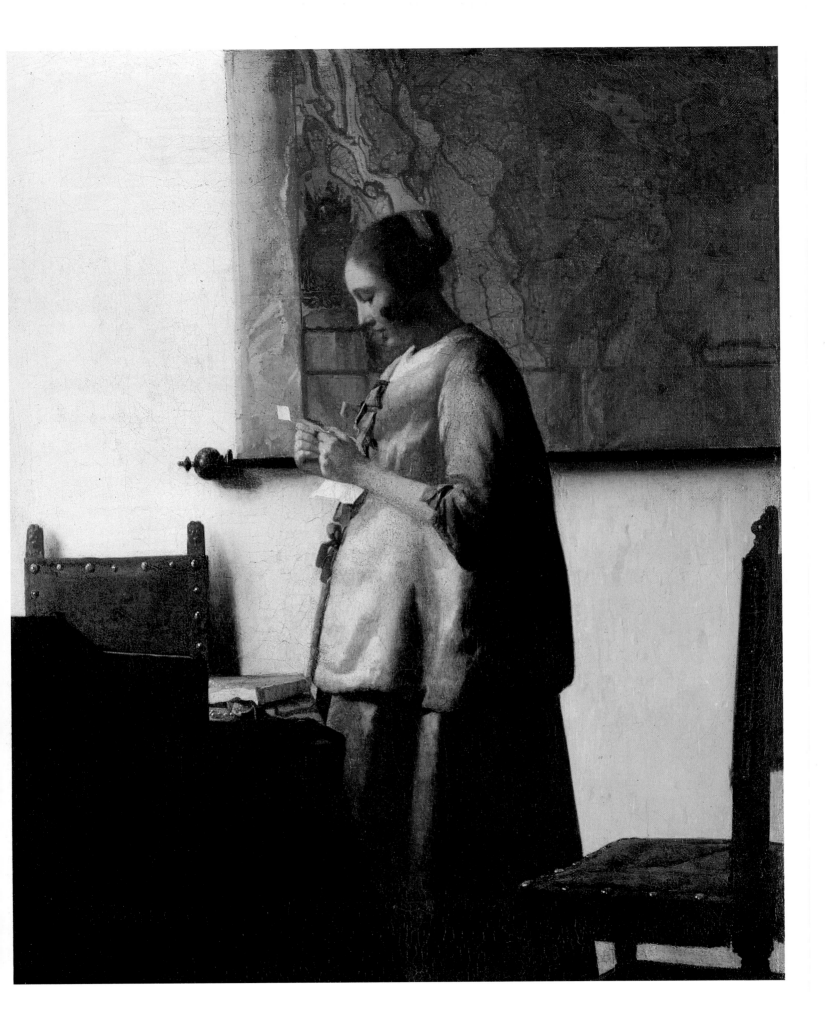

Auguste Rodin (1840–1917)

ETERNAL SPRING

1884, plaster, 26¾ × 31½ × 19⅝

Rodin Museum, Paris

THERE are many kinds of love, but *Eternal spring* represents, I think, the romantic love young girls dream of. The girl is soft and yielding, the man is strong and impetuous. This is a vision of the kind of love that sweeps us away.

Love has the power to carry us out of ourselves. For this reason we seek it—and we fear it. This statue, which I first saw as a young girl in Philadelphia, has always fascinated me with its flowing sensual beauty and the passion it reveals.

I admire Rodin's extraordinary mastery of the whole range of human emotions; from brooding contemplation in *The Thinker* to erotic passion in my favorite, *Eternal Spring.*

HER SERENE HIGHNESS
PRINCESS GRACE OF MONACO

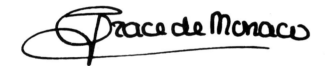

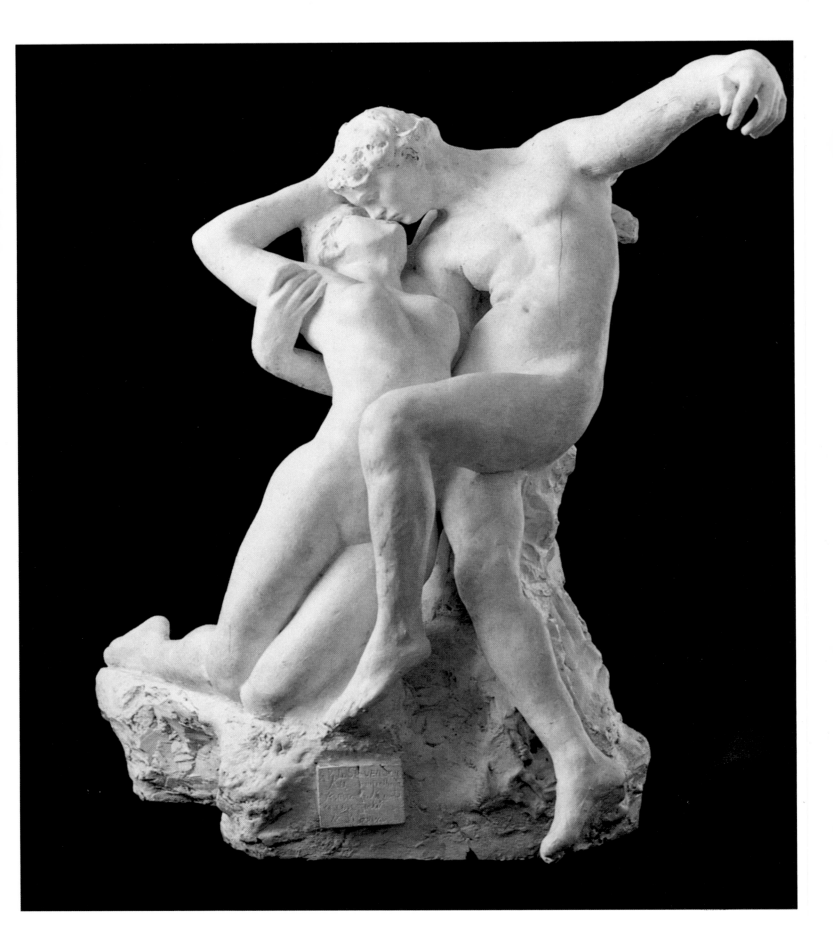

Francisco Goya (1746–1828)

THE PARASOL

1777, oil on canvas, 40 15/16 × 59 7/8"

Prado, Madrid

THE greatness of Goya has never been disputed. In his lifetime he was the foremost painter of Spain, and since his death has been recognized as the master of so many vivid images—the menacing, the melancholy, the revolutionary, the portraitist—all of them reflecting his veneration for Velásquez and Rembrandt.

But this painting of two childlike romantics is not like the ones we see most frequently—not the Goya of kings and queens and duchesses, of bullfighters, of still lifes of raw beef, of dark corridors filled with mad men and women, of children in the streets, of prisoners, of soldiers, of altar masterpieces. Nor even of his celebrated Maja, portrayed both naked and clothed. There is a unique, lovely softness (perhaps even a tenderness) in *The parasol*.

Goya often said that he knew the magic of the atmosphere of a picture. For me, in this one, he seems to have caught the magic of young love.

FLEUR COWLES

Paul L. Clemens (b. 1911)

ROBERT STERLING & FRANCINE CLARK

1942, oil on canvas, 18×15"

Robert Sterling & Francine Clark Museum, Williamstown, Massachusetts

THEY sit close together as usual, sharing a happy task of mutual interest as they catalogue a portfolio of drawings. The man is Robert Sterling Clark and the lady, his wife, Francine. Their marriage reportedly created an enduring breach with his conservative old New York family, since Francine was supposed to have been an actress before wedding Robin, as she always called him. Fortunately, Francine shared Robin's artistic interests. Together, they amassed the highly personal collection in the museum that serves as a memorial to their love for art and for each other.

PAUL L. CLEMENS

Paul L. Clemens

ON OCTOBER 31, 1980, Ariel and I will have been sixty-seven years married. What favors of fortune sustained us on this Marathon? Did physical attraction play a part? Yes, but not in its more obvious ways. I was moved by Ariel's vitality, the joy she took in activity; the happiness that brightened her eyes, despite poverty and a broken home. To be near her was to feel the breath of life; to touch her was to sense a current of fresh youth (she was fifteen) entering my aging (twenty-eight-year-old) frame. She drew me, unresisting, into bodily activity—40-mile bicycle trips, 100-mile walks from the upper Bronx to Philadelphia. She danced entrancingly, "like a feather in the wind". I was ashamed that I had never learned that intoxicating art; I surrendered her to better educated men, and gloried in her grace.

In the early years of our marriage, we had no quarrels; we were too absorbed and united in earning and eating our bread. In the middle years, as our income rose, we had some brief, two searing disputes. I nearly always gave in, except when she wanted to exchange our home in the Hollywood hills for an apartment in the town. I won that one, and now she loves every decaying inch of what she calls our "big shebang".

Life with her grows sweeter daily. We nurse each other in our sicknesses, and rare is the night when I fail to escort her to bed. O you wild youngsters who flit from mate to mate, scratching surfaces—do you think you know what love is?

WILL DURANT

Will Durant

Ed. Note: Although both Will and Ariel Durant have died since this text was written, it is printed in its original form to retain the integrity and intensity of the author's expression.

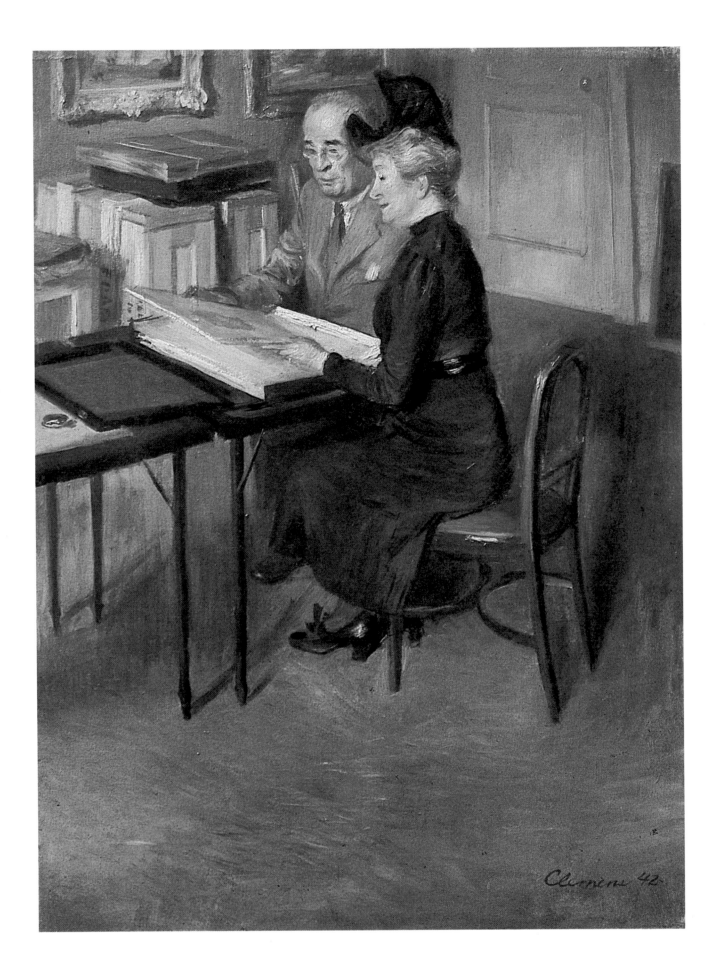

Alfred Jacob Miller (1810–1874)

INDIAN ELOPEMENT

1837, watercolor, 30¼ × 36¼"

The Buffalo Bill Historical Center, Cody, Wyoming

INDIAN *elopement* is a romanticized version of an ancient tribal custom among the Plains Indians. The habit of stealing your future wife is encountered in many primitive cultures; for that matter, it exists among us today. It was a practical way to avoid all kinds of problems, dissenting voices, and envy, and thus come to the point and accomplish rapidly the major purpose, the fulfillment of love.

The picture shows both the warrior and his bride-to-be looking back to detect pursuit. It was customary, in fact, for the relatives of the "fiancée" to go after the couple and try to liberate her from the arms of her selected lover.

Originally, that pursuit was meant to separate the couple and to give a chance to some unlucky pretender to try to kill the future bridegroom, if he could. Later on, it became more ritualistic and the posse would never really catch up with the elopers, much as it is today.

To me, this classic elopement represents what is most powerful and romantic about love, the desire of two people to be together, no matter what the odds or the danger.

OLEG CASSINI

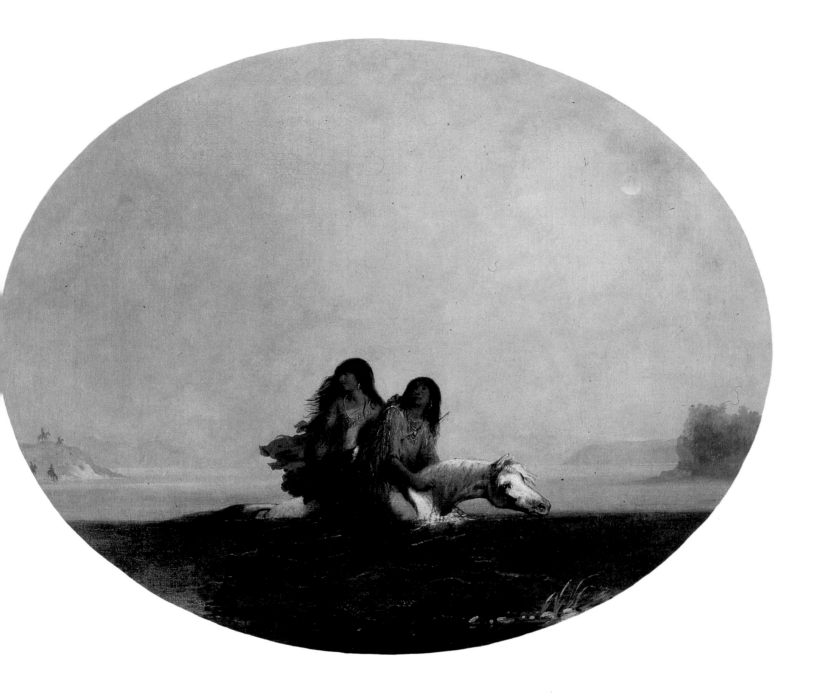

Gustav Klimt (1862–1918)

LOVE

1895, oil on canvas, 23⅝×17⅜"

Historiches Museum der Stadt Wien, Vienna

THE very year Gustav Klimt painted this romantic evocation of young love, Alexandre Dumas fils, the creator of *La dame aux camélias,* died. The painting could well be of Marguerite Gautier and Armand, full as it is of the springtime of life, which Henry James evoked so tenderly in his obituary tribute to Dumas:

> *The play has been blown about the world at a fearful rate, but it has never lost its happy juvenility, a charm that nothing can vulgarize. It is all champagne and tears—fresh perversity, fresh credulity, fresh passion, fresh pain.*

Happy juvenility, champagne and tears—these are not qualities one would normally associate with the highly stylized, decorative art of Klimt, who usually seems more concerned with turning emotions to his symbolic purposes than with catching them on the wing. But this painting has exactly the April air with which Greta Garbo astonished me and the world when I had the deep satisfaction of directing her in the film *Camille.* The passion and the pain, the grace and the charm. In the painting, the play, and the performance alike, they are all magically crystalized for an eternal moment, always young, always fresh, unchangeable in their ability to move us with their intensity and their truth. That is what art— any art—is all about.

GEORGE CUKOR

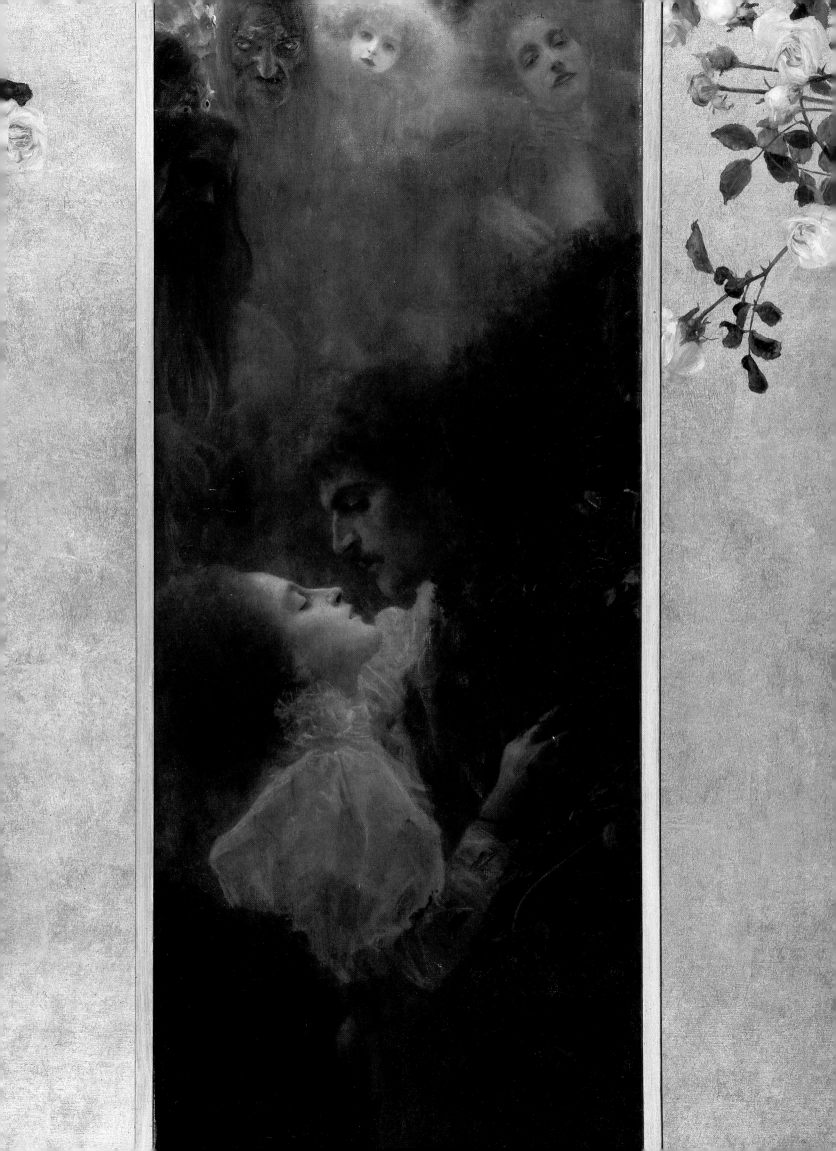

Riccio (Andrea Briosco) (1470–1532)

SATYR AND SATYRESS

1509–9, bronze, height 9⅛″

The Victoria and Albert Museum, London

ONE of the main humanist centers in Italy in the late fifteenth and early sixteenth centuries was Padua, and it was there that this group of a *Satyr and Satyress* was produced. Its author, Riccio, was the great Italian master of the bronze statuette. Many North Italian collections of antiques included representations of satyrs in marble or bronze, but never in antiquity did the satyr have the character it assumed in the Paduan Renaissance: that of a benign primitive being at the mercy of its own sensual appetites, reflecting, in its instinctive actions, the emotional responses of a more sophisticated form of life. At Riccio's hands, in countless inkstands and table ornaments, the Satyr takes on a pathos of its own. He was indeed the Landseer of satyr life, and in his statuettes of begging satyrs, seated with hooves crossed on the ground, hopefully holding out a shell or amphora, he seems to express all the incoherent aspirations of some subhuman species toward a state that it cannot attain.

But satyrs were not entirely to be pitied, and in some respects satyr life was notoriously uninhibited. Roman literature contains many accounts of nymphs protected from the unwelcome attentions of a satyr, usually by water since satyrs could not swim. The satyress was not protected in this way, and there is a beautiful plaquette in Washington which shows a drunken satyr forcing his attentions on a flinching female of his own kind. A cognate subject is depicted in this statuette. In its complete form it showed a satyr and satyress seated beneath a tree, from which a satyr child looked down at them. From a formal standpoint, the interlacing of the figures called into play Riccio's boundless ingenuity, and the group is one of the most subtle and ambitious small bronzes that he devised. Our reaction to it, however, is not primarily to its form but to its humanity, and especially to the exquisitely tender gesture with which the satyr strokes the cheek of the negroid satyress.

The bronze forms an allegory of affection on its simplest and most natural plane, and the more closely we inspect it, the richer and more personal does its content seem.

SIR JOHN POPE-HENNESSY

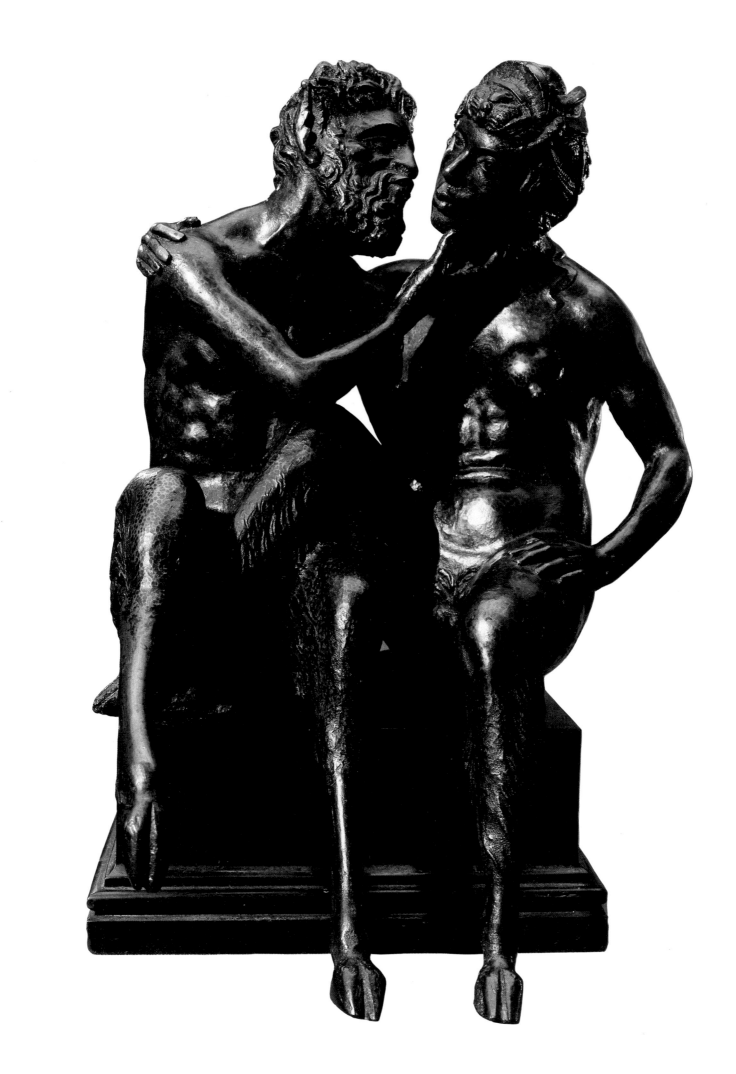

Norman Rockwell (1894–1980)

GAIETY DANCE TEAM

1937, oil on canvas, 36×28″

Collection Variety, Inc., New York

THEY are forty years old, together. He promised her father he would take care of her forever. Last night there was a telegram from their agent, saying that owing to flood conditions the rest of their engagement was canceled.

That's what he told her. He even showed her the telegram. But he'd had the telegram sent from New York by a friend of his. The real telegram said they were canceled because the manager didn't think much of them.

She cried last night and he kissed away her tears. He told her she was better than Ginger Rogers ever was. She told him he was better than Fred Astaire.

She got up early, while he was still asleep, and made him breakfast on their hotplate with the last egg. When he woke up, she told him she'd already had breakfast, which was a lie. Another lie was telling him that she knew the flood conditions were temporary, because she had discovered the real telegram. She didn't want him to be discouraged. She didn't want him to be unhappy . . .

You and I may think that their life together is an insecure and makeshift gypsy caravan. You and I are wrong. I give you Romeo and Juliet: a mere passing fancy. There is no love—including all those in this well-meaning book—as deep, and strong, and fervent, as a young dancing act stranded out of town who know, simply know, that they'll make it big someday.

NORMAN KRASNA

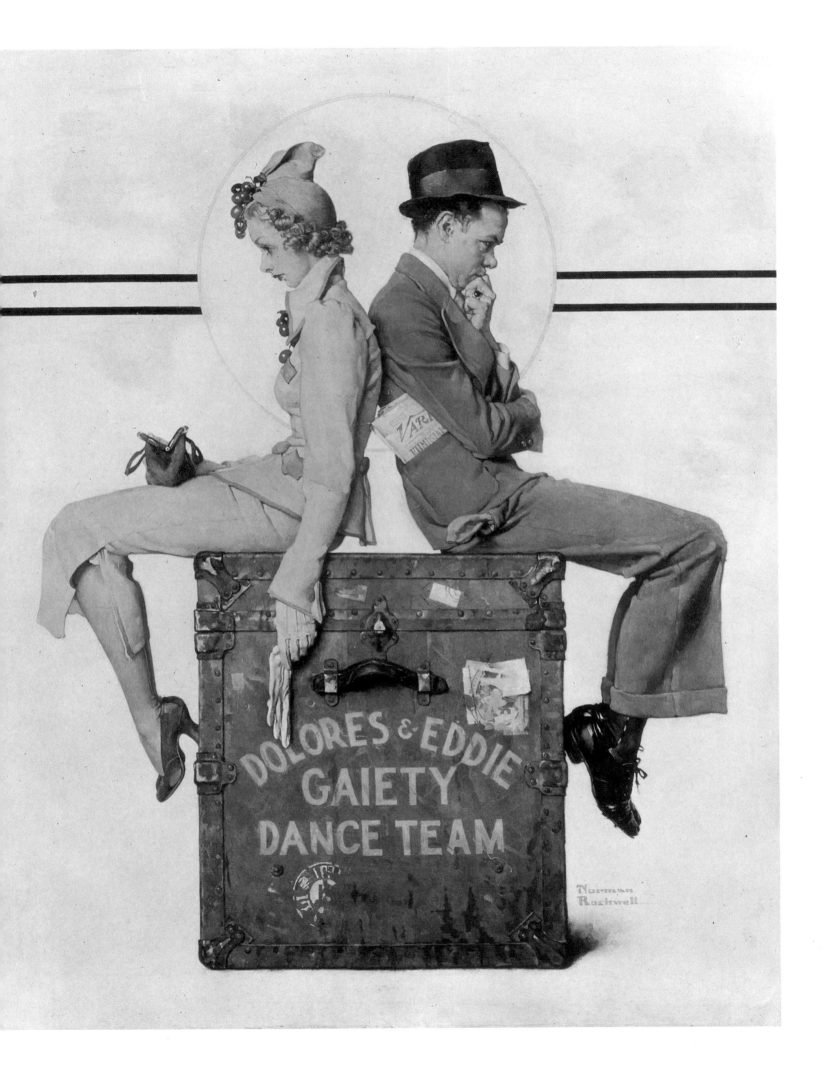

Marc Chagall (b. 1889)

LOVERS AND FLOWERS

1928, gouache, 25×20"

Private collection, Los Angeles

LOVE has been expressed in many modes, but rarely have its enchantments been more exuberantly celebrated than in Chagall's tributes to his wife, Bella. The gouache reproduced here is one of a series of paintings of lovers and flowers, each of which the artist is reputed to have presented to his wife to commemorate successive wedding anniversaries. For me, this painting has a particularly personal signficance.

I first saw it a few weeks after I was married. For days afterwards I carried the glowing beauty of its dreamlike images in my mind's eye. The surreal use of space in which everything floats around together in a rosy sky (and no rational scale exists) became the space of my own nocturnal dreams, splashing them with vivid, luminous color. The painting literally took possession of me. Thus, I was driven to take possession of it, and it became my first purchase of a splendid work of art.

Over the years I have watched the lover spring into the air, holding his beloved next to his heart. I have seen the man and woman dance and float in their eternal embrace as they joyfully become extensions of the copious bouquet that bursts forth from the tilted white vase. The great crimson blossoms seem like suns exploding with the energy and happiness of the lovers' passion, just as the green leaves more quietly express nature's fecundity and the renewal of hope. The delicate, bubble-like circles that seem to propel the lovers into the higher realms reflect the cascade of green grapes that spills out of the basket. Lightly sketched above the basket, a small cow rests, and just beyond it we see the delicate outline of a dream cottage—perhaps the lovers' castle in the air.

This anecdote and vision of a state of mind is an epithalamium in paint. And although it rejoices in nature's bounty and beauty, it is not earthbound. Something in the lovers' solemn, distant gaze reminds us that love with all its earthly delights also soars with the spirit to the far beyond.

DR. REGINA K. FADIMAN

Regina K. Fadiman

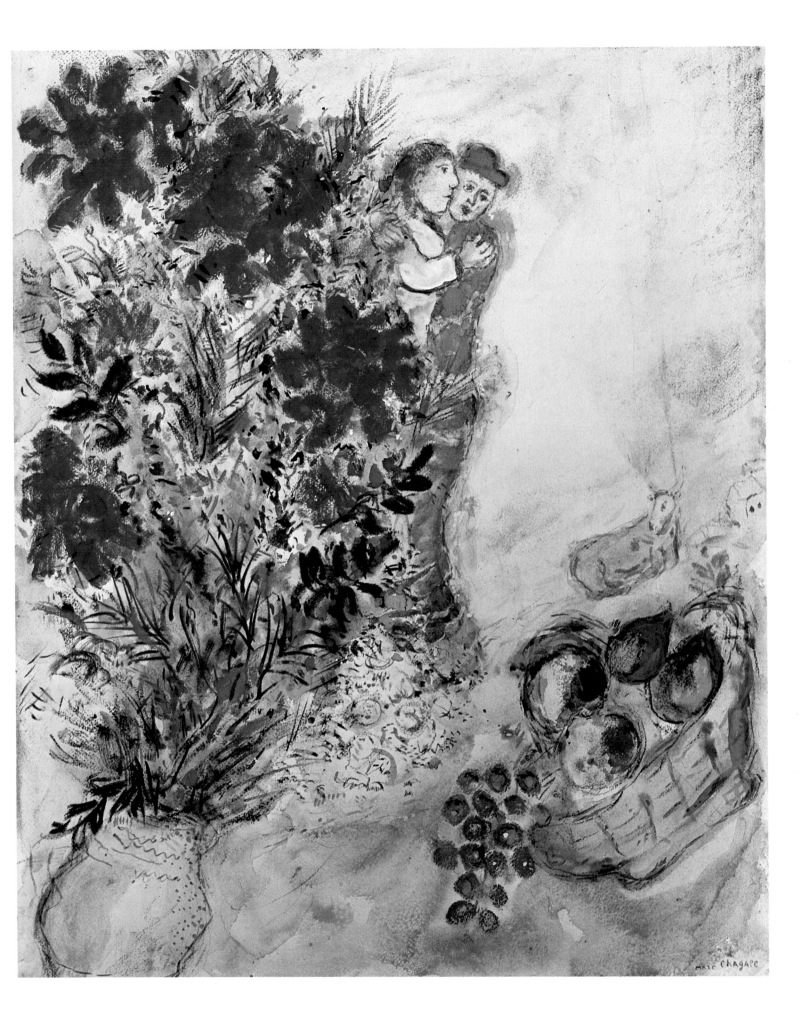

Lorenzo Lotto (1484–1556)

MICER MARSILIO AND HIS WIFE

1523, oil on canvas, 27 15/16 × 33 1/16"

Prado, Madrid

LORENZO LOTTO, Venetian by birth, was a strange, high-spirited man—neurotic, with passionate religious beliefs, but extremely kind. So say his contemporaries. He has left this marvelous double portrait, an unforgettable image filled with symbolism and a touch of irony. A misogynist who never wanted to marry, Lotto presents betrothal in the dual aspects of contract and reciprocal submission. The husband, at first glance, has an expression of serenity and stability. The attitude of the young wife, wrapped in expensive garments luxurious to the touch, is one of extreme modesty. The expression in her eyes is quizzical but at the same time argumentative. In this, Berenson wittily points out that she reflects both ambition and vanity.

Curiously, Lotto's mentality was that of a middle class merchant. He was pragmatic in thought, and his concern for financial status was reflected in his own clothes and jewelry. In the notebooks that the artist kept, his orders and specifications, the payments received for this painting, his special interests and difficulties, the representation of silk cloth, jewels, and necklaces—all are discussed and recorded. They underline the emphasis he put on the commission, the prevailing concept of matrimony, and social class.

The painter adds a shade of wit and malicious irony, of playful love and deceptive smiles. On the shoulders of the husband he puts symbolic marriage ties that restrict his movement and freedom, and laurel leaves to show triumphant social union and strong character.

The quality of the painting, the blacks and grays of the masculine suit sparkling in a masterful Venetian technique, make this particular work one of Lotto's finest.

ALFONSO E. PEREZ-SANCHEZ

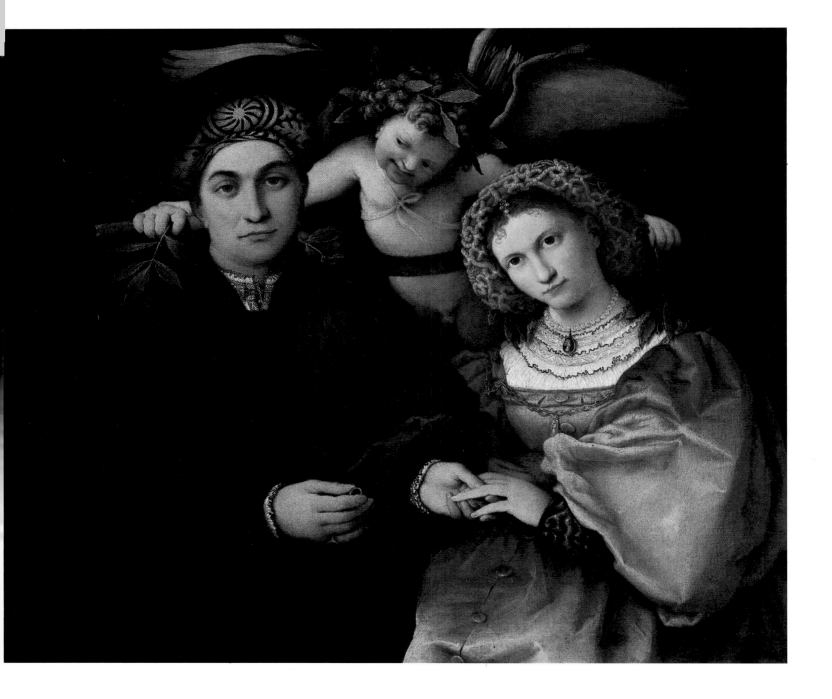

S. A. Aitbaev (b. 1938)

HAPPINESS

1966, oil on canvas, 63×63"

Kazakh Shevchenko State Art Gallery, U.S.S.R.

134

NO GREATER love has ever been demonstrated than that of the wives of the Dikabristi (the Decembrists) who loyally followed their husbands into Siberia. In 1825, Czar Nicholas of Imperial Russia banished this group of noblemen for daring to ask for reforms in the government. This preceded the Russian Revolution by nearly one hundred years. The Czar did not count on the strong love of the wives of these men and he was unprepared for the requests to join their exiled husbands in the remote outposts of civilization. But join them they did, even though their families and friends begged them to reconsider.

This group of intellectuals, idealists, officers, and guards included Prince Wolkonsky, the Davidors, Raierskys, and Nikita Mourarier, all aristocrats whose birthright had been great wealth, cultivation, and ease, combined with a sense of responsibility verging on the democratic. My ancestors were in this group—Princess Ekaterina Troubetzkoy journeyed across Russia to be with her Prince. The hardships and lack of all refinements gave them a strength that endured throughout their lives.

I'm sure they must have encountered Siberian peasants who resembled the couple portrayed by Aitbaev, a contemporary Russian artist. The title of the painting is simply *Happiness*. Stripped of all luxuries, only the human elements remain, which bring a man and a woman closer together and enable them to experience a passionate love that could flourish by fighting for survival. My forebears did this and I am proud of them—and of the love stories of the Decembrists, which will be told and retold.

PRINCE YOUKA TROUBETZKOY

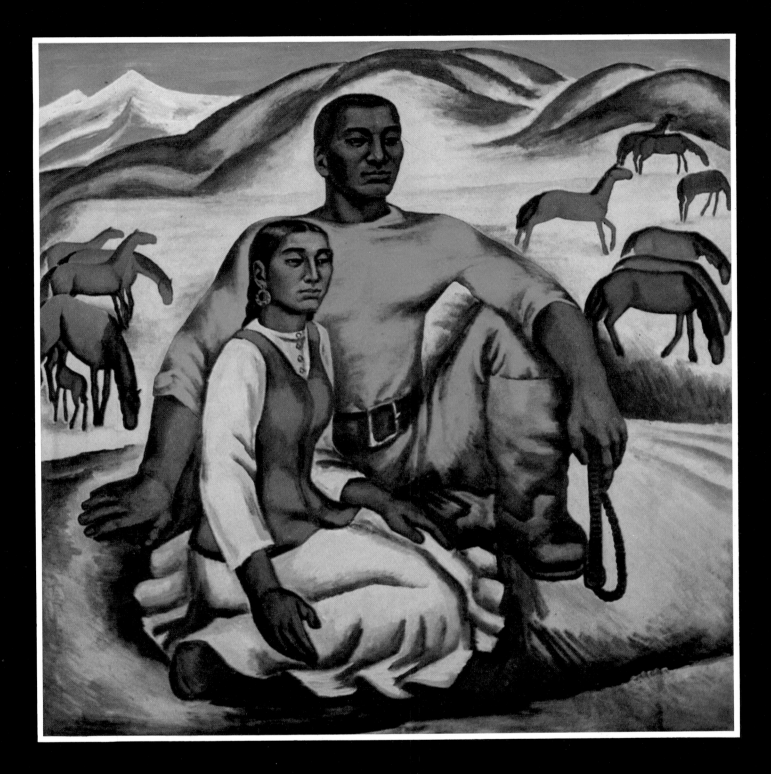

François Boucher (1703–1770)

WINTER

1755, oil on canvas, 22⅜ × 28¾"

Frick Collection, New York City

WHEN I'm in a light, romantic mood, I appreciate François Boucher almost more than any other master. It's always a delight to visit the Frick Collection in New York, and to see—among the other feasts for the eyes—the group of *Four Seasons*. The one shown here is "Winter", and it makes me dream even more than I usually do when I gaze on something especially exquisite.

I wonder: Is the pretty lady, who looks coquettishly at the artist, in love with the man who pushes her sleigh? Is she flirting with him, or just flirting with the idea of love? Is theirs an already consummated love? Perhaps it's a forbidden romance. Or did it happen, as Mr. Keats so hauntingly described it:

> *And they are gone: aye, ages long ago*
> *These lovers fled away into the storm.*

MERLE OBERON

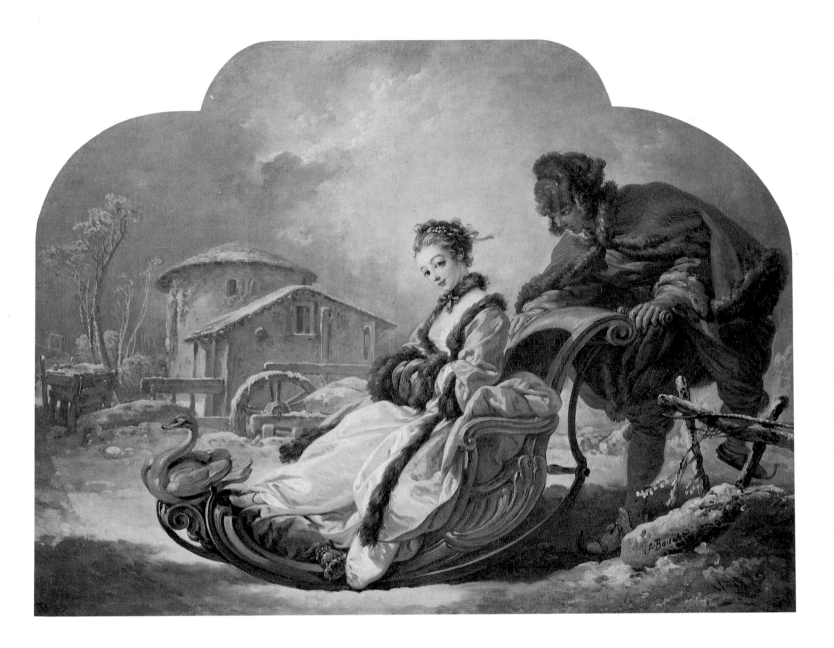

Constantin Brancusi (1876–1957)

THE KISS

1912, stone, height 23"

Philadelphia Museum of Art: the Louise and Walter Arensberg Collection

IN 1909, a thirteen-year-old Russian girl—Tanyusha Sashevakaya—committed suicide because she had fallen in love hopelessly too soon. Moved by her tragic story, Constantin Brancusi placed upon her grave in the Montparnasse cemetery the first cut-in-stone sculpture of *The kiss*.

The kiss is that rare masterpiece balanced on the razor's edge between opposite styles: the most primitive art and the most sophisticated. One form starts from simplicity; the other arrives at it.

The kiss is "love", in the same way that Brancusi's *The magic bird* is "flight". One asks: Has life the right to arise out of a block of stone? The rules of logic are against it. But Brancusi ignores and laughs at rules. He is a prophet speaking to eternity. *The kiss* achieves a noble simplicity in line and form, a dignity of infinite calm.

The kiss could be as big as a mountain or as small as a thimble. Brancusi takes us in a flight into a new reality, the truth of your heart, the counting of time . . .

JEAN NEGULESCO

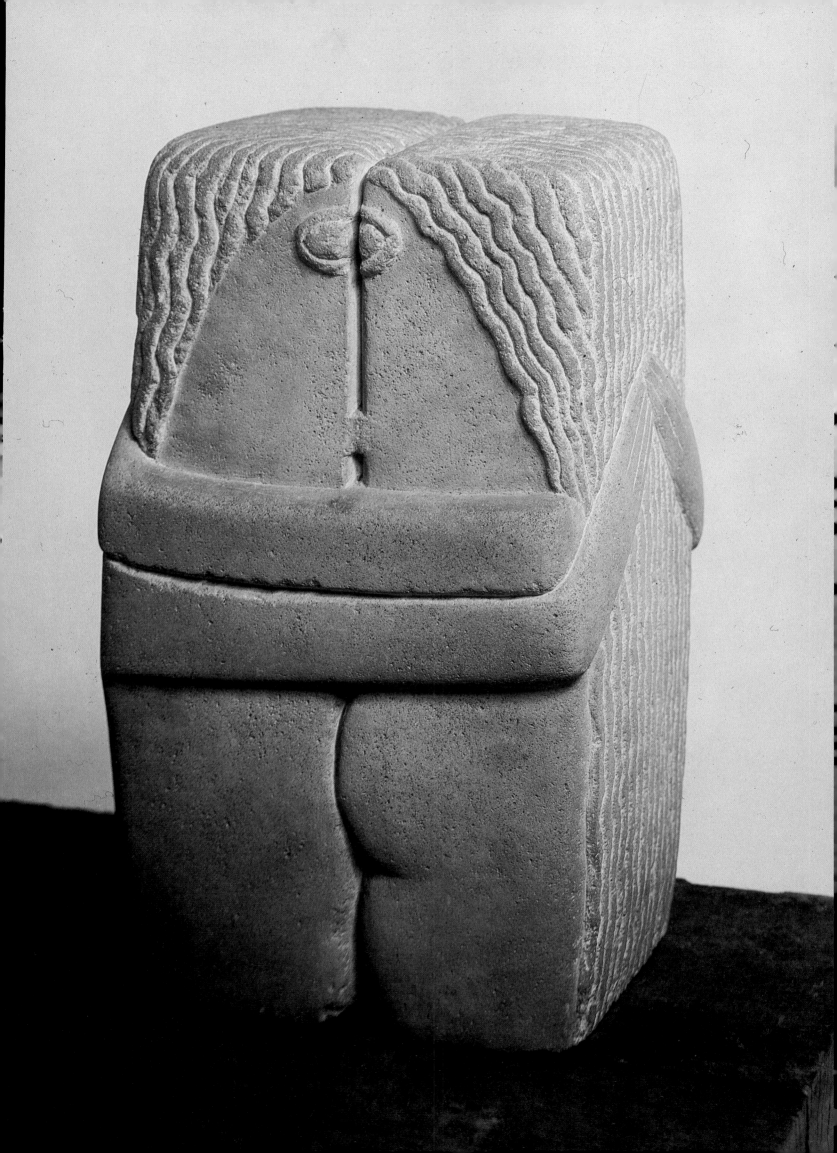

George Tooker (b. 1921)

LOVERS I

1959, egg tempera on pressed wood board, 17½ × 23¾"

Private collection, New York

THE poem which inspired this painting is by W. H. Auden: section XI of "Song for St. Cecelia's Day", from *The Collected Works of W. H. Auden,* which begins:

> *Lay your sleeping head, my love,*
> *Human on my faithless arm;*
> *Time and fevers burn away*
> *Individual beauty from*
> *Thoughtful children, and the grave*
> *Proves the child ephemeral:*
> *But in my arms till break of day*
> *Let the living creature lie,*
> *Mortal, guilty, but to me*
> *The entirely beautiful.*

GEORGE TOOKER

George Tooker

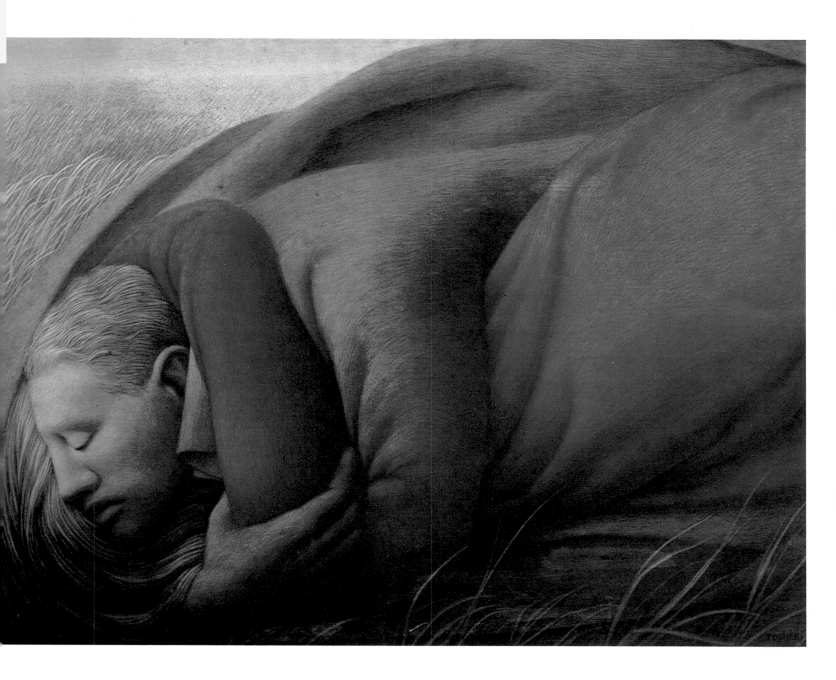

John Swope (1908–1979)

LAURENCE OLIVIER AND VIVIEN LEIGH IN *ROMEO AND JULIET*

1940, photograph, 3×4 Linhof camera with 90mm lens

Collection Vogue, Condé Nast, New York

EVERYONE loves a lover, especially when the two lovers are such beautiful and talented stars as Laurence Olivier and Vivien Leigh acting in one of the greatest romantic love stories of all time: *Romeo and Juliet*. Actually, it was not just a great love affair between two people; it was a triangle, because as surely as Olivier and Leigh were deeply in love, so was the theater public in love with them.

Naturally, I was somewhat in awe when I traveled to San Francisco to meet the challenge of capturing these two lovers on film. As I entered the darkened theater, they were already on stage and in costume. They made my assignment much easier than I had anticipated because of their immediate warmth and professional approach, responding easily to the few things I asked of them in order to get the best possible results.

When this photograph appeared in the June, 1940 issue of *Vogue* magazine, it captured, for me at least, the highly charged excitement of that afternoon in San Francisco. It was a gratifying experience and even today evokes fond memories.

JOHN SWOPE

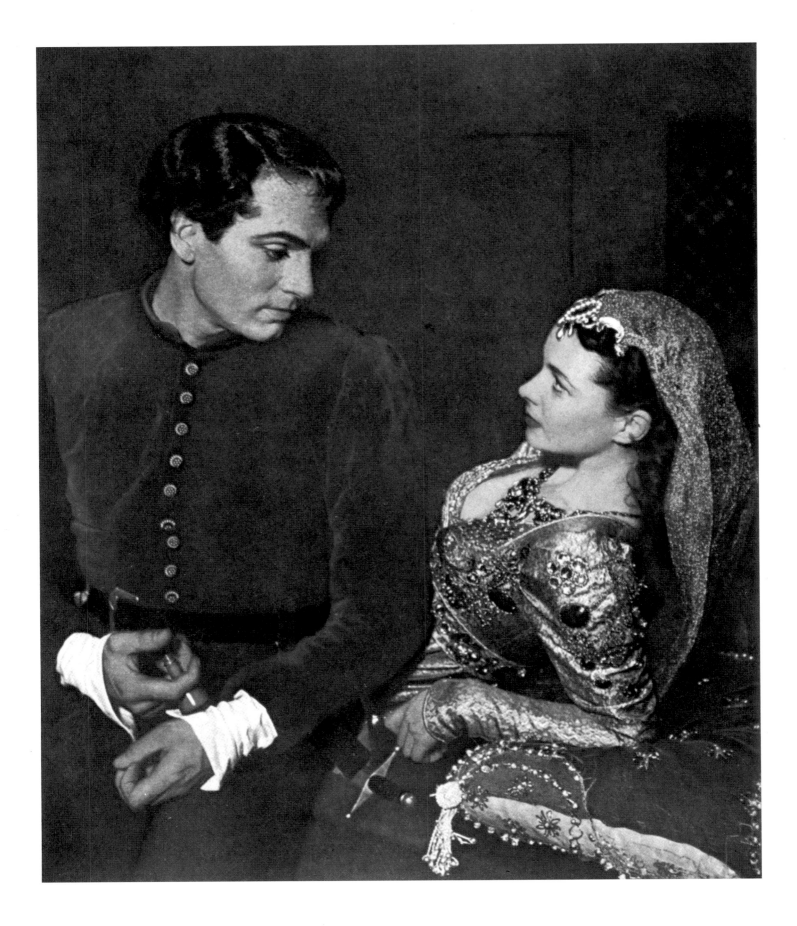

Jacques-Louis David (1748–1825)

CUPID AND PSYCHE

1817, oil on cavas, 72½ × 95⅛"

Cleveland Museum of Art, purchase, Leonard C. Hanna Jr. bequest

THIS painting now hangs in Cleveland but it was in the Louvre when I made my first visit there in 1936. I wasn't exactly ignorant of art, but I was totally unprepared for the overwhelming dramatic impact that first visit had on me.

I particularly remember rounding a corner and finding myself in front of the painting of *Cupid and Psyche* by Jacques-Louis David. It's a large picture, the figures nearly lifesize, and because of David's almost magic realism, you have the feeling you are there with the young lovers. It is impossible not to be envious of their youth, innocence, and joy at the same time you are enjoying their happiness.

Am I, maybe, just a little jealous of a god's life?

HENRY FONDA

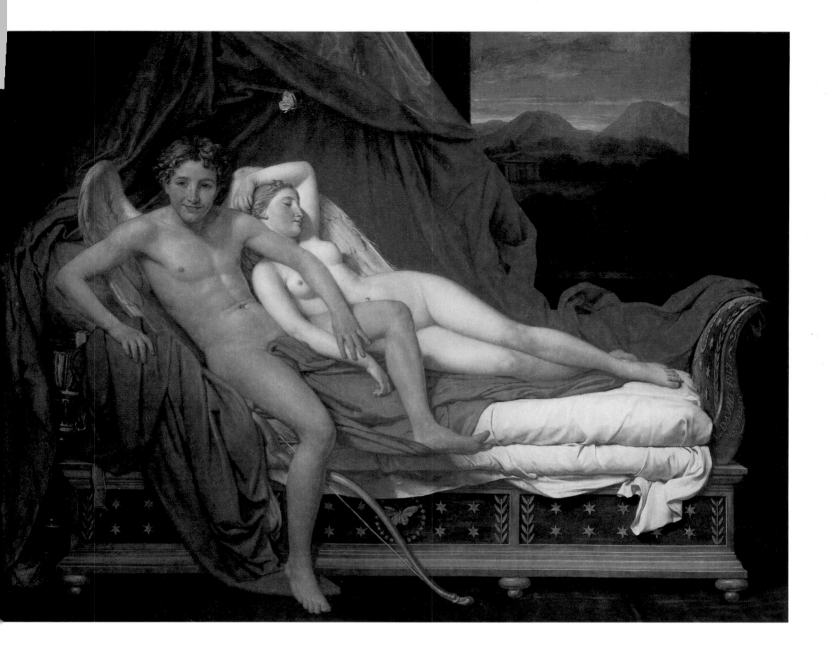

Francisco Goya (1746–1828)

THE DUCHESS OF ALBA

1797, oil on canvas, 82¾ × 58¾"

The Hispanic Society of America, New York

146

ALTHOUGH the relations between the Duchess of Alba and Goya have become legendary, it is impossible, today, to determine their true depth. The Duchess was a woman full of charm and vivacity. All who made her acquaintance, whether Spanish or foreigner, were in agreement on this. Her presence caused admiration even among children. Goya painted two large portraits of her, one in a white dress with a red sash, which is in Liria Palace, and another, wearing a black dress, which is the one we see here. The stiff formal character of the former, painted in 1795, contrasts with the fluid movement of the latter, painted in 1797. In both paintings the upper part of the figure is set against a clear sky with nothing to distract the attention from contemplation of the subject. These works have a common trait; in both, the Duchess's hand is pointing at the name of Goya. It is most interesting that her figure reappears in a great many of Goya's paintings and drawings, as if he had made of her an image of the eternal feminine ideal.

CAYETANA, DUCHESS OF ALBA

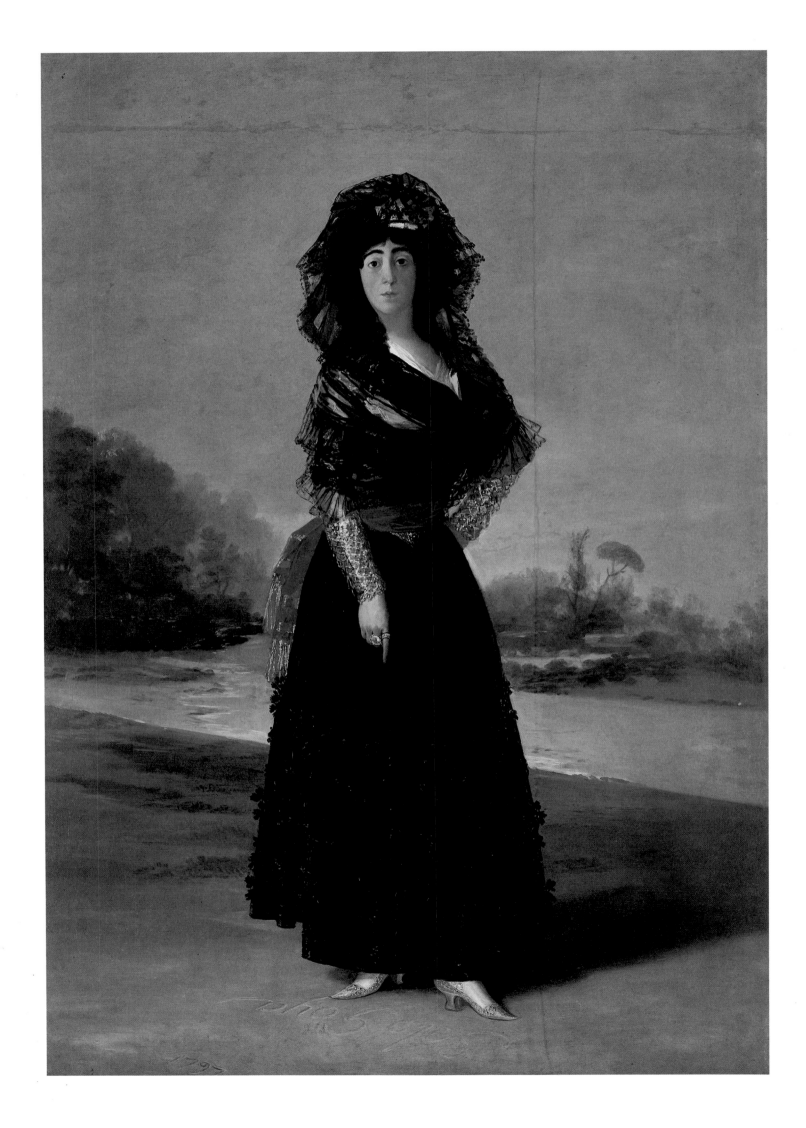

Anon.

EMBRACING TANTRIC DEITIES

15th cent. (Nepal), silver with polychrome, height 5"

Doris Wiener Gallery, New York

INDIA has been called the land of lovers, but love with a difference; though evocatively erotic, it remains innocent, which sounds paradoxical but is true. It would not occur to any Indian to link sex with sin or shame; sex, the love-act, is as holy as life, and the female "yoni" (a round hole) and the "lingam" or phallus that fits it, are found carved in temples everywhere. It is we Westerners who have taken books of the highest Hindu mystical teaching, like the *Chandyoga Upanishad* and more widely known *Kama Sutra*, and made them pornography. To an Indian there is no such thing; there are orgies of course, debauchings, and these, too, are unashamed. Yet, paradoxically again, to an Indian man or woman, their love-making is intensely private. Oriental lovers do not embrace, or even touch each other in public—and, until recently, even in films the hero and heroine did not kiss. Maithuna—union— is the holiest of acts, but this does not prevent it being fun, warm, and tender. In fact, in India, love seems to excel in something that is almost gone from Western sex life, and that is dalliance, love play, provocative teasing. This can be seen in the frank and tender statues of temples and holy places, figures embracing, not lewdly but in attitudes so vibrant with life and sensuality that their very stone or the precious metal in which they are carved or molded seem to quiver, as in this little silver pair of lover-gods from Nepal.

Here, uncommonly, the female is the larger, the one in power, probably because, though the image is Tantric, she is a manifestation of the Great Goddess. In Hindu thought, the Goddess is the source of energy—shakti—as are all women. She is the real power, which does not mean she cannot be shy:

> *When his mouth faced my mouth, I turned aside*
> *And steadfastly gazed only at the ground;*
> *I stopped my ears, when at each coaxing word*
> *They tingled more; I used both hands to hide*
> *My blushing, sweating cheeks. Indeed I tried,*
> *But oh, what could I do, then, when I found*
> *My bodice splitting of its own accord?*

This poem is from the Sanskrit *Amaru* collection, fifth or sixth century, but its delicate eroticism could have been written today. We in the West turn increasingly to India for wisdom in religion and philosophy. She could also teach us a great deal about the art of love.

RUMER GODDEN

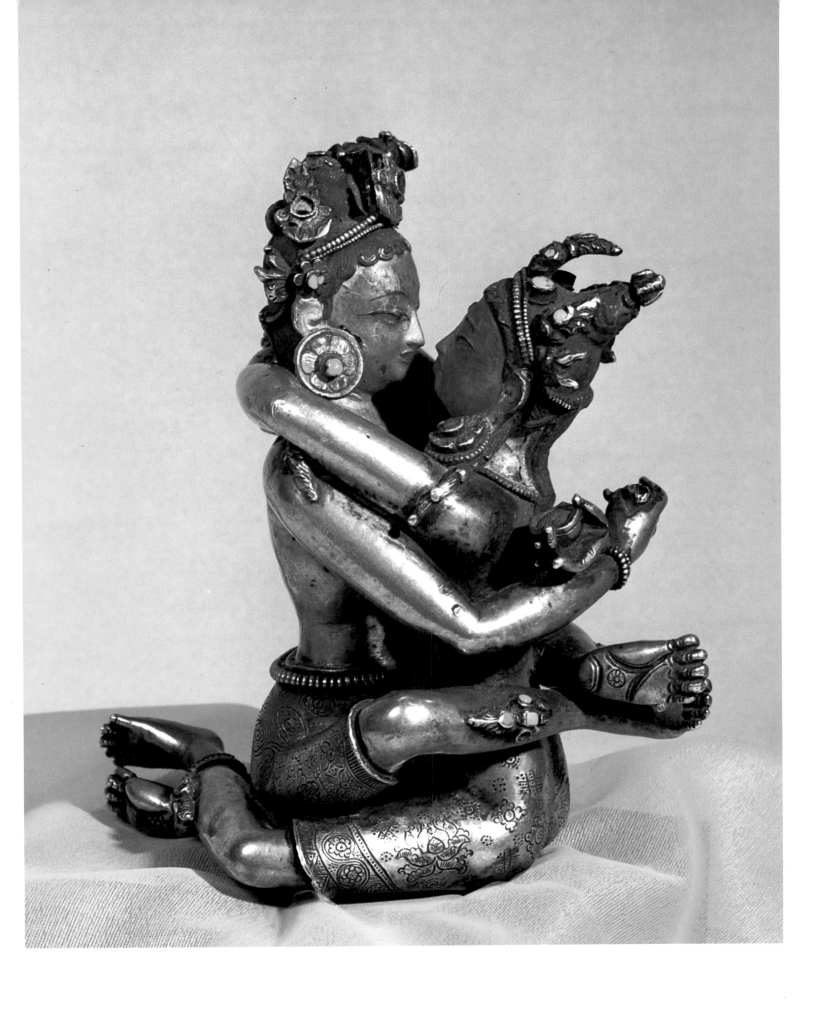

Claude Emile Schuffenecker (1851–1934)

THE RENDEZVOUS

1884, oil on canvas, 22½ × 18"

Private collection

THIS picture was painted almost a hundred years ago, but it could have been done yesterday. The youthful emotions and feelings the artist has caught are timeless. The scene is universal. It could just as easily have taken place in France, where indeed it did, as in an ice cream parlor in America, or any meeting place of young lovers anywhere.

Here are dreams and plans exchanged, promises made. Infinite possibilities are felt, with most of life still to unfold. Surely Claude Emile Schuffenecker, only 33 when he painted the picture, understood well the tender yet vibrant feelings of the boy and girl in this scene when he bathed the romantic encounter in the soft light of impressionism.

Not as well known now as are his contempories Gaugin, Pissaro, and Seurat, Schuffenecker was closely associated with, and respected by, them and many other impressionist and post-impressionist masters. It is interesting to learn that it was he who persuaded Gaugin to leave his office job and devote himself to painting.

It is almost impossible to look at this beautiful painting without falling under the spell of these two young lovers. Those who have never experienced such feelings long to, and those who have—remember.

MARY MARTIN

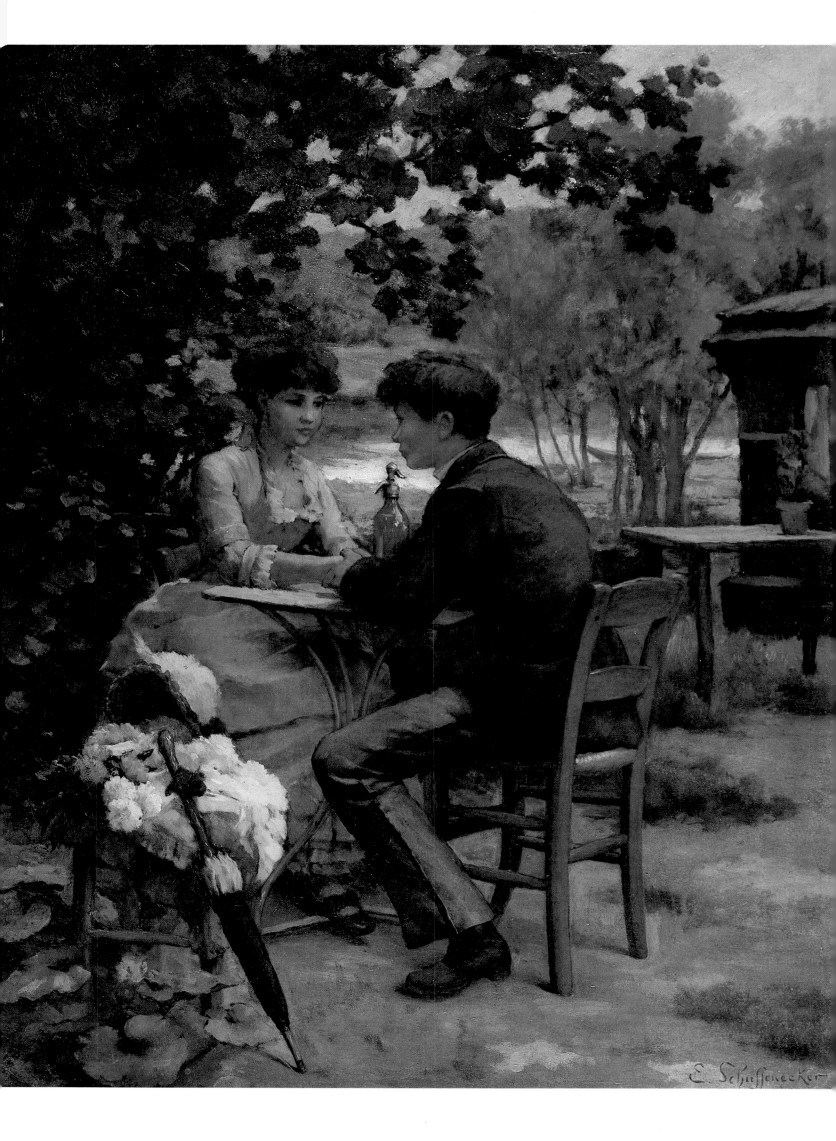

François Gérard (1770–1837)

NAPOLEON

1805, oil on canvas, 87¾ × 56¼"

Versailles, Musée du Chateau

JOSEPHINE

1807, oil on canvas, 84⅝ × 63"

Chateau Fontainbleau

152

NAPOLEON has always been a figure of romance as well as history. The insatiable French Emperor cultivated an image combining pomp, elegance, and power, not unlike the image-promotion of current film stars. The powerful figures of that era used painters instead of films to create the proper image—see the refined and haughty aristocrats embodied in Gérard's portraits of Napoleon and his lover, Josephine. Josephine herself, of course, is an important element of Buonaparte's image, for his ardent letters to her during the Italian campaign reveal the depths of a lover's passion, mitigating somewhat his reputation for a voracious and bloodthirsty lust for personal power.

At any rate, no traces of the sitters' personal foibles are visible in their official state portraits by the court painter. Both Napoleon and Josephine are represented in carefully calculated poses, attired in the finest Empire fashions. Ironically, it was just this sort of excessive display of splendor that provoked the proletarian outrage that was a major contributing factor to the French Revolution. And ironically, too, Josephine, Napoleon's first great love, was eventually cast aside for her failure to bear her husband a son and heir, while her former husband was to end his life in exile.

LOUIS JOURDAN

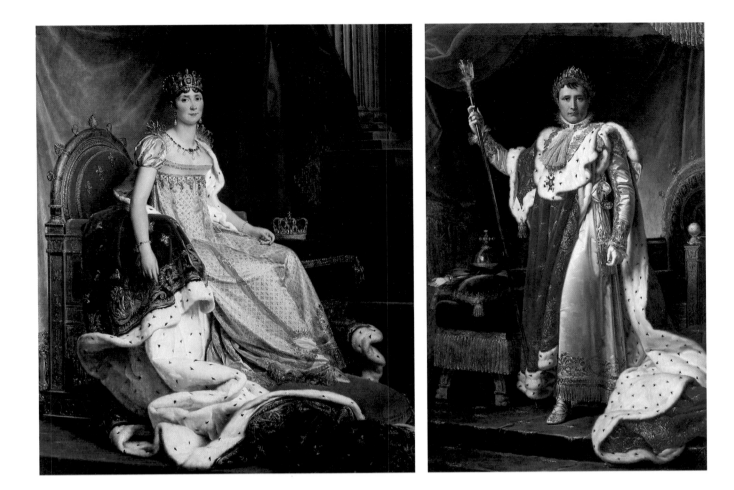

Jean-Honoré Fragonard (1732–1806)

THE LOCK

1790, oil on canvas, 13×9½"

Louvre, Paris

WHEN my great-great grandfather, Jean-Honoré Fragonard, painted *Le verrou (The lock),* he was at the height of his superb talent. In this painting one can find the *élan* and the vigorous sense of life and movement that characterize him. I like the simplicity of composition and the light, both warm and vaporous, that show off so well the extraordinary dance step of this couple clasped in each other's arms. There is a vibrant aura of sensuality about the scene; the haste of the virile young man to push shut the lock, the abandon (still only half consent) of the girl, the promising softness of the bed: right down to the little apple, symbol of temptation. Everything helps us to imagine clearly the scene that will follow.

There is in the painting a feeling not only for the impulse of the bodies, but also for the impulse of hearts: a fine balance between sensuality and poetry.

Curiously, all trace of this "Verrou" was lost for nearly two centuries, until, in 1974, one of the big Paris dealers offered it to the Louvre. The price was so high that the museum could not afford to buy it. It was then that Monsieur Giscard d'Estaing, who was Finance Minister at the time, feeling that this masterpiece by Fragonard should be in the Louvre, made available the big loan enabling the museum to acquire *Le verrou.*

COUNTESS DE VOGÜÉ

Catherine de Vogüé

Auguste Renoir (1841–1919)

THE LOVERS

N.D. oil on canvas, 69¼ × 51⅛"

National Galerie, Prague

156

WHEN is the moment of falling in love? How deep must the look go, before the answering look rises to meet it, swept upward from the heart like a bird or a current? Which is the moment of seeing, when what was known before turns strange, and what was strange is strange no longer, but recalled as though from a dream? What sudden glance or silence, what lifted hand or piteous look, fragrance, light upon flesh, unspoken promise, knocks on the door of memory, lights the warm lamp of seeing, opens to hunger again, to the Thou-art-mine of the spirit, the I-am-thine of the heart? No one can say; there is no rule, there is no history. It comes in silence; the moment is full of doubt and wonder.

<div align="right">—The Enchanted Voyage</div>

Is it indeed your voice that whispers here,
Or my heart's own? For I have heard this said
In music most, or in the soundless, clear
Meadows of night by beauty visited.
Are these your words by which my mind is fed,
Or did I speak them? Love, I do not know;
They are my spirit's honey and its bread—
Take them for yours, since you have made them so.
Let our two hearts, though dust of different earth,
Linked in one likeness since the world began,
Speak with a single voice; for what are worth
Laughter and tears and all the life of man,
But this?—That two who love shall be as one,
Till life and death and time itself are done.

<div align="right">—The Green Leaf</div>

ROBERT NATHAN

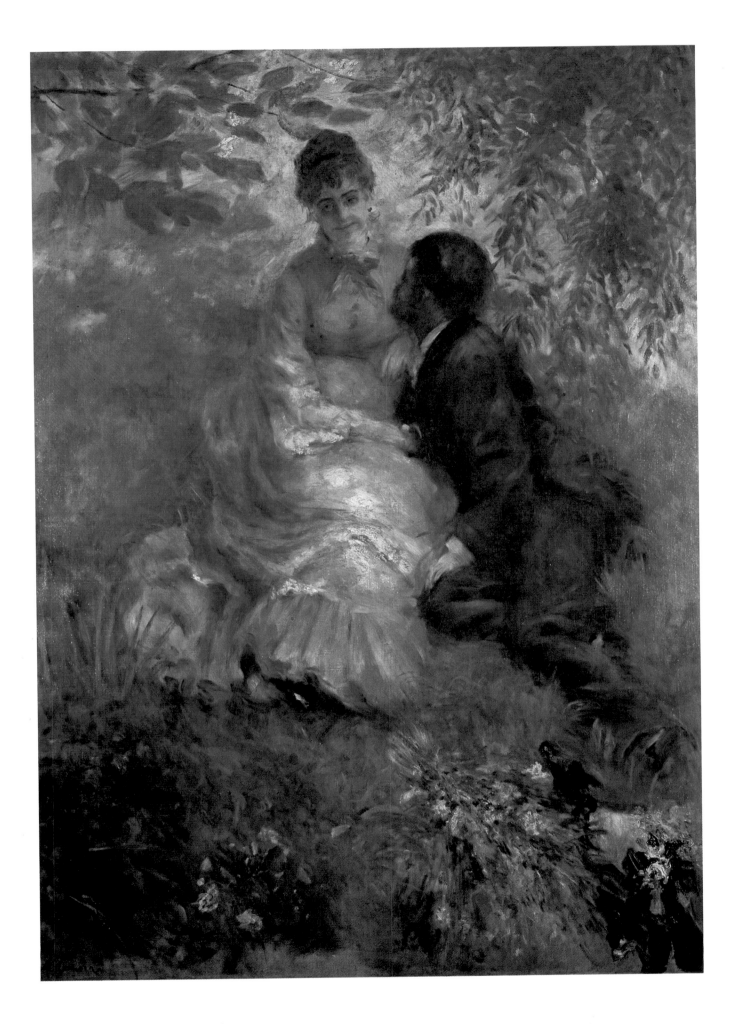

Anon.

MEETING OF JOACHIM AND ANNE AT THE GOLDEN GATE

c. 1525 (German), lime wood relief, polychrome and gilding, 38¼ × 32"

Passau, Germany

MUCH has been written in every age and language, in poetry and prose, to celebrate young love. Thought and praise have rarely been given to that beautiful love of older persons for one another, that deep and lasting love which makes lovers friends and friends lovers.

Young love is like a seed planted in the ground of desire; older love is the tree, glorious in its full growth. It is the same seed, but now in a new and more splendid form, brought to maturity with time and loving care.

Does not every lover pledge eternal love and faithfulness in the first blossoming of love? Does not every lover yearn to be together forever with the beloved, to see his love become confident and trusting, powerful and patient, serene, forgiving, and everlasting?

Conjugal love is the most sublime of human acts, a real collaboration with the Divine. There, in that moment of ecstasy and total surrender, Creator and created meet in the onward thrust of creation. How true this was when Joachim and Anne were united at the Golden Gate. From their union issued Mary, the Virgin, the mother of the Son of Man.

Across the ages this love of Joachim and Anne shows itself enduring, creative, imitable, a model and inspiration for everyone who has ever loved. Every lover longs to meet the beloved at the Golden Gate.

DANIEL O'KEEFE BROWNING

Daniel O'Keefe Browning

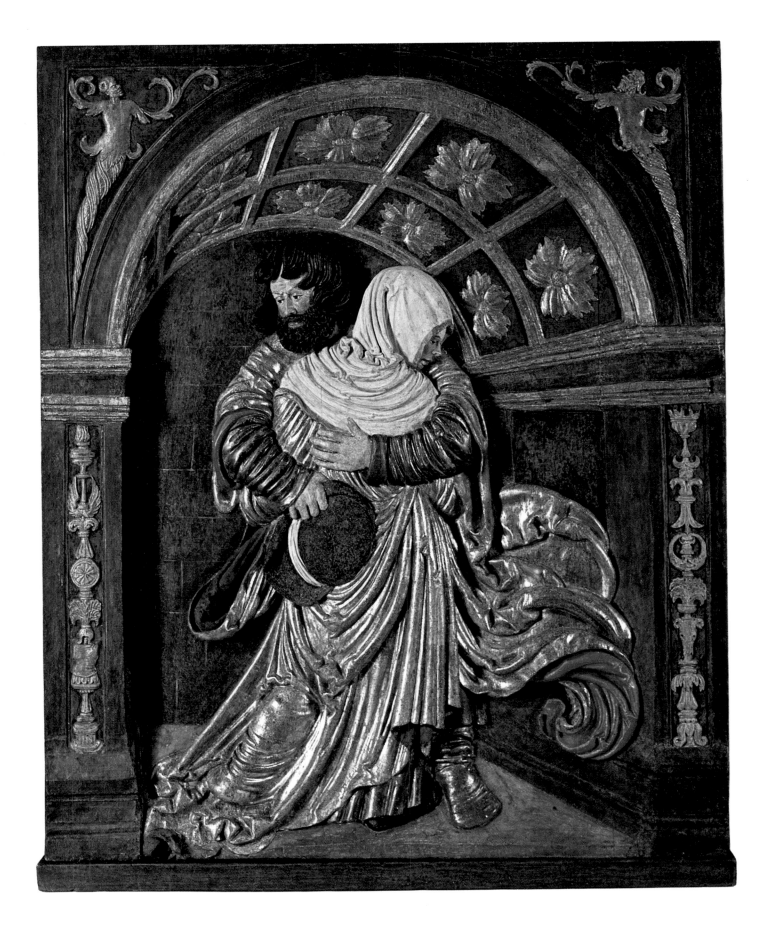

Marie Laurencin (1885–1956)

THE KISS

1927, oil on canvas, 31×24¾"

Private collection, London

THOUGH Marie Laurencin had been beloved by the poet Guillaume Apollinaire and was married for a while to a German, her paintings betray a distinct preference for her own sex which cannot have been purely aesthetic. Her mother, as Gertrude Stein has related, "had always had it in her nature to dislike men" after living as the mistress of Marie's father, and Marie dared not introduce Apollinaire to her until she was about to die. Mother and daughter shared an apartment, and they lived as in a convent, "acting toward each other exactly as a young nun with an older one". And when, against friendly advice, she got married, Marie explained that her husband was "the only one who can give me a feeling of my mother".

Marie Laurencin was as intensely feminine a painter as Colette was a writer: neither would have cared to be mistaken for a male artist. The delicate gradation of Laurencin's colors, the graceful choreography of her compositions, which seem to flutter and dance before our vision, are totally feminine, yet as free from sentimentality as from frivolity. Lightly clad in rose pink and silvery-gray chiffon, her slender nymphs leap through fairy landscapes like the figures she designed for *Les Biches* (signifying both a female deer and a flapper), a ballet with music by Poulenc epitomizing the elegance of Parisian taste in the 1920's.

The kiss evokes Proust's *À l'ombre des jeunes filles en fleurs* (translated by Scott-Moncrieff as *Within a Budding Grove*) and the blossoming girls who filled the narrator with such sweet anguish. It portrays a feminine courtship. The gentle approach of one girl's lips to the cheek of her dreamy friend has the spontaneity of true tenderness. Their fresh naïveté has an idyllic quality reminiscent of Sappho. But one cannot imagine them studying Greek or joining a feminist league. They are essentially Gallic: "Deux pigeons s'aimaient d'amour tendre."

SIR HAROLD ACTON

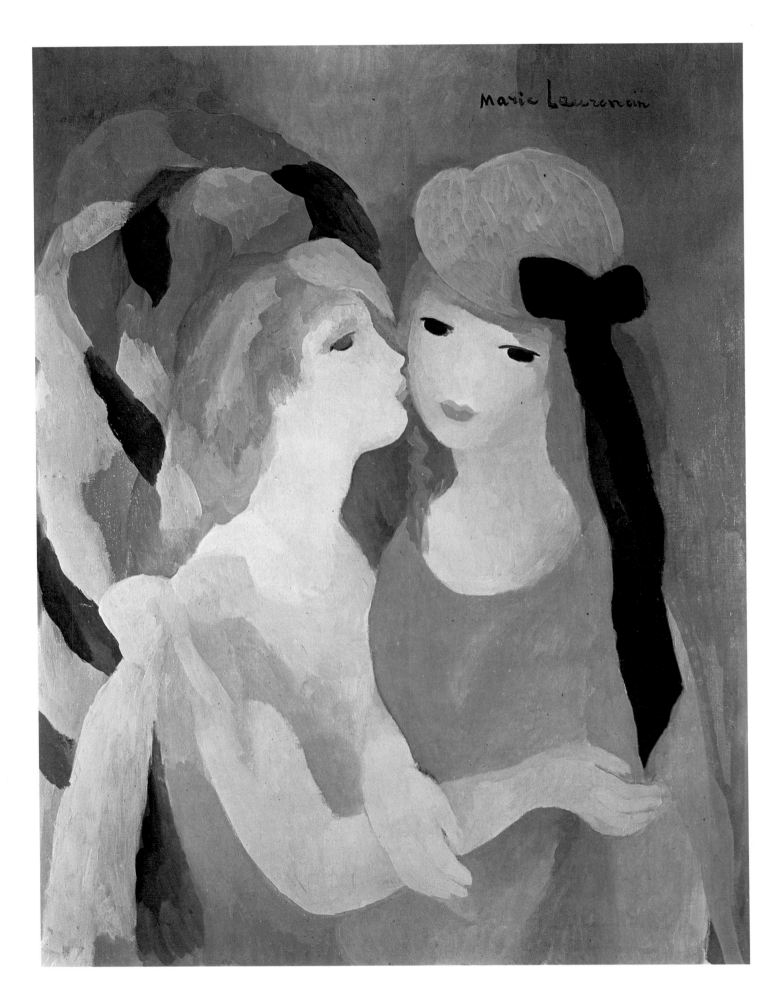

George Romney (1734–1802) L. F. Abbott (1758–1805)

LADY HAMILTON AS NATURE HORATIO NELSON

1782, oil on canvas, 29⅞ × 24¾" ca. 1798, oil on canvas, 29½ × 24½"

Frick Collection, New York The National Portrait Gallery, London

To ANYONE walking around the Naples shore where, under high cliffs, hotels end and a tumble of houses begins, a scarcely visible winding path may appear as it climbs the steepness. First lost among the houses and then in the brushwood of the cliff, this was the route by which Horatio, Lord Nelson, the young Mediterranean commander, would leave his frigate anchored in the darkness below, to climb to the royal palace and his Emma.

England at that time was entering the century of propriety: Southey, Nelson's first and most devoted biographer, evidently had difficulty in combining Lady Hamilton with his hero. But what is most noticeable in an affair that carries our emotions with it to this day is the fact that no amount of general respectability, no kindness even toward poor Lady Nelson left to suffer, no finger pointed at Emma's unedifying end, has been able to dim the enthusiasm of our Victorian "nation of shopkeepers" for this most romantic of national heroes, who was carried into his love with the same completeness and passion that carried him to battle.

It is interesting to see how, even in the most respectable of eras, respectability goes under when the true pagan god appears. His feeble derivatives, encumbering our civilizations, are forgotten.

DAME FREYA STARK

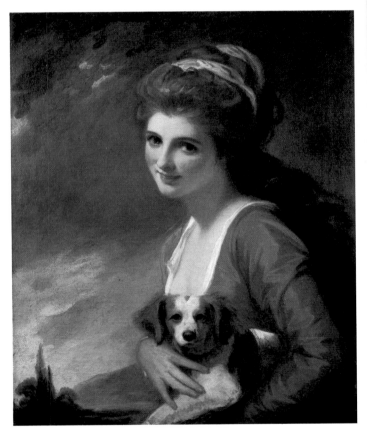

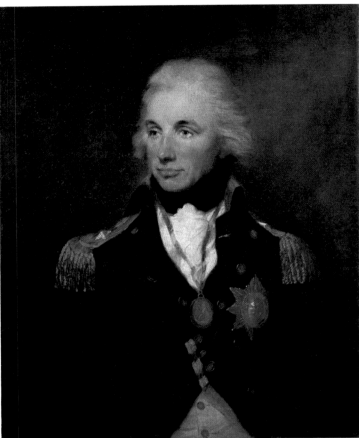

Sandro Botticelli (1445–1510)

THE BIRTH OF VENUS: Detail

1482, tempera on canvas

Uffizi, Florence

ONCE in an optometrist's shop I met a very young hang-glider who wanted to purchase a pair of binoculars so that he might "see the wind".

Here, in Botticelli's young lovers, you "see the wind":

Youthful, playful winds that soar
The heavens, tease the waves, tumble
Down mountains, race across the
Earth-embracing trees, scattering
Seeds and pollen, leaves and
Flowers—winds of love.

Here the lovers are attendant at the birth of Venus:

Goddess, we welcome you, and invest
you with the sweet winds of love—
unseen—all around and everywhere.

DOROTHY McGUIRE

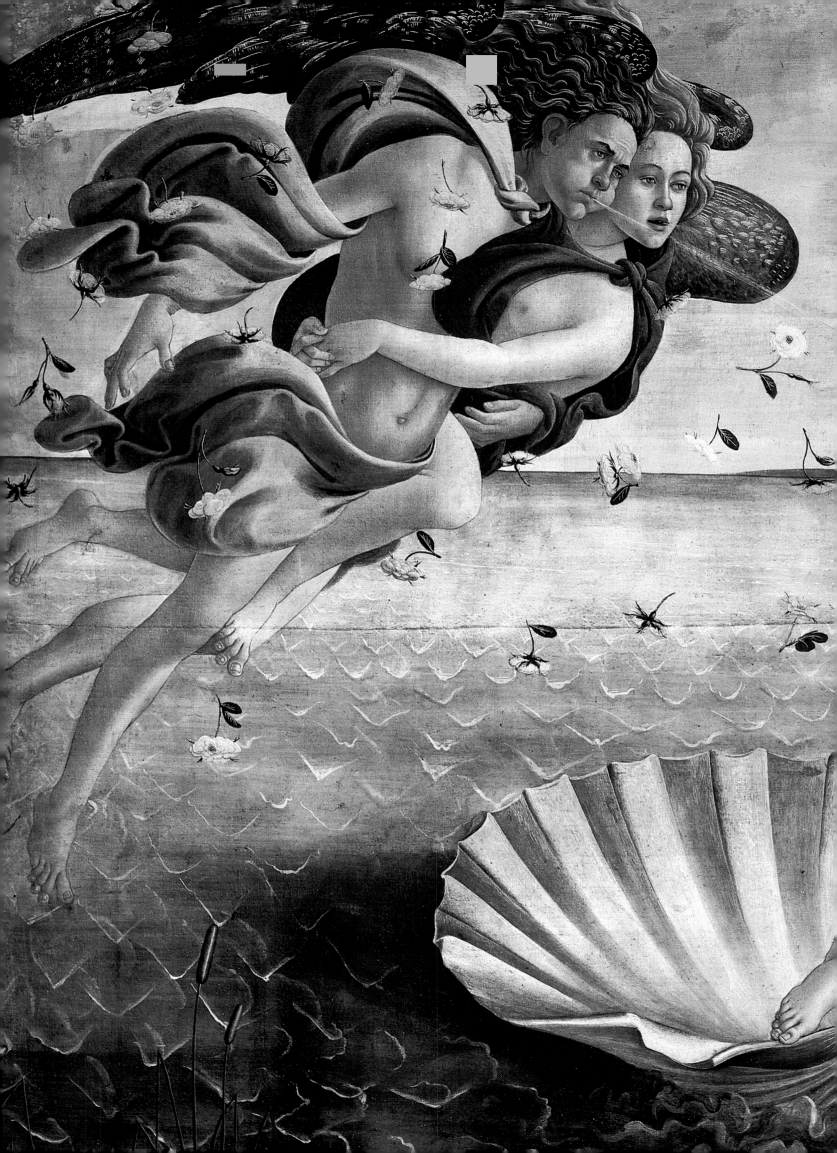

Vicente Palmaroli (1834–1896)

CONFESSIONS

1883, oil on wood, 64×24¾"

Prado, Madrid

IN A handsome classical building serving as annex to the Prado is the Museo del Prado Arte Espanol del Digli XIX, facing a charming little square. It is not to be missed. The entrance is impressive, and one is immediately carried from room to room on a wave of light and sun.

I wandered in wonder—history, romance, nature, poetry in all its aspects opened up to me as I spent a rainy afternoon in this radiant atmosphere. Eventually, I came upon the Salon Pintura de Historia, where nine marvelous works of art appear. One of these is an unexpected gem by Vicente Palmaroli Gonzalez. Palmaroli painted his *Confessions* at a time of transition, when artists began working out of doors and were greatly affected by light and atmosphere in nature.

The mood is not grandiose but rather down to earth. The young girl sitting in a high straw beach chair is dressed in clothes of the period. The sky blue of her silk skirt and the detail of the lace trimmings (on her dress and on the top of the straw beach chair) is quite remarkable, while her black gloves provide striking contrast. Remarkable, too, is the attention Palmaroli gives to the crisp straw of the chairs, the shimmering light on the water, and the transition of wet to dry sand. The girl has a pensive air; she is listening to what could be her lover's "confessions" of his innermost feelings.

He is eager, perched nervously on a beach stool, smiling slightly and grasping a silver-topped cane in his hand. He has thrown his coat onto the sand. One might imagine a day of wind with the straw chair in the bottom left corner toppled over, and in the background the sea with its whitecaps. There is a feeling of movement in each of the figures, yet both are seated. It is obvious that these two sentimental figures must be lovers.

FRANCESCA BRAGGIOTTI LODGE

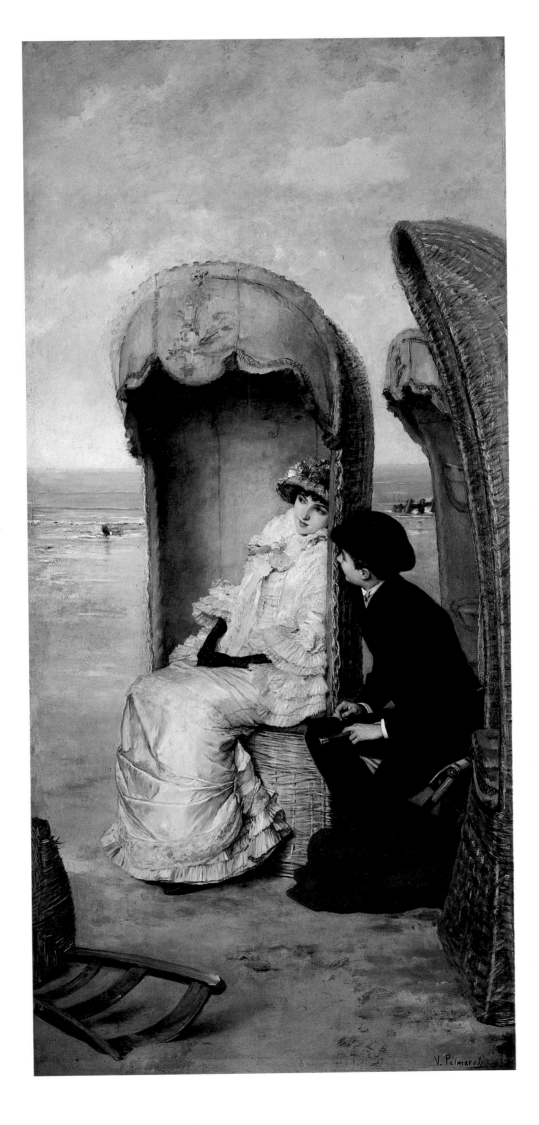

Emil Nolde (1867–1956)

LOVERS

1932, watercolor, 13¼ × 19½″

Collection Margaret Mallory, Santa Barbara

THE magnetic intensity of these *Lovers* gives us an insight into Nolde's private world.

A lonely, melancholy artist, Nolde was a peasant from Schleswig-Holstein on the North Sea, a region of windswept cloud-laden saltmarshes, suddenly illuminated by blazing sunsets. His images were born out of a storm of color, burning, ecstatic, and mystical; and through his concentration on watercolor, he became one of the leading masters of the twentieth century.

During the thirties he created a series of fantasy couples: a monkey and witch; old men and young girls; dark men and beautiful blondes. In the *Lovers,* a self-portrait with his wife, the dark, brooding artist and the quiet, blond Ada are psychologically arresting. The intense inner pull of the sexes possesses a visionary quality that transcends physical reality.

In his desire to express inner truth, Nolde, then sixty-five, portrays himself and Ada as the *Lovers* of their youth. The feverish haste with which Nolde achieved this painting was typical of his approach to art. He believed that a work should be created in one sitting to capture the immediate inspiration.

In 1932, the dejected and impecunious artist and his wife stayed in Berlin with Professor Iso Brante Schweide. Professor Schweide wrote in 1957:

> This watercolor of dramatically conceived figures was created during one night. Nolde suddenly jumped from bed. . . . [He] rushed to the studios to express a vision which symbolized the love of his own happiness. Ada was amazed and told me in his presence that Emil worked as though obsessed and refused to eat until the picture was finished. He then took a deep breath and said, "This is our best portrait of our superior being".

MARGARET MALLORY

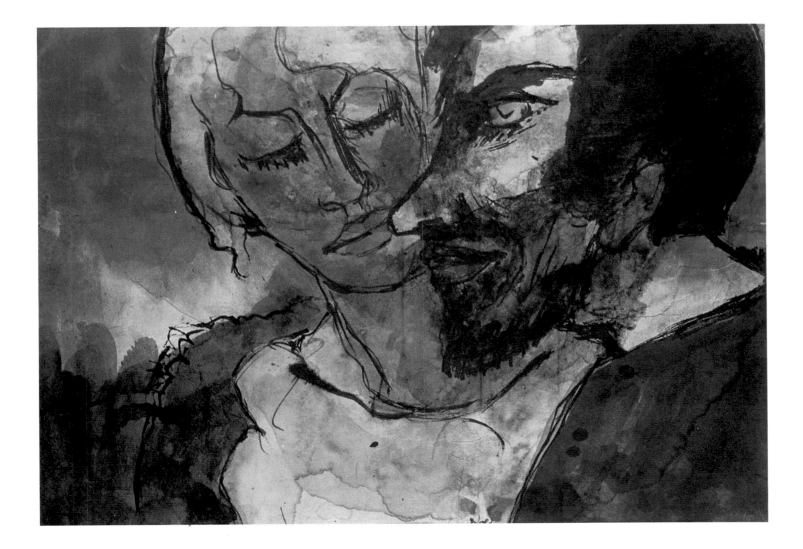

Anon.

LOVING COUPLE

1300–1000 B.C. (Olmec), terracotta, height 8½"

National Museum of Anthropology and History, Mexico

170

And let me touch your little breasts that swell
with joy remembered where, kisses fell.

GEORGE SYLVESTER VIERECK

Over three thousand years ago, in the middle "pre-classic horizon" period in Mexico, an Olmec artist created these lovers out of polychromed terracotta. He selected an eternal theme—the physical love of a man for a woman. Probably from memory, but possibly using actual models, he recreated an ecstatic male caressing the breast of his mate.

These nude figures were found in the ancient Tlatilco (Place-where-things-are-hidden) area near Mexico City. The style of the facial features of both male and female leads to interesting conjectures. One group of anthropologists thinks that the broad turned-down mouth with its feline appearance (sometimes called tiger face) and the elongated heads relate to the jaguar totem. But others, myself included, believe that these people, like the American Indians, were descended from an early race that migrated to North America from Asia. If so, it is understandable that these ancient lovers would have Asian features.

Although this piece appears roughly made to modern Western eyes, this is not the work of a primitive artist. The sculpture is conceived with deliberate rhythm and form and without accidental effects: it is indeed an image of timeless love.

BRADLEY SMITH

Bradley Smith

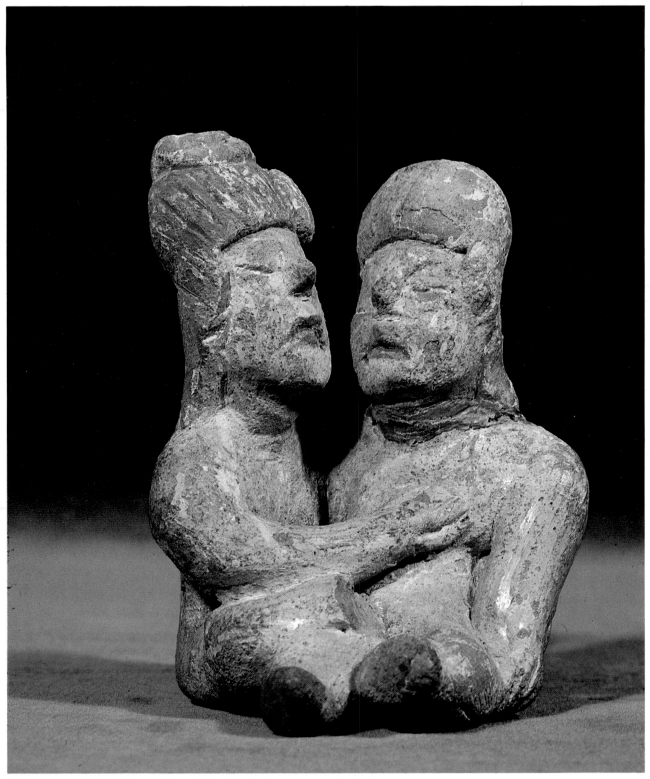

Edward Burne-Jones (1833–1898)

DEPTHS OF THE SEA

1887, watercolor and gouache on paper attached to panel, 77×30"

Fogg Art Museum, Harvard University, Grenville L. Winthrop Bequest

IN 1849, Matthew Arnold published *The Forsaken Merman,* and in 1887 Burne-Jones painted this marvelous watercolor. As so many of his pictures have literary references, may we not presume that he took his title from these lines of Arnold: "Down, down, down/ Down to the depths of the sea"? Of course, the picture is the reverse of the poem, in which a mortal lady abandons her merman in his cavern under the sea and returns to her village on the land. Burne-Jones shows us a mermaid pulling her lover down to the depths of the sea, not caring or not knowing that she is drowning him as she does so. It is a macabre picture, which is unusual for Burne-Jones, as is the mermaids's enigmatic smile. The typical Burne-Jones figure is languid, wistful, and almost always slightly melancholy. Our mermaid is very pleased with her catch. Perhaps it is the sense of eternal triumph we see in her smile. Surely she is the sea itself and will in the end triumph over man's love.

Yeats, the great Irish poet, must have seen this picture:

> *A mermaid found a swimming lad,*
> *Picked him for her own,*
> *Pressed his body to her body,*
> *Laughed; and plunging down*
> *Forgot in cruel happiness*
> *That even lovers drown.*

JANE WYATT

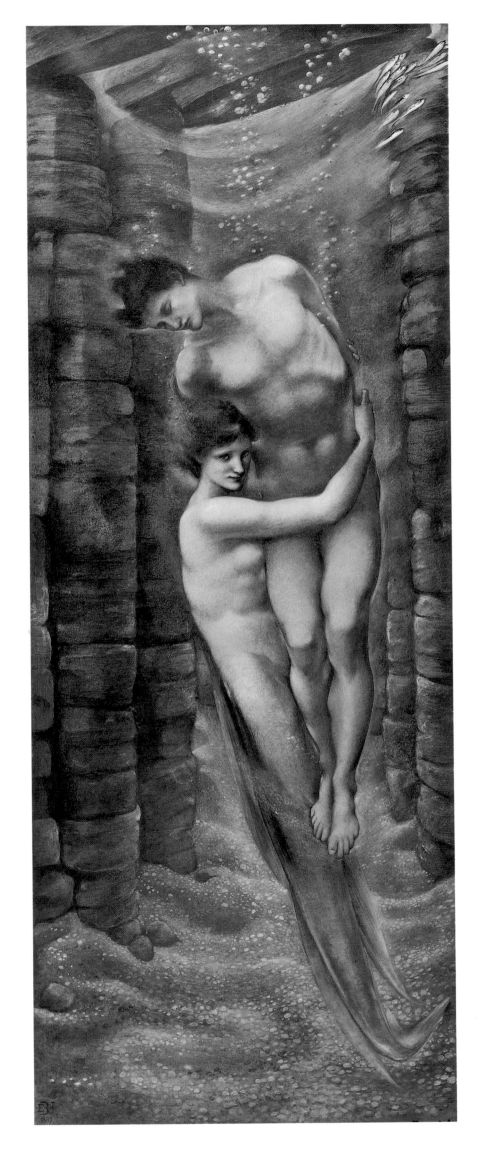

Peter Paul Rubens (1577–1640)

RUBENS AND ISABELLA BRANT IN THE HONEYSUCKLE ARBOR

1609–10, oil on canvas, 70×53½"

Alte Pinakothek, Munich

THE lovers in this picture epitomize a time and a way of life of extraordinary extravagance—their superb clothes are gloriously painted, intricately detailed, and demonstrative of the sheer impracticality but rare beauty of the clothes of that age. The skill of Rubens' technique in painting brocade, silk taffeta, lace, and embroidery is tested here to the utmost and is a joy to behold.

I find humorous and delightful the mad shoes of the man and his very amusing tasseled garters, clasped tightly below the knee. In today's world of jeans, fast action, and laxness, it is sheer paradise to look back at Rubens' wedding picture with his first wife and feel the sense of timelessness, observe the richness of the costumes, the extraordinary care of one's person that are apparent here.

The composure of this tranquil couple is expressed in the way their hands rest gently, one upon the other. The peace of that simple gesture speaks volumes.

Rubens's faces are believable and ageless. There is a quiet happiness in this beautifully executed painting, projecting the sense of security and self-assurance born of true love.

ROBIN CHANDLER DUKE

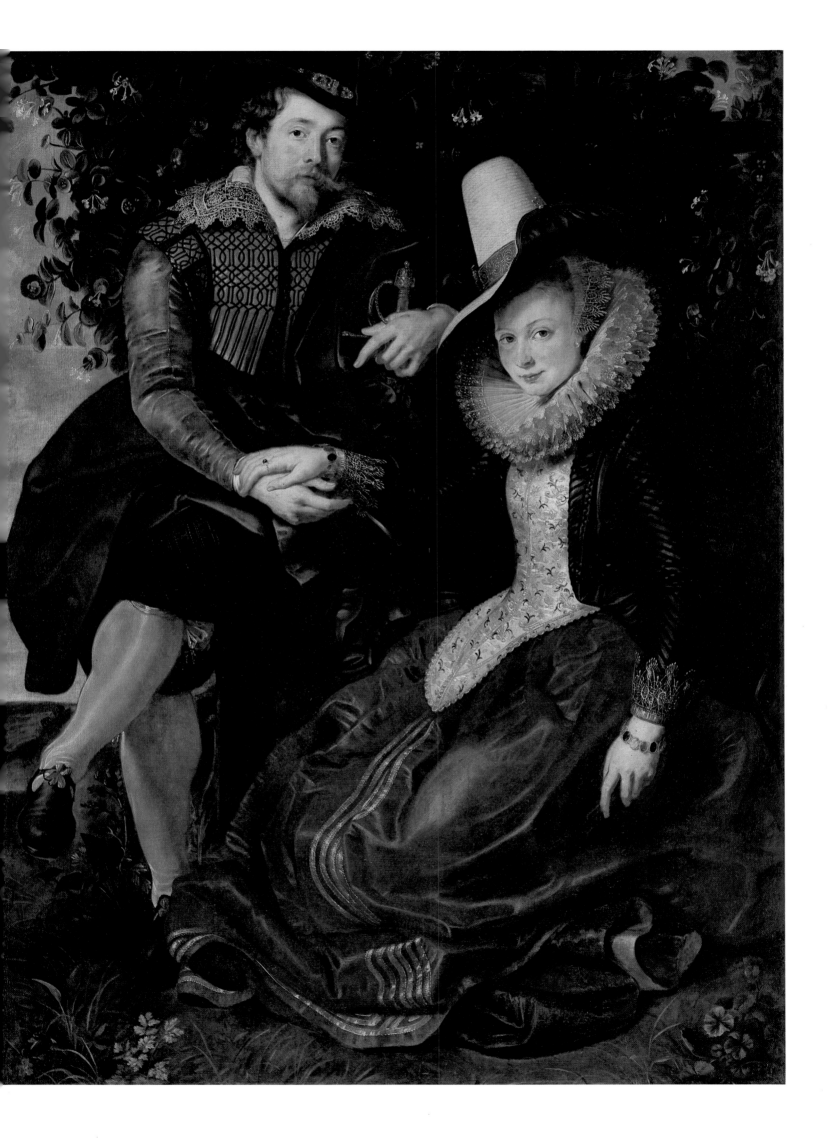

Edvard Munch (1863–1944)

MAN AND WOMAN IN THE FOREST

1903, oil on canvas, 68×56"

Munch Museum, Oslo

BORN in Oslo, I have always known Norwegians to be the most passionate, erotic romantics. Our long dark winter nights and our equally endless summer days each contribute to an intense, virile nature; my favorite romance as a young girl was *Sins in the summer sun.*

I asked many of my Norwegian friends, ranging from His Majesty King Olav V to an Oslo cabdriver, which work of art seemed to them the Norwegian epitome of love. Almost as one their opinion was Edvard Munch's *The kiss.* An artist who entitled his paintings *Fear, The scream,* and *Sickroom* could, at the same time, depict both the beauties of our country and the ardor of our natures.

On leaving the museum in Oslo where I had gone to see *The kiss,* I came upon *Man and woman in the forest* in the foyer. Twenty thousand words could not better illustrate strength and sensuality. First exhibited in Leipzig in 1903, in the opinion of the curator of the Munch Museum it might have been repainted in 1918, for Munch originally placed an embryo in the foliage and tree which separate the couple. This picture is a section of a frieze from the *Modern life of the soul* upon which Munch worked for thirty years. In that same year, 1918, he wrote of his work-in-progress: "The frieze is a poem of life, love, death. The theme of the largest picture, *Man and woman in the forest,* showing two figures, perhaps stands somewhat apart from the others, but it is as necessary to the frieze as a whole as the buckle is to the belt." The Munch Museum possesses 1,100 paintings in storage, with which to replenish its ever-changing exhibit, but no suitably vast room was ever built to house the entire frieze in which *Man and woman* could be the "buckle" of the belt of life; love, the ever-connecting link.

Good health and nature, fjords and midnight sun, and the great surge of love and ardor that is life itself, all are in this lovely painting.

ELIN VANDERLIP

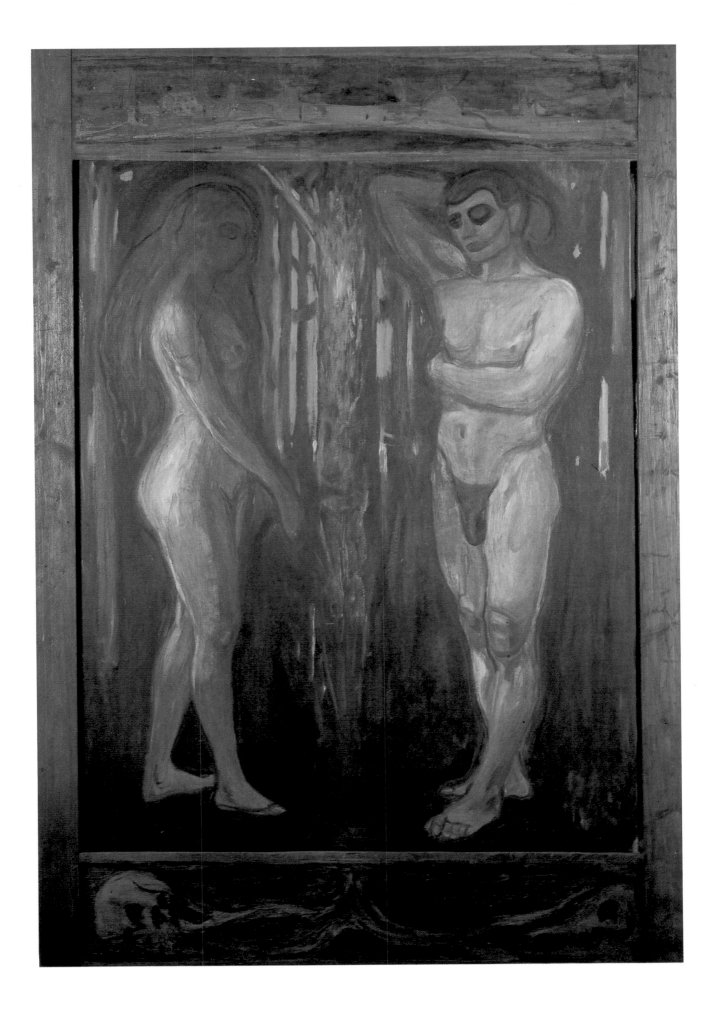

Rembrandt (1606–1669)

THE JEWISH BRIDE

N.D. oil on canvas, 47¾×65½"

Rijksmuseum, Amsterdam

THE supreme example of Rembrandt's use of paint to lift a subject onto a different plane, as language may lift a commonplace sentiment to the level of the highest poetry, is the picture known as *The Jewish bride*. When did the picture first acquire this title, which seems to have as little relevance as *The night watch*? It has set scholars off in search of Old Testament stories, and they have usually closed for Isaac and Rebecca, of whom Rembrandt had made a hasty drawing much earlier, based on a fresco in Raphael's Loggia.

But to argue over the picture's title is frivolous. As in all the greatest poetry, the myth, the form, and the incident are one. Rembrandt saw any loving couple, long sought and wholly devoted, as Isaac and Rebecca, and whether or not the position of their hands is that of a Jewish betrothed, it is an ancient and satisfying symbol of union, which, through the magic of Rembrandt's transforming touch, has become one of the most moving areas of paint in the world.

The Jewish bride is the climax of Rembrandt's lifelong struggle to combine the particular and the universal, and he has achieved his aim in two ways: by relating accidents of gesture to the deep-rooted recurring motives of Mediterranean art, and by seeing episodes in actual life as if they were part of the Old Testament.

LORD CLARK

Kenneth Clark

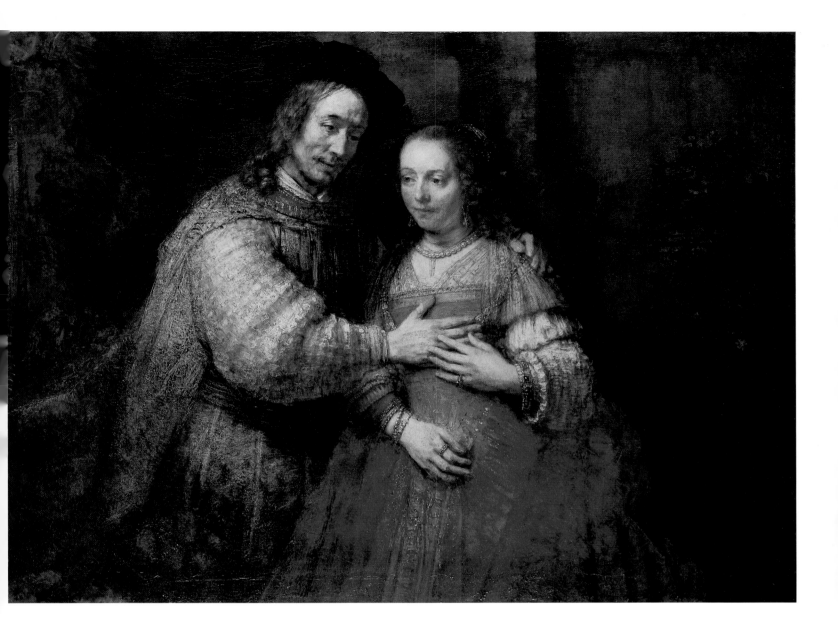

Gaston Lachaise (1882–1935)

PASSION

1932–34, bronze, height 28"

Lachaise Foundation, Robert Schoelkopf Gallery

PASSION is the title of this emotion-charged pair of nude bronze figures. The female stands on tiptoe on one leg, tense with erotic excitement as she lifts her other leg to embrace the male; he presses her full-blown body and mouth into his own. The two are completely and passionately one.

To me, it is an extraordinary fact that their creator, the sculptor Gaston Lachaise, owed his own lifework to the same word: "Passion".

His best known sculptures are nude women, heroic in size and bursting with sexuality, all modeled after his wife Isabel. From their first chance encounter in a Paris park, it was this "majestic woman" who was Lachaise's inspiration and his life-drive. At the time of their meeting in 1903, he was twenty years old, she (an American, married) was ten years his senior. Their rapturous partnership began at once. When she had to return to the United States, he struggled to earn the money to follow her: in 1906 he succeeded, arriving in America penniless and unable to speak the language. But once married to Isabel and settled in New York City, he worked "like a man possessed" to create his voluptuous works of art.

During Lachaise's lifetime only a few appreciated his genius. Said Nelson A. Rockefeller, "Gaston Lanchaise's unique force, grace, and sense of volume have always appealed to me enormously. He was one of the first great modern sculptors".

ELEANOR HARRIS HOWARD

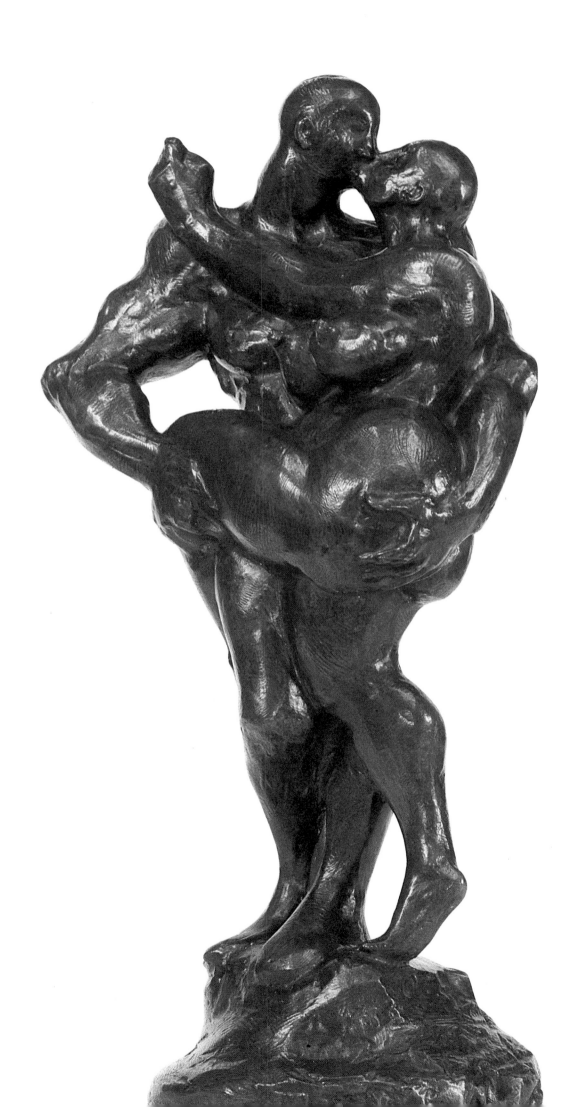

Michele Gordigiani (1830–1909)

ROBERT BROWNING, ELIZABETH BARRETT BROWNING

1858, oil on canvas, 28½×23⅛" and 29×23"

The National Portrait Gallery, London

THE enchanting love story of Robert Browning and Elizabeth Barrett is known the world over since the success of Rudolph Besier's play *The Barretts of Wimpole Street* in the 1930's and its later screen version. In 1944, Katharine Cornell, myself, and a brilliant company crossed the Atlantic on a troopship and played it in England for six months, and then for the armed forces through Italy, France, Belgium, and Holland.

On a dark and freezing November day we picked our way over the rubble and devastation of Florence to see the Casa Guidi, the house where the Brownings settled after their flight from England a hundred years before. There it was that Browning stood looking out the window on his birthday morning when his wife came behind him and pushed a packet of papers into his pocket, told him to read them and tear them up if he did not like them, and fled to her own room. He did like them, urged their publication despite their intimate character, and chose the title *Sonnets from the Portuguese* because he used to call her in jest "my little Portugee".

These sonnets, among the most exquisite love poems in English, are an expression of Elizabeth's love for Robert who, coming like a burst of sunshine and fresh air into her darkened life, had transformed her poetry as well as herself. There are forty-four sonnets; this is the forty-third:

> *How do I love thee? Let me count the ways.*
> *I love thee to the depth, and breadth and height*
> *My soul can reach, when feeling out of sight*
> *For the ends of being and ideal grace.*
> *I love thee freely, as men strive for Right;*
> *I love thee truly, as they turn from Praise.*
> *I love thee with the passion put to use*
> *In my old griefs, and with my childhood's faith.*
> *I love thee with a love I seemed to lose*
> *With my lost saints,—I love thee with the breath,*
> *Smiles, tears of all my life!—and, if God choose,*
> *I shall but love thee better after death.*

BRIAN AHERNE

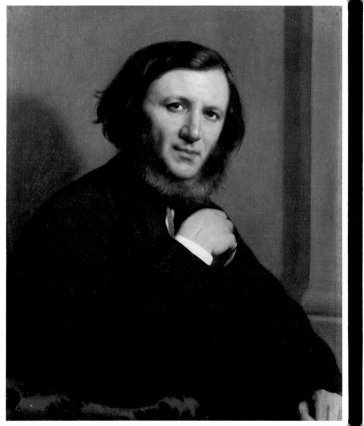

Antonio Correggio (1494–1534)

THE SCHOOL OF LOVE

ca. 1520, oil on canvas, 61¼×36"

The National Gallery, London

THIS is love in a defensive form. The little god is likely to cause such havoc that he must be tamed at an early age. Mercury and Venus, in the guise of his parents, therefore supervise his education. Mercury is trying to teach him to read. Venus stands by encouragingly, but is not above flirting, with her eyes, with those of us who look at the picture.

Correggio's companion picture to this one is now in the Louvre and shows the more dangerous aspects of love. A beautiful young satyr has discovered a sleeping girl—Venus—naked in a wood. The sequel is only too obvious. But the true lesson, the counterbalance, is the present picture. The spiritual aspect of love is the alternative to the carnal. Both pictures, in all probability, were painted for the pleasure-loving Duke of Mantua in the 1520's. In both of them the sensuous beauty of the painter's technique ably suits the subject, and in this one, in particular, it would be difficult to surpass the delicacy of the young Cupid's wings, which seem to grow quite naturally from his body.

A faithful copy of this picture, and several of Correggio's originals, arrived in Paris early in the 18th century and exercised enormous influence over French art at a time when the arts of love, and the art of representing it, were being cultivated in a more sophisticated way than ever before.

CECIL GOULD

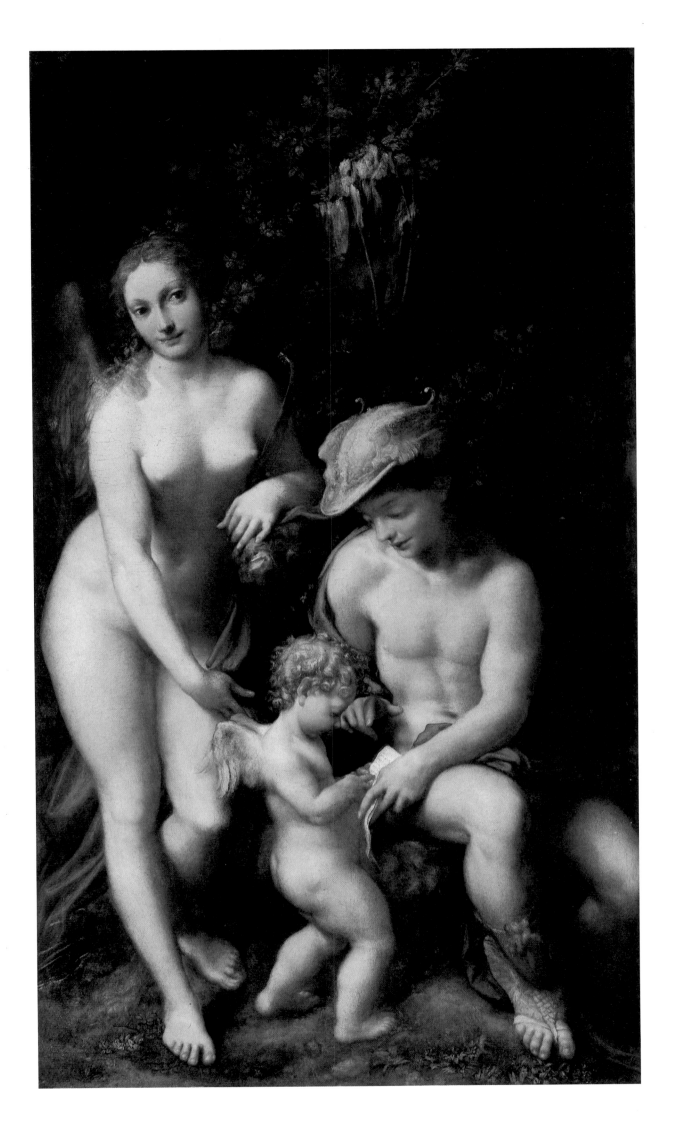

Jean-Honoré Fragonard (1732–1806)

THE STOLEN KISS: Detail

1750's, oil on canvas, 17¾×21½"

Hermitage, Leningrad

WHEN one thinks of lovers one must think of Jean-Honoré Fragonard, for love in all its aspects was the subject of his paintings throughout his lifetime.

Thank heavens he adored·beautiful women and painted them with passion and joy. His lovers' encounters often seem more like clandestine frolics than enduring commitments. Perhaps for that very reason they titillate our senses, and somehow we find ourselves wondering, "Will the servant tell?" . . . "Will the husband walk in?"

But Fragonard was more than a painter of erotic scenes. "A sensual Provençal", says art historian André Michel, "who was enchanted by women, enflamed by light, and amused by everything in life".

The stolen kiss is not as exuberant as some of Fragonard's earlier subjects, but it is painted with tenderness and warmth, and one feels a more mature, less passionate eye looking upon the stolen pleasures of love.

He painted the French court scene as he saw it . . . gay, carefree, enjoyment in the moment . . . but with a master's brush. Always a master's brush, whether in an over-decorated boudoir, an idyllic garden, or an elegant interior. Beauty was his beckoning Muse; he captured her with voluptuousness and joy.

JANET GAYNOR

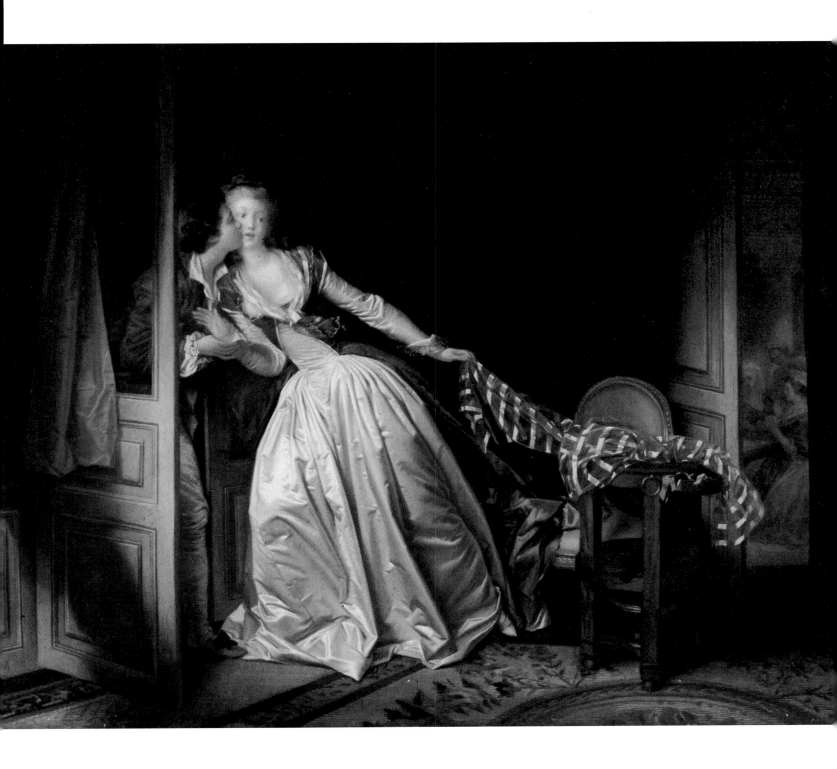

(Currier and Ives)

COURTSHIP: THE HAPPY HOUR

1857, lithograph and wash on paper, 8½ × 12¾"

Private collection

I GUESS that the young lady has been angling for this young man for quite a long time! No doubt there were row boat excursions with picnic luncheons spread on the grass, a sedate waltz under a Mother's watchful eye, a naughty game of croquet, showing a well-turned ankle, and perhaps even a playful romp with a dog she lovingly caresses before the young man's jealous eye. But in her mind must have been the thought, "how is it going to end?" Obviously, he is serious and well behaved, so he must have other young ladies on his track. She surely stayed awake many hours at night, lying primly between her starched sheets in her long-sleeved nightgown, perhaps even getting up to write a poem, only to tear it up at dawn. Now, at last, she has lured him on to this tiny sofa, beside her in a vase the bouquet he brought. This is the great moment; she wants to jump up and clap her hands in joy, but she discreetly hides her feelings behind a wistful and dreamy smile. This is truly The Happy Hour, and Mama, who is sitting in the next room with her ear out, is probably happier than both of them!

The famous series of nineteenth-century lithographs known to us as "Currier and Ives prints" were printed and published by, first, N. Currier and then Currier and Ives, but they were made after drawings by various artists. This one is believed to be the work of Fanny Palmer, one of the best and most prolific of them all.

BROOKE ASTOR

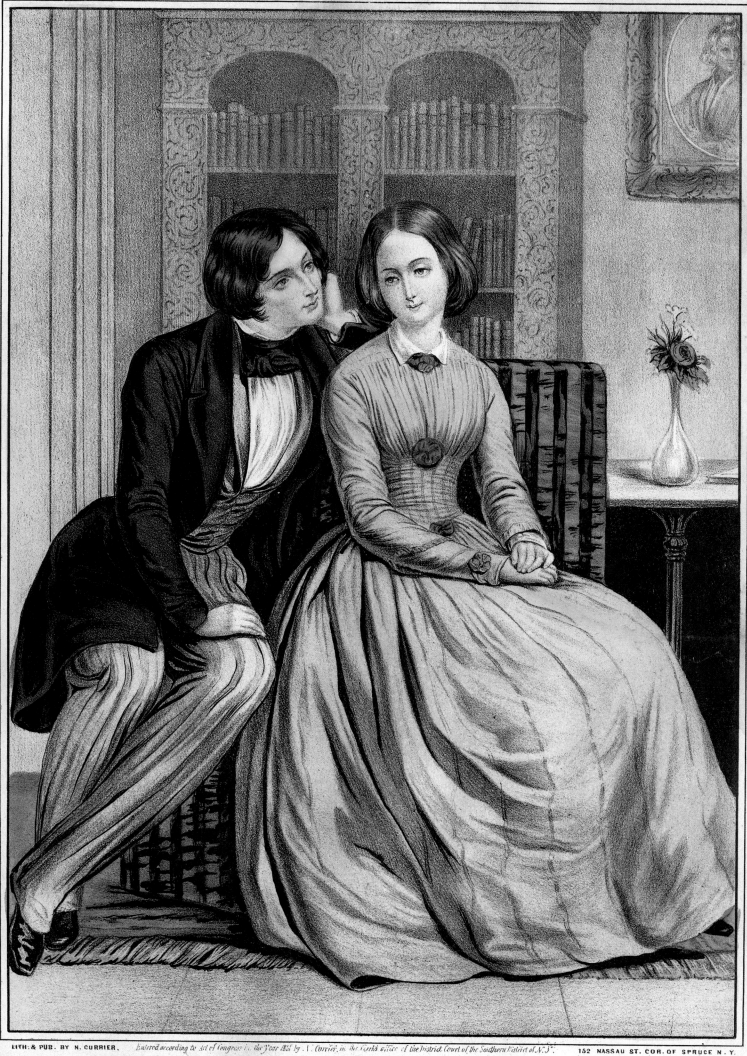

LITH: & PUB. BY N. CURRIER, Entered according to act of Congress in the Year 1846 by N. Currier, in the Clerk's office of the District Court of the Southern District of N.Y. 152 NASSAU ST. COR. OF SPRUCE N.Y.

COURTSHIP.

THE HAPPY HOUR.

Albert Grafle (1807–1889)

EMPEROR MAXIMILLIAN and EMPRESS CARLOTTA

1865, oil on canvas, 100¾ × 67⅜"

Chapultepec Palace, Mexico City

190

FERDINAND MAXIMILIAN JOSEPH, the younger brother of Emperor Franz Joseph of Austria, was crowned Emperor in Mexico in 1864. Along with his beautiful, beloved wife Carlotta, the daughter of King Leopold of Belgium, he had been persuaded by Napoleon III to come to the New World.

Maximilian thought the Mexican people had voted him in. He was not aware that certain Mexicans and Napoleon had created this maneuver to overturn the government of President Benito Juarez. Maximilian's ingenuousness placed him at the mercy of the international intrigue which had put him on the throne. He reigned only three short years. As commander of the Imperial Army, he was defeated by Juarez while defending "his people". He was later executed on a hill outside Queretaro. His wife was in Europe at the time frantically seeking aid for her husband from a, by then, reluctant Napoleon III and Pope Pius IV.

In these portraits, the artist has captured Maximilian and Carlotta in all their youth, beauty, and court finery. They were a couple who had been given virtually everything life could lavish on them. They were royal, wealthy, educated, and handsome.

What brought them down, then? Perhaps they lacked discretion. Poor Carlotta had plenty of time to reflect on that. Maddened by grief, she survived Maximilian's firing-squad death by 60 years.

JOHN GAVIN

Anon.

SATYR AND MAENAD

1st cent. (Roman), fresco, 14½ × 17¼"

House of Epigrams, Pompeii

I WAS in the ruins of Pompeii some twenty years ago, stepping carefully over some hot lava which had not yet cooled, never getting too far from the safety of the tour bus in the event that Vesuvius decided to come back and destroy whatever it may have missed the first time. While my wife was inspecting a 2,000-year-old loaf of petrified bread, which didn't seem to be much harder than what your average hotel sends up with room service, I was tapped on the shoulder by a shifty-eyed Neapolitan who inquired in hushed tones whether I would like to see some "hot pictures—for men only". Never the one to miss out on adventures in art, I left my wife perusing seven bowls of ashes, a rather unappetizing-looking dinner even for those days, and after an exchange of a few hundred lira, I was led along with five or six other male artlovers down a few rubble-strewn streets into a secluded alleyway, and then into a small house.

The wall was covered with a wooden enclosure and carefully locked. Our guide gave a few glances around to make sure we were not followed by innocent women or inquisitive children, then took out a key and unlocked its forbidden secret treasure. What we saw was a lovely and delicate painting of two young, beautiful lovers in an embrace not much more explicitly detailed than you would find in a PG movie today.

The moral being, sex is not so much in what you see as in the extent you go to keep it from being seen.

NEIL SIMON

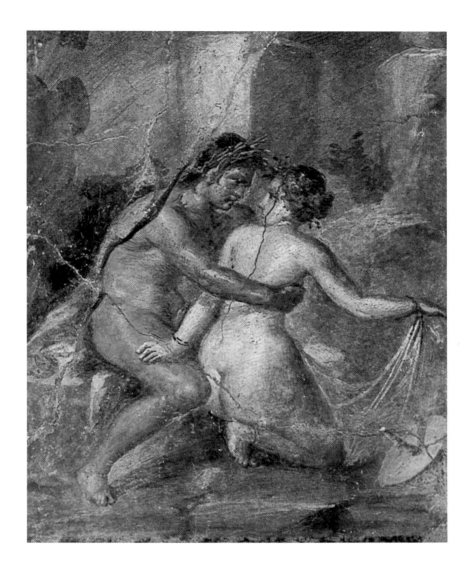

Giovanni Boldini (1842–1931)

A WALK IN THE WOODS

1910, oil on canvas, 91×51¼"

Collection Ferrara Museum, Ferrara, Italy

BOLDINI, in this grand picture, represents all the poetry of the turn of the century. He painted a style and a way of life that reflected the era he lived in, became famous in, and is remembered for. Rita Lydig and her husband, Captain Lydig, lived and loved each other at a time when elegance played an important role. She is like a queen advancing toward her throne, preceding her court. The two lovers are alone, yet there is a feeling that they are passing among a group of admirers.

This painting was a kind of challenge for the master. All of the dark colors of Boldini, from the black of the woman's clothes, including her muff and the velvet of her hat, to the black of the man's trousers and jacket—have a variety and felicity of tone that enchants. I knew this couple, the Lydigs. They were in love and they belong in this book, immortalized by my husband's painting.

EMILIA CARDONA BOLDINI

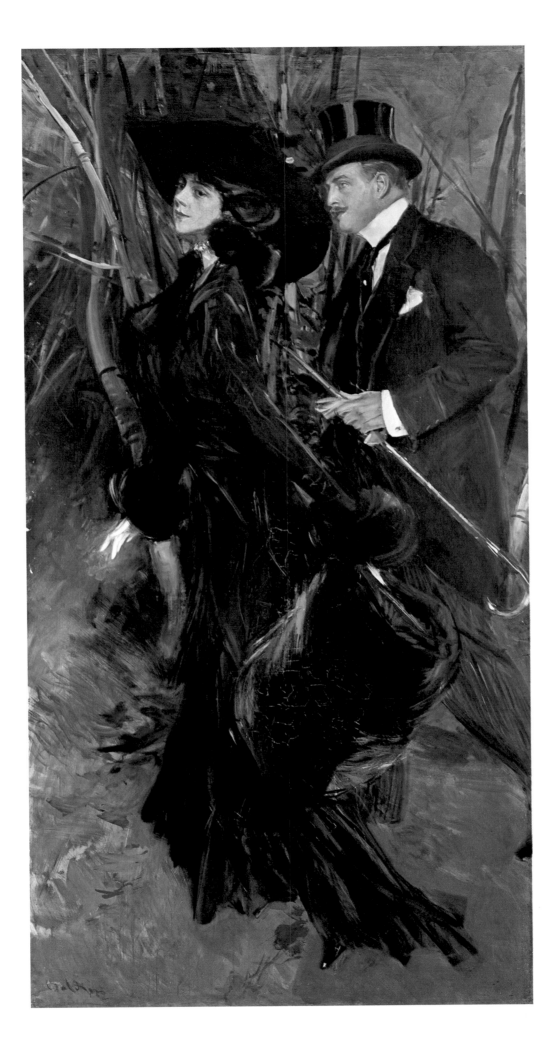

Ivan Mestrovic (1883–1959)

WELL OF LIFE

1905, bronze, height 42½"

Mestrovic Museum, Zagreb, Yugoslavia

MY FATHER executed the *Well of life* in 1905 when he was only twenty-two years old. Although it is one of his early works, there is a very accomplished artistic quality to it, but above all it shows deep spiritual maturity. In it, I think, the artist expresses clearly what I felt was his credo throughout his whole life: God is the fountain of life, and all of us, from the moment we are born to the time we die, try to drink from that Water, the only one which will quench our thirst for the perfect and the infinite. It is through our love and union with Him that we are joined in a circle to one another. Through human love we shall achieve divine love, linked by a single fountain that flows eternally.

The work of the young Mestrovic does not lack, of course, the sensuality and the torment of the flesh; one also feels the influence that Rodin's art had, at the time, on my father. But the inner vision surpasses the powerful language of form and even its creator (I mean the artist), leaving a message beyond what is perishable and transitory.

The words my father had engraved on the bell of the Cavtat Memorial Chapel in 1920 confirm what I have just said: "Learn the secret of love and you will discover the secret of death and believe in life eternal."

MARIA MESTROVIC

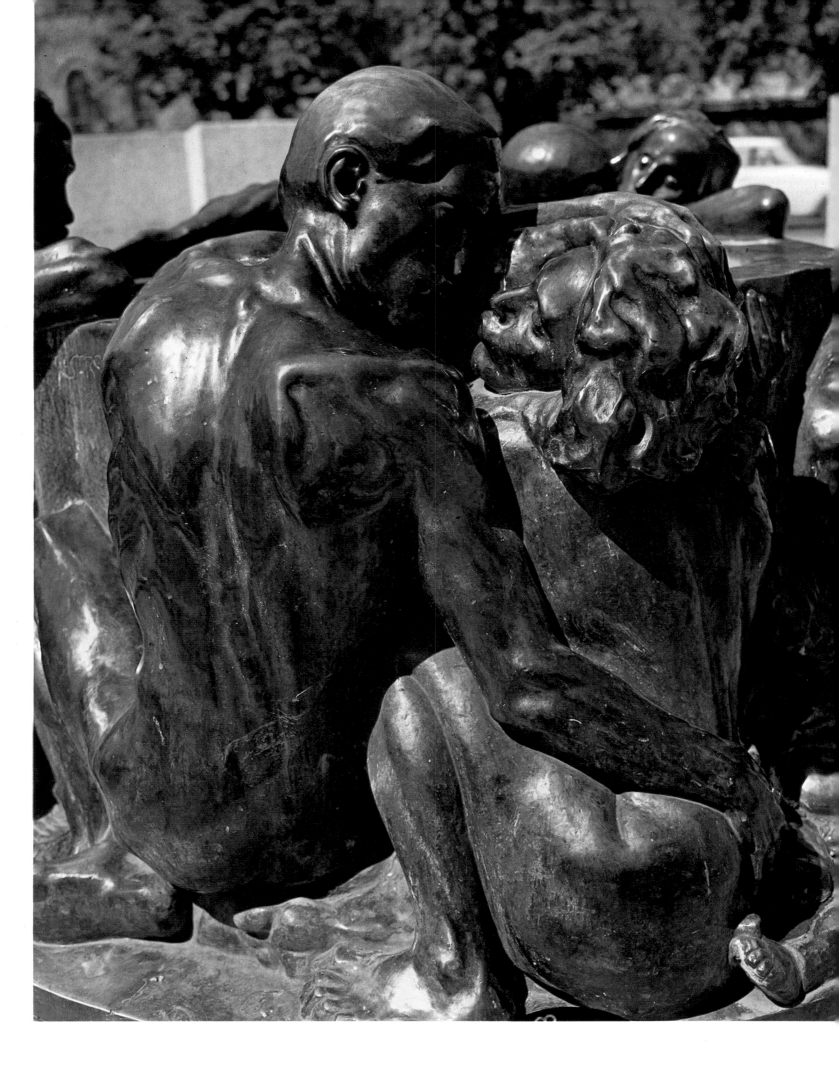

Giovanni Segantini (1858–1899)

LOVE, FOUNTAIN OF LIFE: Detail

1869, oil on canvas, detail height 61¼"

Galleria de' Arte Moderna, Milan

SEGANTINI'S dreamlike vision and his romantic concept of lovers are expressed in this fantasy in nature. Italians often express the same feeling in music, when we say that lovers are transported into what we call an "Al di la" (beyond-the-beyond). Isn't that what we feel when we fall in love?

When I go through the Modern Art Gallery in Milan I like to stop and absorb the feeling in this painting. Although these lovers are only a detail in Segantini's large canvas, I have the feeling they will have a meeting in Infinity. Their love is definitely "Al di la". I'm sure they must inspire many young lovers, who relate to them as I do.

ROSSANO BRAZZI

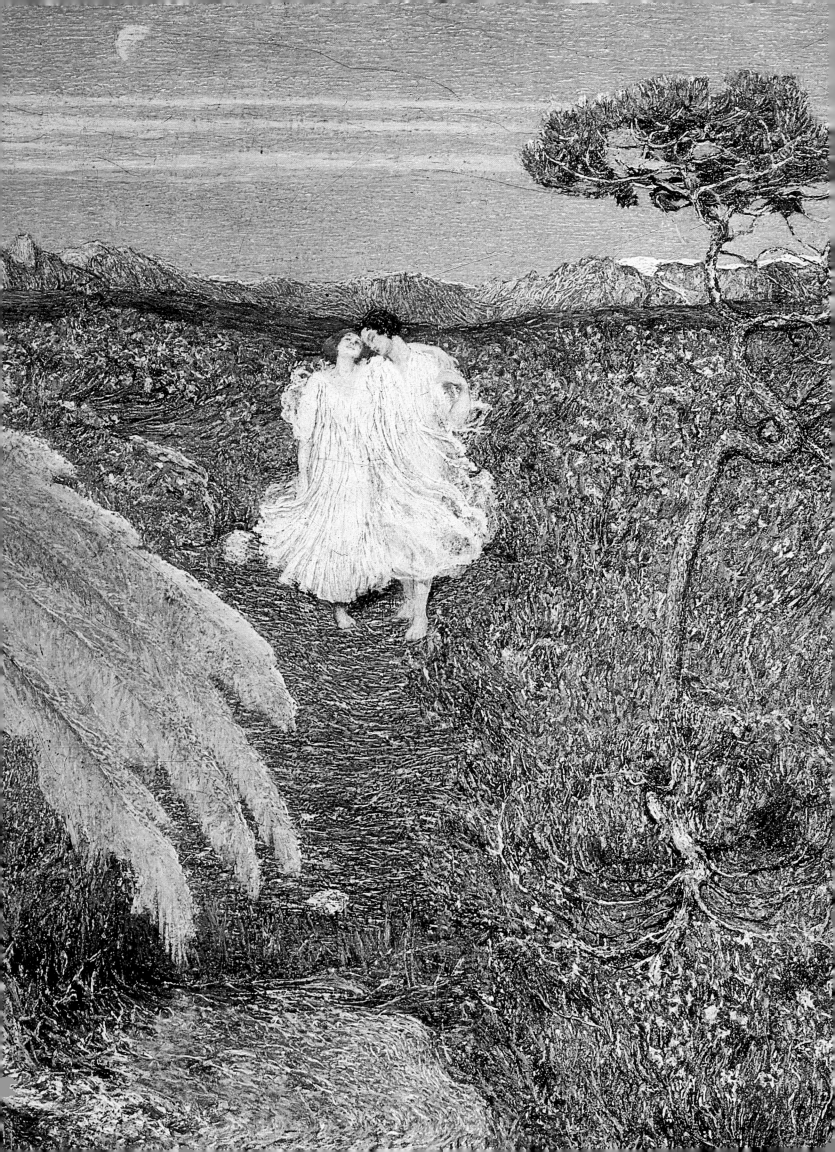

François Boucher (1703–1770)

LOVERS IN A PARK

1758, oil on canvas, 90½ × 76"

Timken Gallery, Putnam Foundation Collection, San Diego

IN THE painting *Lovers in a park,* something seems a little odd.
There are three figures—which is unusual, unless a ménage à trois
is meant. No, this is not the case. The lovers are at the right,
caught in a moment of woodsy intimacy wherein he is placing
flowers in her hair and she is leaning on his leg. Their dalliance is
interrupted by a girl who walks by with baskets of flowers on a
pole, and the slightly disheveled lover pauses in the art of
decorating his mistress with blossoms to glance up at the flower
girl. Their eyes meet. Even the little dog, for centuries the symbol
of fidelity, looks up, perhaps in alarm as if he had sensed a danger
signal.

All we are shown by the witty and clever artist is the possible
supposed moment when the eye of the captured lover may start to
wander in search of his next conquest. This was, after all, the
endless pastime of the French court and of everyone in it: the
intrigues necessary to start a romance, the further ones needed to
conduct the affair, and finally the fleeting instant at which
everything is shattered. As a sad commentary, one might observe
that the adorable girl at his side is seemingly unaware that his eye
has strayed. This was very much the Court Game of Love as played
at Versailles.

As the French know so well, and as Boucher was so adept at
portraying, flirtatious romance is very elusive. No sooner is the
blossom plucked and its aroma and beauty enjoyed by the senses,
than it starts to wilt; or, as in this case, the male turns to look for a
younger, more innocent blossom.

HENRY G. GARDINER

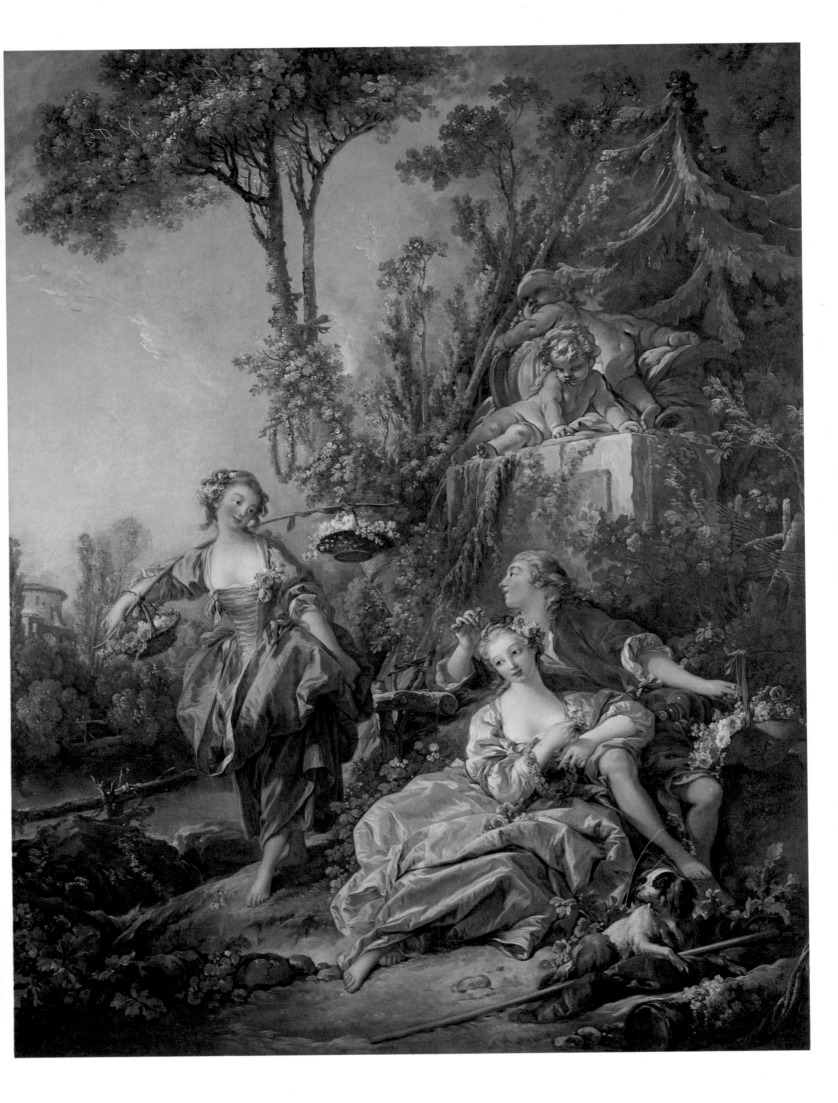

Pablo Picasso (1881–1973)

LOVERS ON A STREET

1900, pastel on paper, 23⅝ × 14¼"

Picasso Museum, Barcelona

IT WAS raining—not hard, just a drizzle—and the music was not very gay. It was monotonous, never-changing, like poverty and desperation.

Every little square in Paris, grand or poor, has its little band, and couples are dancing. Little girls dancing with their fathers, old people, young people, midinettes together, and strangers with strangers. They do not know many steps, but everyone clings to a partner.

Picasso has given us something like the first Fourteenth of July after the Armistice of 1918. The woman has loved many times in many ways. She is old and painted now, but she joins the throng of her particular Arondissement. And shabby and cold as they are, clinging together, two souls—total strangers—submerge in a moment of love. He a cadaverous youth and she an old woman. They are in harmony for this hour.

DIANA VREELAND

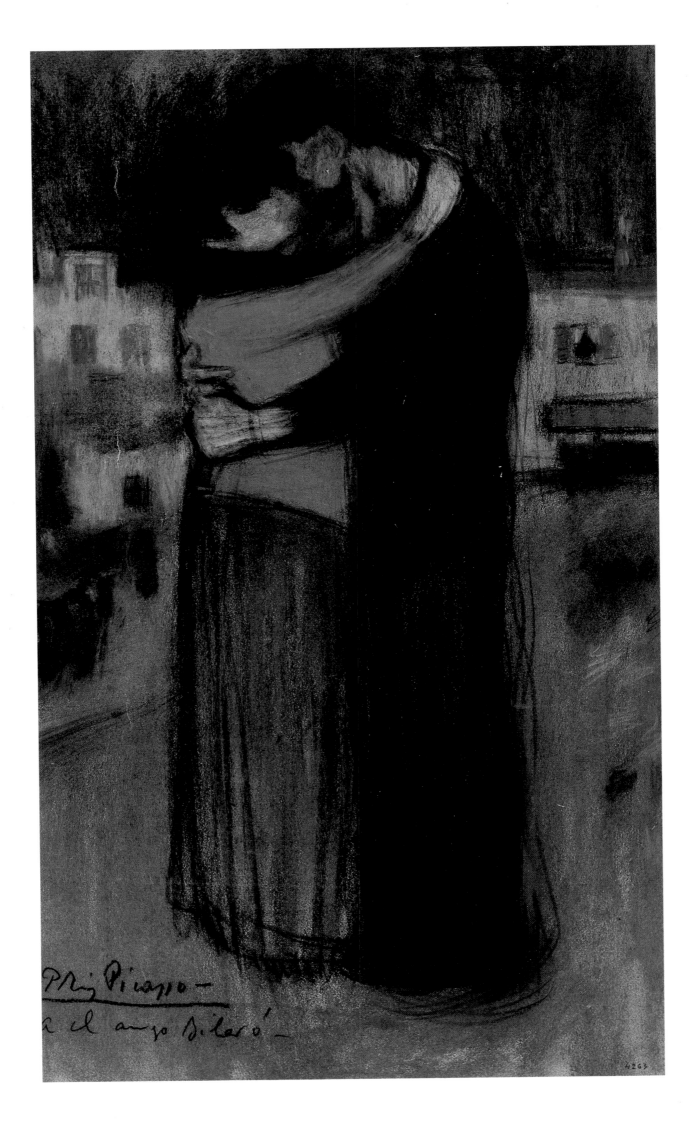

Eugène Delacroix (1798–1863)

GEORGE SAND	CHOPIN
1838, oil on canvas, 31×22⅜″	1838, oil on canvas, 15×18½″
Ordrupgaard Samlingen, Copenhagen	Louvre, Paris

DELACROIX has captured Madame Sand listening to Chopin playing. These paintings were originally a double portrait, but the picture was subsequently cut in two, possibly so that the owner would profit more by selling the parts. Delacroix spent three summers visiting at George Sand's country home while Chopin was there. He loved to have long discussions with Chopin because he felt the aesthetic problems of the painter and the composer were similar. Both arts made a direct appeal to the emotions.

It is said that opposites attract. After their first meeting, neither Chopin nor Sand had kind words to say about each other. Yet an extraordinary relationship of some eight years ensued between the great genius and the highly admired and controversial woman, resulting in one of the great and most romantic of love stories.

I do not say "love affair" because that presupposes a physical relationship as well, which, for Chopin and Sand, was of extremely short duration. Sand (perhaps not unwisely) used Chopin's ill health as her reason for discontinuing any physical relationship.

Perhaps her amorous desires were more than Chopin could satisfy (judging from her past, this could very well have been true). Did Chopin have more energy for his composing because of her decision to deny him her bed? Would his health have suffered more had he not been forced to abstain? Who can say?

What is fact is that he composed some of his greatest work during his years with Sand. She provided a home and family atmosphere, which included her two children, to nurture him, and Chopin shortly became "another son", according to Sand. So they became lovers of a different sort. He often asked her musical opinion about works he was composing, since he admired her writing and her strength. Nohant, her country home in France—so her granddaughter, Aurore, told me—was made to run for Chopin.

He had to be more than grateful for all of that. But such an incomplete love could not last. Much bitterness developed eventually, and Chopin died two years after their separation. A broken heart? . . . or the normal deterioration of his illness?

He was heard to murmur on his death bed: "And she said I would die in no one else's arms but hers."

BYRON JANIS

Anon.

LOVERS

1000 B.C. (Indian), fresco

Ajanta Caves, Aurangabad, India

I WAS in no mood to visit a cave, even the Ajanta caves, because now we were on the Indian subcontinent, that place of incredible heat and dust. I wanted to relax in my air-conditioned Bombay hotel room.

But they might be cool, those caves, I finally reasoned. And so I went to Aurangabad, and saw those wonders of antiquity, too, all filled with wall and ceiling paintings of extraordinary grace, in rooms literally sculpted out of the limestone of the Inhyadri Hills by the Waghora River. And the caves *were* cool, dry, and deep, dimly lighted by handheld lamp as we traveled back in time to well before the birth of Christ. Imaginary creatures of every manner, numerous Buddhas resplendently jeweled, bearded beggars as saints-in-disguise, heavenly musicians and playful figures among lotus tendrils everywhere; all, each and every one, offering devotions to Buddha, and extolling the virtues of the new god. But it was the rare earthly and carnal couple, exquisitely amorous, in the first cave, that I wanted to see again.

Do you see how seriously the young man tends to business—a huge white lotus bud for Buddha—and how they dressed for the occasion? Do you see how she longs for her love, patiently, but with right arm and fingers grazing his shoulder, her left hand lingeringly alight but deliciously high on his thigh, her high bare breast touching his arm (the easier to bear the bud of course), her face at his shoulder, breath on his arm, her black eyes smoldering? Now he takes one brief businesslike backward glance into her eyes—and then? Oh, we can see clearly now: business does come first and success will be theirs. And oh, the thrill of the promise in her eyes and patience implied!

DONNA REED

Titian (1477–1576)

THE THREE AGES OF MAN: Detail

1512–15, oil on canvas

Duke of Sutherland Collection, on loan to the National Gallery of Scotland, Edinburgh

208

IN THIS detail from Titian's *Three ages of man* the two lovers are at the height of their physical and spiritual power, having left their childhood, but not yet facing old age. Their discovery of each other and their trust in each other is beautifully represented. Many artists portray lovers, but few succeed in capturing the romantic mood that floods Titian's canvas. The adoring expression in the man's face, his compassion and lyricism, combine with the joy of love. Titian here celebrated the beauty and richness of life, the mystery of life and death.

I take pride in this great Venetian artist because Venice is my home. I have a special interest in him because my predecessor, Mr. Fortuny, restored three of his paintings. As present head of the house of Fortuny, I like to feel that I am a link—however small—between Titian the master and the masterpieces the world enjoys today.

Reveling in this age, we identify with these lovers. They are happy to have left the first age, but are they ready to move onto the third? Are we?

COUNTESS ELSIE GOZZI

Jean Antoine Watteau (1684–1721)

MELODY OF LOVE

ca. 1717, oil on canvas, 20×21"

The National Gallery, London

WHETHER we recall the period which this painting by Watteau represents, or whether it reminds us of emotions in our own lives and times, surely none of the arts is more interwoven with love than music. Some may be unaware of its pervading and persuasive influence; as a composer, I feel its power in shaping the pattern of love's course.

Shakespeare wrote: "If music be the food of love, play on!", which would be an apt title for this particular painting of Watteau's. Or, bringing it into our own time, consider the lines of Conrad Aikin:

> *Music I heard with you was more than music,*
> *And bread I broke with you was more than bread.*

So it is that with lovers, music becomes a part of the expression of love, and love is forever a part of the expression of music.

ELINOR REMICK WARREN

Michelangelo (1475–1564)

ADAM AND EVE: Detail

1509–12, fresco

Sistine Chapel, St. Peter's, Rome

MICHELANGELO was commissioned by Pope Julius II to paint the frescoes of *Creation* on the walls and ceiling of the Sistine Chapel. He was forced to search the depths of his own talent and individuality to accomplish this master task. In the panel depicting the Garden of Eden, our ancestors are shown in their birthday suits.

The myth of God making the woman out of one of Adam's ribs is really a "rib" in itself. It shows what the early writers thought of womankind. Eve is just beginning today to emerge from this preposterous image. In Hebrew, the word "Adam" means mankind and woman is an integral part of mankind, not an off-spring of Adam.

To be in love with the product of one's rib would necessitate a viewpoint limited by narcissism. They are lovers because all that Adam lacks, Eve fulfills, and vice versa. Hence the completeness, the oneness of all mankind.

KING VIDOR

INDEX OF ARTISTS

Abbasi, Reza-ye, 38
Abbott, L. F., 162
Aitbaev, S. A., 134

Beaton, Cecil, 32
Bellows, George, 58
Bernini, Gian Lorenzo, 76
Boldini, Giovanni, 194
Botticelli, Sandro, 164
Boucher, François, 136, 200
Brancusi, Constantin, 138
Briosco, Andrea (Riccio), 126
Brown, John, 14
Burne-Jones, Edward, 172

Chagall, Marc, 130
Chirico, Giorgio di, 44
Clemens, Paul, 120
Copley, John Singleton, 100
Correggio, Antonio, 184
Courbet, Gustave, 30
Culiner, Jack, 50
(Currier & Ives), 188

David, Jacques-Louis, 144
Delacroix, Eugène, 204
Duquette, Elizabeth, 84

Ernst, Max, 92

Fagan, Robert, 56
Fragonard, Jean-Honoré, 154, 186

Gainsborough, Thomas, 68
Gérard, François, 152

Gordigiani, Michele, 182
Goya, Francisco, 118, 146
Grafle, Albert, 190

Hals, Frans, 108
Harunobu, Suzuki, 20
Hayez, Francesco, 52
Holiday, Henry, 96
Hughes, Arthur, 102

Klimt, Gustav, 34, 124
Kokoschka, Oskar, 16
Kunnuk, Vivi Aluluk, 72

Lachaise, Gaston, 180
Laurencin, Marie, 160
Lempicka, Tamara, 110
Limbourg, Pol de, 82
Lotto, Lorenzo, 132

Martin, Fletcher, 70
Mestrovic, Ivan, 196
Michelangelo, 212
Millais, John Everett, 54
Miller, Alfred Jacob, 122
Moore, Henry, 36
Munch, Edvard, 176

Nolde, Emil, 168

Page, William, 66
Palmaroli, Vicente, 166
Picasso, Pablo, 22, 202
Prinet, René, 90

Rembrandt, 178

Renoir, Auguste, 46, 156
Riccio, (Andrea Briosco), 126
Rockwell, Norman, 128
Rodin, Auguste, 116
Romney, George, 162
Rousseau, Henri, 18
Rubens, Peter Paul, 174

Sargent, John Singer, 40
Schuffenecker, Claude Emile, 150
Segantini, Giovanni, 198
Sosios Painter, The, 28
Swope, John, 142

Tiepolo, Giandomenico, 80
Tiepolo, Giovanni, 88, 104
Titian, 208
Tooker, George, 140
Toulouse-Lautrec, Henri de, 60

Van Eyck, Jan, 74
Vermeer, Jan, 114
Vigeland, Gustav, 98

Warhol, Andy, 64
Watteau, Jean-Antoine, 210
West, Benjamin, 94

INDEX OF COMMENTATORS

216

ACTON, SIR HAROLD—*patron of the arts; writer,* 160

AHERNE, BRIAN—*actor; writer,* 182

ALBA, CAYETANA, DUCHESS OF, *patron of the arts,* 146

ARGYLL, MARGARET, DUCHESS OF—*patron of the arts; writer,* 68

ARNOLD, ANNA BING—*patron of the arts,* 42

ASTOR, BROOKE—*patron of the arts, writer,* 188

AXELROD, GEORGE—*playwright; film writer,* 26

BAXTER, ANNE—*actress; writer,* 74

BELLINI, GIUSEPPE—*collector; writer,* 96

BINNEY, DR. EDWARD, 3rd—*collector; art historian,* 112

BISHOP, BUDD HARRIS—*Director, Fine Arts Gallery, Columbus, Ohio,* 58

BOLDINI, EMILIA—*widow of Giovanni Boldini; writer,* 194

BORGHESE, PRINCESS MARCELLA—*patron of the arts,* 76

BRAZZI, ROSSANO—*actor,* 198

BROWN, J. CARTER—*Director, The National Gallery, Washington, D.C.,* 22

BROWNING, DANIEL O'KEEFE—*patron of the arts,* 158

CASSINI, OLEG—*designer,* 122

CESCHI, COUNTESS MARIA TERESA—*writer,* 104

CLARK, LORD (KENNETH)—*art historian,* 178

CLEMENS, PAUL—*artist,* 120

COPLEY, HELEN—*publisher,* 100

COWLES, FLEUR—*artist; writer,* 118

CUKOR, GEORGE—*film director* 124

CULINER, JACK—*artist,* 50

DART, JANE—*collector; member U.S. Fine Arts Commission,* 72

DUKE, ROBIN CHANDLER, *writer,* 174

DUQUETTE, TONY—*artist,* 84

DURANT, WILL—*writer,* 120

ESFANDIARY, SOROYA—*patron of the arts,* 38

EU, MARCH FONG—*Secretary of State, California,* 48

FADIMAN, DR. REGINA K.—*writer,* 130

FARRIS, CAROLYN—*collector,* 64

FONDA, HENRY—actor, 144

GARDINER, HENRY G.—art historian, 200
GAVIN, JOHN—actor; U.S. Ambassador to Mexico, 190
GAYNOR, JANET—actress; artist, 186
GODDEN, RUMER—writer, 148
GOULD, CECIL—former Deputy Keeper, The National Gallery, London; writer, 184
GOZZI, COUNTESS ELSIE—Director of Fortuny Fabrics, 208
GRACE, HER SERENE HIGHNESS, PRINCESS, OF MONACO—patron of the arts, 116
GUINNESS, DESMOND—President, Irish Georgian Society; writer, 56

HAYES, HELEN—actress, 80
HAYWARD, BROOKE—writer, 34
HINKHOUSE, DR. FOREST MELICK—Founding Director, Phoenix Art Museum, 18
HOLMES, NANCY—writer, 66
HOWARD, ELEANOR HARRIS—writer, 180
HUTTON, BARBARA—patron of the arts, 20
HUXLEY, LAURA—writer, 86

INGRAM, BARBARA—writer, 54

JANIS, BYRON—musician, 204
JOURDAN, LOUIS—actor, 152

KERR, DEBORAH—actress, 52
KNIGHT, ARTHUR—critic; writer, 36
KRASNA, NORMAN—playwright; film writer, 128

LEMPICKA, TAMARA—artist, 110
LODGE, FRANCESCA BRAGGIOTTI—patron of the arts, 166
LOGAN, JOSHUA—stage and film director, 16
LOOS, MARY—writer, 78

McGUIRE, DOROTHY—actress, 164
MALLORY, MARGARET—collector, 168
MARTIN, FLETCHER—artist, 70
MARTIN, MARY—actress, 150
MELCHETT, LADY —writer, 88
MESTROVIC, MARIA—daughter of Ivan Mestrovic, 196
MOORE, COLLEEN—actress; writer, 102

NATHAN, ROBERT—writer; poet; film writer, 156
NEGULESCO, JEAN—film director; artist, 138

OBERON, MERLE—actress, 136

PELLENC, BARONESS FRANCES—*artist; collector,* 82

PERELMAN, S. J.—*humorist; writer,* 90

PEREZ-SANCHEZ, ALFONSO E.—*Chief Curator, The Prado, Madrid,* 132

PICKFORD, MARY—*actress,* 14

POPE-HENNESSY, SIR JOHN—*art historian,* 126

PRICE, VINCENT—*actor; writer; collector,* 106

REED, DONNA—*actress,* 206

RENAULT, MARY—*writer,* 28

ROCHEFOUCAULD, ARMAND DE LA—*patron of the arts,* 46

ROGERS, BUDDY—*actor,* 14

SANDBLOM, DR. PHILIP—*collector,* 30

SEUSS, DR.—*artist; writer,* 44

SHARIF, OMAR—*actor,* 62

SHAW, IRWIN—*writer,* 114

SIMON, NEIL—*playwright; film writer,* 192

SMITH, BRADLEY—*photographer; writer,* 170

SMITH, KENT—*actor,* 94

SPITZER, ARTHUR—*collector,* 92

STARK, FREYA—*writer,* 162

SWOPE, JOHN—*photographer,* 142

TIERNEY, GENE—*actress,* 40

TOOKER, GEORGE—*artist,* 140

TOULOUSE-LAUTREC, COUNT DE—*patron of the arts,* 60

TROUBETZKOY, PRINCE YOUKA—*patron of the arts,* 134

VANDERLIP, ELIN—*writer,* 176

VIDOR, KING—*film director,* 212

VOGÜÉ, COUNTESS DE—*patron of the arts,* 154

VREELAND, DIANA—*special consultant, Costume Institute, The Metropolitan Museum of Art, New York,* 202

WARREN, ELINOR REMICK—*composer,* 210

WEST, JESSAMYN—*writer,* 108

WHITE, KATHERINE—*collector,* 24

WIKBORG, TONE—*Curator, Vigeland Park Museum, Oslo,* 98

WINDSOR, DUCHESS OF—*patron of the arts,* 32

WYATT, JANE—*actress,* 172

218

Mary Lawrence thinks love and art are alike; they alone can conquer death. Both love and art have been compelling influences in her life. Her first book, *Mother and Child,* in the same format as *Lovers,* was published in 1975. Miss Lawrence has three children and three grandchildren. She was educated at Columbus School for Girls, Western College for Women, Oxford, Ohio, and the University of California in Los Angeles. She has had professional careers as an actress in movies, television, radio, the stage, and as an interior decorator. She is now married to Samuel Doak Young, lives in El Paso, Texas, and La Jolla, California, and is working on her third book. Miss Lawrence is holding a terracotta figure she did while studying with Archibald Garner.